METEORITEN – ZEITZEUGEN DER ENTSTEHUNG DES SONNENSYSTEMS
METEORITES – WITNESSES OF THE ORIGIN OF THE SOLAR SYSTEM

METEORITEN – ZEITZEUGEN DER ENTSTEHUNG DES SONNENSYSTEMS
METEORITES – WITNESSES OF THE ORIGIN OF THE SOLAR SYSTEM

ILLUSTRIERT AN DER WIENER METEORITENSAMMLUNG
ILLUSTRATED BY THE VIENNA METEORITE COLLECTION

FRANZ BRANDSTÄTTER LUDOVIC FERRIÈRE CHRISTIAN KÖBERL

VERLAG DES NATURHISTORISCHEN MUSEUMS EDITION LAMMERHUBER

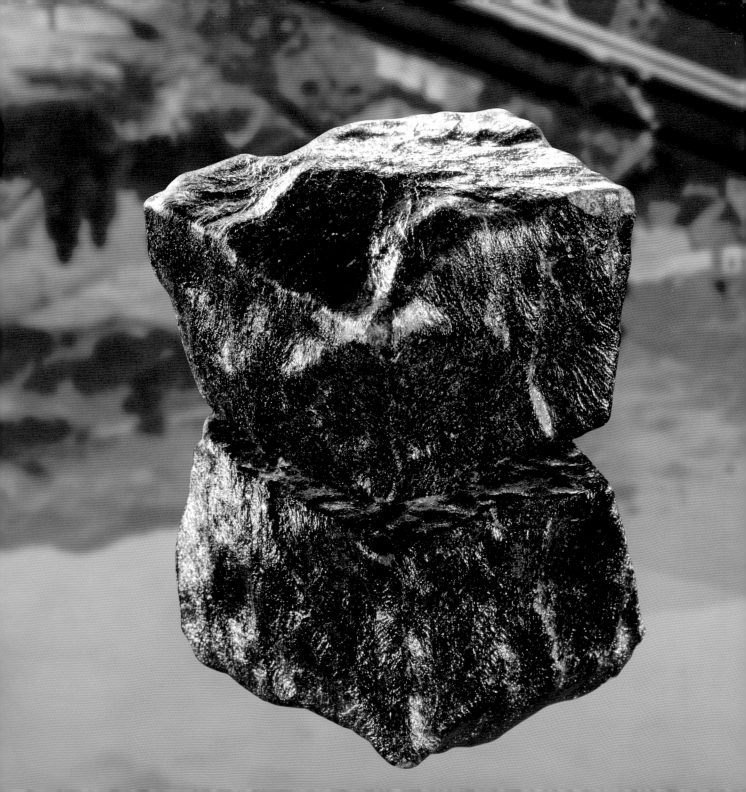

INHALTSVERZEICHNIS
TABLE OF CONTENTS

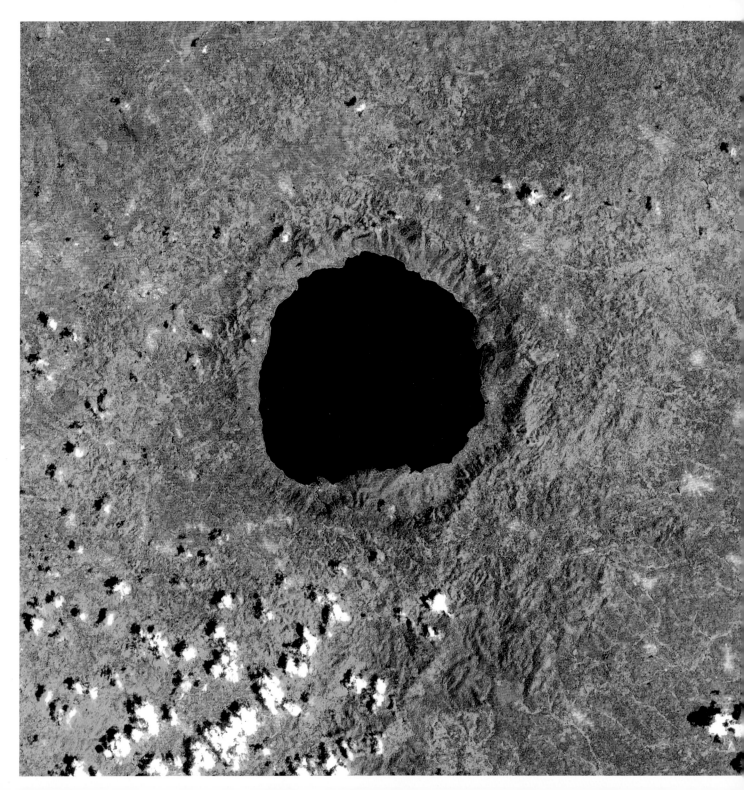

TROTZ IHRER UNSCHEINBARKEIT – meist sind es graue oder braune Steine – zählen Meteoriten zu den faszinierendsten Objekten, die es gibt. Diese „Steine, die vom Himmel fallen" sind die einzigen Zeugen, die wir für die Entstehung der Erde und des Sonnensystems haben. Ihre Zusammensetzung hat aber auch Aufschluss über die Herkunft der chemischen Elemente gebracht, aus denen unsere gesamte Welt – und auch wir Menschen – bestehen.

Das Naturhistorische Museum in Wien besitzt die älteste und eine der wichtigsten Meteoritensammlungen der Welt, die für wissenschaftliche Forschungen zur Verfügung steht. Außerdem zeigt das Museum die bei weitem größte Meteoritenschausammlung und macht die spektakulären Himmelsboten auf diese Weise auch einem breiten Publikum zugänglich.

Das vorliegende Buch, publiziert anlässlich der Neueinrichtung des Meteoritensaals, bietet einen allgemeinen Überblick über die Welt der Meteoriten und der Meteoritenkrater. Ich wünsche Ihnen viel Vergnügen beim Lesen und Staunen!

Christian Köberl
Generaldirektor
Naturhistorisches Museum Wien

EVEN THOUGH METEORITES ARE RATHER INCONSPICUOUS – most are just dull brown or gray rocks – they are among the most fascinating objects that we know. These "stones that fall from the sky" are the only witnesses that can tell us about the origin of the Earth and the solar system. Their composition has provided information about the formation of the chemical elements that make up our world – and us.

The Natural History Museum in Vienna has the oldest and one of the most important meteorite collections in the world, which is available for scientific research. The museum also has the largest meteorite exhibit and thus makes these messengers from space accessible to the public.

This book is published on the occasion of the reopening of the modernized new meteorite hall at the museum and provides a general overview of the fascinating world of meteorites and impact craters. Enjoy!

Christian Köberl
Director General
Natural History Museum Vienna

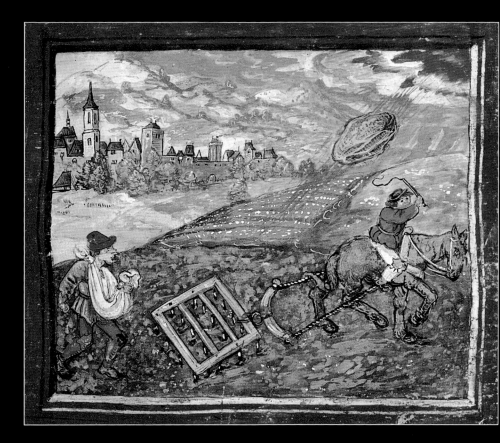

Der Meteoritenfall von Ensisheim, 1492
The meteorite fall at Ensisheim, 1492

465 v. Chr. / *BC*	Gallipoli, Türkei/*Turkey*
861 n. Chr. / *AD*	Nogata, Japan
1492	Ensisheim, Frankreich/*France*
1749	„Pallas-Eisen", Sibirien/*Siberia*
1766	Albareto, Italien/*Italy*
1794	Siena, Italien/*Italy*
1795	Wold Cottage, England
1803	L'Aigle, Frankreich/*France*
1806	Alais, Frankreich/*France*
1807	Weston, USA
1808	Stannern, Tschechien/*Czech Republic*
1815	Chassigny, Frankreich/*France*
1864	Orgueil, Frankreich/*France*
1891	Canyon Diablo, USA
1954	Sylacauga, USA
1969	Allende, Mexiko/*Mexico*
1982	Allan Hills A81005, Antarktis/*Antarctica*

Bis in das 17. Jahrhundert wurden Berichte über Steine, Eisenbruchstücke und „Hunderte andere Dinge", die vom Himmel ge-fallen waren, in Büchern festgehalten. Man interpretierte die Fälle als übernatürliche Zeichen, die meisten von ihnen als „Zorn des Himmels".

Until the end of the 17th century, reports on stones, native iron fragments, and "hundreds of other things" that fell from the sky were documented in books. The falls were interpreted as supernatural signs – most often as "wrath from the heavens".

DIOGENES VON APOLLONIA (499–428 v. Chr.). Vom Himmel fallende Steine waren in der Antike eine anerkannte Tatsache. Bekannt ist der Meteoritenfall auf der thrakischen Halbinsel Gallipoli um 465 v. Chr., den der griechische Naturphilosoph Diogenes von Apollonia als Fall eines erloschenen Sterns deutete.

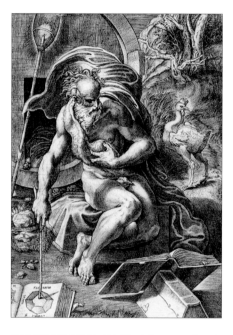

DIOGENES OF APOLLONIA (499–428 BC). In ancient times, the idea of stones falling from the sky was an accepted reality. Among them was the famous meteorite fall at the Thracian peninsula Gallipoli from around 465 BC. The Greek philosopher Diogenes of Apollonia interpreted it as the fall of an extinguished star.

TEMPEL FÜR BÄTYLIEN. Menschen der Antike sahen die Sterne als Sitz der Götter an, Meteoriten wurden als deren Gesandte verehrt. Die vom Himmel gefallenen Steine – Bätylien genannt – bildete man auf vielen Münzen ab.

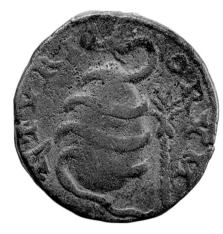

TEMPLE FOR BETYL STONES. In ancient times, people believed that stars were home to the gods, and meteorites were worshipped as their envoys. Stones that fell from the sky – so-called Betyl stones – were displayed on many coins.

METEORITENFUNDE IN DER NEUEN WELT. Auch für die Ureinwohner Nordamerikas waren Meteoriten Kultobjekte, wie Funde belegen. 1915 wurde ein in einem Federkleid eingewickelter Eisenmeteorit in einer Grabstätte der Sinagua (ca. 1100–1200 n. Chr.) bei Camp Verde, Arizona, gefunden. 1928 entdeckte man den Steinmeteoriten Winona in den Ruinen von Elden Pueblo in Arizona – er war in einer Steinkiste vergraben.

METEORITE FINDS IN THE NEW WORLD. The native people of North America also used meteorites as cultic objects, as has been documented in archaeological finds. In 1915, an iron meteorite, wrapped in a feather cloth, was found at a burial place of the Sinagua people (~1100–1200 AD). In 1928, the Winona stony meteorite was discovered in a stone burial vault at the ruins of the Elden Pueblo, Arizona.

DER METEORIT VON NOGATA. Der älteste beobachtete Meteoritenfall, von dem noch Material existiert, ist Nogata in Japan. Der Steinmeteorit ist am 19. Mai 861 in der Nähe eines Shintō-Tempels gefallen, wo er bis heute verwahrt wird. Schriftliche Zeugnisse gibt es nicht, das Ereignis wurde mündlich überliefert. Dass es sich wirklich um einen Meteoriten handelt, wurde erst um 1980 – mehr als tausend Jahre später – wissenschaftlich bestätigt.

THE NOGATA METEORITE. The oldest witnessed meteorite fall of which a specimen still exists took place in Nogata, Japan. On 19 May 861, the stony meteorite fell near a Shinto shrine where it is still preserved. No written records exist, but oral traditions have preserved the story of the fall. Not until 1980 – more than 1 000 years later – was the meteoritic nature of the stone confirmed.

DER METEORITENFALL VON ENSISHEIM. In Flugblättern beschrieb Sebastian Brant (1457–1521) den Meteoritenfall in Gedichtform, und er wurde in einem Holzschnitt dargestellt. Unbestritten ist, dass der Stein vom Himmel kam.

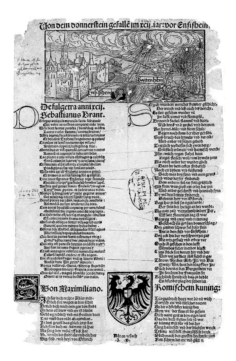

THE METEORITE FALL AT ENSISHEIM. This meteorite fall was described by Sebastian Brant (1457–1521) in verse form on pamphlets, together with a woodcut depicting the event. The reality of the stone falling from the sky was not questioned.

DER FALL VOM 7. NOVEMBER 1492 ist der älteste beobachtete Meteoritenfall Europas, von dem noch Material existiert. Das Ereignis wurde als gewaltige Explosion im weiten Umkreis der elsässischen Stadt und in Teilen der Schweiz wahrgenommen. Der ca. 130 kg schwere Steinmeteorit schlug ein mehr als ein Meter tiefes Loch in ein Weizenfeld. Vom ursprünglichen Stein wurden im Laufe der Jahrhunderte zahlreiche Stücke abgeschlagen, so etwa auch für Kaiser Maximilian I. (1459–1519). Der größte verbliebene Teil des Meteoriten (53,8 kg) wird im „Palais de la Régence" in Ensisheim (Frankreich) aufbewahrt.

THE OLDEST OBSERVED METEORITE FALL in Europe of which a specimen still exists took place on 7 November 1492. An enormous explosion was heard over a wide area in Alsace and parts of Switzerland. The 130 kg stone plunged into a wheat field, making a more than one metre deep hole. Over the centuries, many fragments were broken off the original stone, including a piece for emperor Maximilian I. (1459–1519). The largest remaining mass of the meteorite (53.8 kg) is kept in the Museum of the Palais de la Régence in Ensisheim (France).

DIE NEUEN NATURWISSENSCHAFTEN versuchten alle unbekannten Erscheinungen auf Basis rationaler physikalischer Gesetze zu erklären. Trotz historisch belegter Meteoritenfälle ging das Wissen um das Naturphänomen im Zeitalter der Aufklärung verloren. Vom Himmel fallende Steine galten nun als Aberglauben des Volkes. Sternschnuppen und Feuerkugeln wurden ausschließlich von irdischen Kräften abgeleitet – etwa als „Auswürflinge" von Vulkanen.

THE EMERGING NATURAL SCIENCES tried to explain all unknown phenomena on the basis of rational physical laws, and relegated stones falling from the sky to superstition. The knowledge of historically documented meteorite falls was lost during the age of the Enlightenment. Shooting stars and fireballs were thought to be derived from terrestrial sources – e.g., volcanic ejecta.

DAS „PALLAS-EISEN". 1749 wurde in Sibirien eine rund 700 kg schwere Masse aus metallischem Eisen gefunden. Auf Veranlassung von Peter Simon Pallas (1741–1811), einem deutschen Naturgelehrten, kam das „Pallas-Eisen" 1776 in die Kunstkammer von St. Petersburg. Heute heißt der Meteorit „Krasnojarsk". Der Fund hat einen heftigen Gelehrtenstreit über die Herkunft der Mineralart „Metallisches Eisen" ausgelöst. Der Stein-Eisen-Meteorit ist der Namensgeber der Pallasite.

THE PALLAS IRON. In 1749, a heavy mass of metallic iron weighing 700 kg was found in Siberia. On the request of Peter Simon Pallas (1741–1811), a German professor of natural history, the "Pallas iron" was transferred to the St. Petersburg treasury. The current name of the meteorite is "Krasnojarsk". This find initiated intense scientific debate about the origin of the mineral species "native iron". The "pallasite" group of stony-iron meteorites is named after this specimen.

DER STEIN VON ALBARETO. Im Juli 1766 wurde in Italien ein Meteoritenfall bei Albareto beobachtet. Der Jesuit Domenico Troili (1722–1792) hielt in einem Buch Augenzeugenberichte fest und deutete den Stein als vulkanischen „Auswürfling" einer unterirdischen Explosion. Mit seiner Abhandlung verfasste Troili eine der ersten wissenschaftlichen Beschreibungen eines Meteoritenfalls. Das Mineral Troilit (FeS), ein häufiger Bestandteil von Meteoriten, wurde später nach ihm benannt.

THE STONE OF ALBARETO. In July 1766, a meteorite was observed to fall at Albareto in Italy. In his book, the Jesuit Domenico Troili (1722-1792) documented eye witness reports and suggested that the stone was ejected by a subterranean volcanic explosion. Troili's treatise was one of the first published scientific descriptions of a meteorite fall. The mineral troilite (FeS), an abundant inclusion in some meteorites, is named after him.

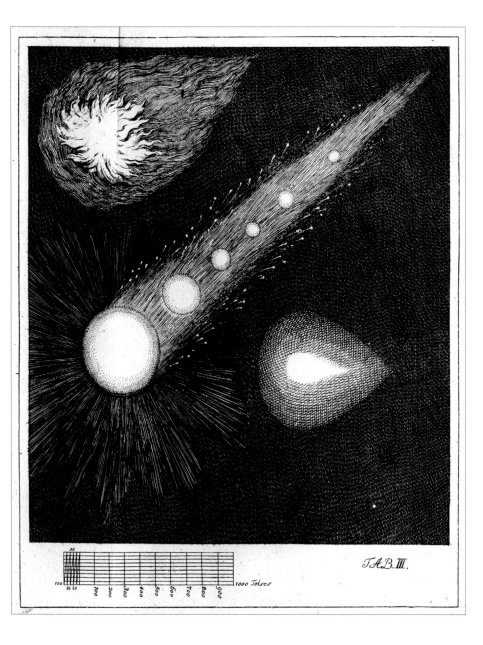

TAB. III.

DIE FEUERKUGEL VOM 23. JULI 1762. In einer Abhandlung von J. E. Silberschlag (1721–1791), Prediger und Mitglied der Königlich-Preußischen Akademie der Wissenschaften zu Berlin, wurde die Erscheinung einer Feuerkugel, die 1762 zwischen Leipzig und Berlin zu sehen war, detailreich beschrieben. In der Theorie von Silberschlag zur Entstehung der Feuerkugel wurde diese als Produkt der Anreicherung von „schleimigen oder öligen" Dünsten in den oberen Schichten der Atmosphäre erklärt.

THE FIREBALL OF 23 JULY 1762. J. E. Silberschlag (1721–1791), a preacher and member of the Royal Prussian Academy of Sciences at Berlin, provided a detailed description of the fireball that was observed between Leipzig and Berlin in 1762. In his theory on the formation of the fireball, Silberschlag explained it as an accumulation of "slimy or oily" exhalations in the upper layers of the atmosphere.

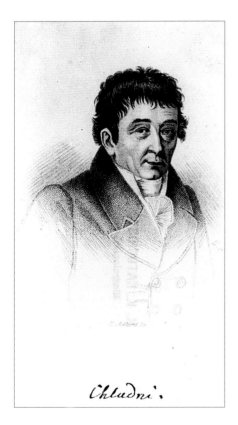

Chladni.

ERNST FLORENS FRIEDRICH CHLADNI (1756–1827). Der deutsche Physiker veröffentlichte 1794 seine bahnbrechende Abhandlung mit dem Titel „Über den Ursprung der von Pallas gefundenen und anderer ihr ähnlicher Eisenmassen, und über einige damit in Verbindung stehende Naturerscheinungen". In seinem Buch beschrieb und diskutierte Chladni belegte Feuerball-Erscheinungen, Fälle von Stein- und Eisenmassen, aber auch die Vorkommen großer Eisenobjekte weitab jeglicher Erzlagerstätten oder Schmelzplätze. Er folgerte, dass die Meteoriten von den Feuerbällen abstammen und außerirdischen Ursprungs sein müssen. Chladni wurde zum Begründer der wissenschaftlichen Meteoritenkunde.

ERNST FLORENS FRIEDRICH CHLADNI (1756–1827). In 1794, the German physicist published his pioneering treatise with the title "On the origin of the mass of iron found by Pallas and of other similar iron masses, and on a few natural phenomena connected therewith". In his book, Chladni described and discussed documented fireballs, falls of stone and iron masses, as well as the occurrence of large iron masses in areas far from ore deposits or smelting sites. He concluded that meteorites originate from fireballs and are of extraterrestrial origin. Chladni became the founder of the science of meteoritics.

DER METEORITENSCHAUER VON SIENA. Am 16. Juni 1794 ging nahe der norditalienischen Stadt Siena um 7 Uhr abends ein Meteoritenschauer nieder. Zahlreiche Steine wurden eingesammelt; der größte wog 3,5 kg. Viele Augenzeugen bestätigten das Ereignis, das sich aufgrund der Nähe zur Universität rasch in der Gelehrtenwelt ganz Europas verbreitete und die Suche nach der Herkunft von Meteoriten zum wissenschaftlichen Thema machte.

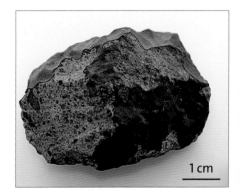

1 cm

THE METEORITE SHOWER AT SIENA. At 7 p.m., on the evening of 16 June 1794, a meteorite shower occurred near the Italian town of Siena. Numerous stones were collected, the largest weighing 3.5 kg. Many witnesses confirmed the fall. Learned societies from all over Europe were drawn to the event because of reports from the nearby University of Siena, which started the reexamination of the true source of meteorites.

METEORITENFALL VON WOLD COTTAGE.

Nach mehreren Detonationen fiel am Nachmittag des 13. Dezembers 1795 bei Wold Cottage in Yorkshire, England, ein ca. 25 kg schwerer Steinmeteorit. Das Ereignis wurde von drei Männern beobachtet und eidesstattlich bezeugt. Captain E. Topham (1751–1820), der Grundbesitzer der Fundstelle, stellte den Meteoriten in London öffentlich aus und ließ 1799 ein Denkmal an der Einschlagstelle errichten.

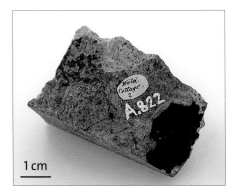

1 cm

METEORITE FALL AT WOLD COTTAGE. On the afternoon of 13 December 1795, after a series of explosions, a stony meteorite weighing about 25 kg fell at Wold Cottage, England. Three men witnessed the fall and gave a sworn testimony. The landowner, Captain E. Topham (1751–1820), put the meteorite on display in London and in 1799 gave an order to erect a monument at the site of the fall.

DER METEORITENSCHAUER VON L'AIGLE.

Nach dem Erscheinen eines Feuerballs ging nahe der französischen Ortschaft L'Aigle in der Region Basse-Normandie am 26. April 1803 kurz nach Mittag unter Detonationen ein Meteoritenschauer nieder. Geschätzte 2 000–3 000 Steine fielen vom Himmel.

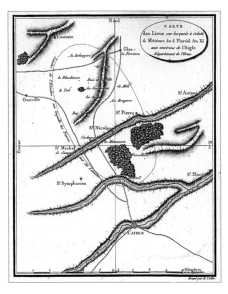

THE METEORITE SHOWER AT L'AIGLE. Shortly after noon, on 26 April 1803, after the appearance of a fireball that was accompanied by explosions, a meteorite shower fell at the village of L'Aigle in north-western France. About 2 000–3 000 stones fell from the sky.

DIE FRANZÖSISCHE AKADEMIE der Wissenschaften

in Paris entsandte den Physiker Jean-Baptiste Biot (1774–1862) nach L'Aigle. Biot befragte zahlreiche Augenzeugen und verfasste einen detaillierten Bericht. Biots Ausführungen veranlassten die Akademie dazu, den extraterrestrischen Ursprung der Meteoriten offiziell anzuerkennen.

THE FRENCH ACADEMY OF SCIENCES in Paris sent the physicist Jean-Baptiste Biot (1774–1862) to L'Aigle. Biot interviewed numerous witnesses and subsequently published a detailed report of his findings. Biot's report was cited by the Parisian Academy – one of the leading scientific institutions in Europe – as definitive proof of the extraterrestrial origin of meteorites.

DER ERSTE KOHLIGE CHONDRIT. Am 15. März 1806 fielen bei Alais, Frankreich, zwei Steine (2 und 4 kg). Sie sind – anders als bisher bekannte Meteoriten – auch innen schwarz, leicht zu zerreiben und riechen intensiv nach Bitumen. Dieser erste kohlige Chondrit besteht aus Tonmineralien mit hohem Kohlenstoffgehalt und enthält Wasser – wie der schwedische Chemiker Berzelius 1834 analysierte.

THE FIRST CARBONACEOUS CHONDRITE. On 15 March 1806, two stones (2 and 4 kg) fell at Alais, France. Unlike previous meteorites, they not only had a black crust but also a black interior, were friable and smelt of bitumen. This was the first recognized carbonaceous chondrite; it is composed of clay minerals with abundant carbon and water – as analyzed in 1834 by the Swedish chemist Berzelius.

DER WESTON-METEORIT. Benjamin Silliman und James Kingsley von der Yale University untersuchten den Meteoritenfall bei Weston in Connecticut von 1807 und begründeten die wissenschaftliche Meteoritenkunde in den USA. Dem amerikanischen Präsidenten Thomas Jefferson (1743–1826) wird dazu folgende Aussage zugeschrieben: „Es ist leichter zu glauben, dass zwei Yankee-Professoren lügen, als dass Steine vom Himmel fallen können."

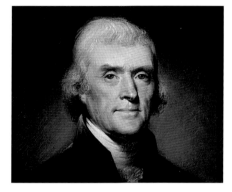

THE WESTON METEORITE. Reports on the meteorite fall in 1807 at Weston, Connecticut, USA, were published in local newspapers. Benjamin Silliman and James Kingsley, professors at Yale University, investigated fragments of the fall and founded the science of meteoritics in the USA. The (unconfirmed) statement "It is easier to believe that two Yankee professors would lie than that stones would fall from heaven" is ascribed to the American president Thomas Jefferson (1743–1826).

STANNERN: DER ERSTE ACHONDRIT. Am 22. Mai 1808 fielen bei Stannern/ Stonařov, Tschechien, rund 200–300 Steine vom Himmel. Carl von Schreibers (1775–1852), Direktor des Vereinigten k. k. Naturalien-Cabinets in Wien, berichtete über den Meteoritenfall in Gilberts „Annalen der Physik". 1809 klassifizierte der französische Chemiker Vauquelin Stannern als neue Art von Steinmeteoriten – heute Achondrite genannt.

STANNERN: THE FIRST ACHONDRITE. On 22 May 1808, after a series of loud explosions, some 200–300 stones fell from the sky near Stannern/Stonařov (Czech Republic). The director of the Viennese Natural History Cabinet, Carl von Schreibers (1775–1852), reported on the meteorite fall in Gilberts "Annalen der Physik". In 1809, the French chemist Vauquelin classified it as a new type of stony meteorite; today these are called "achondrites".

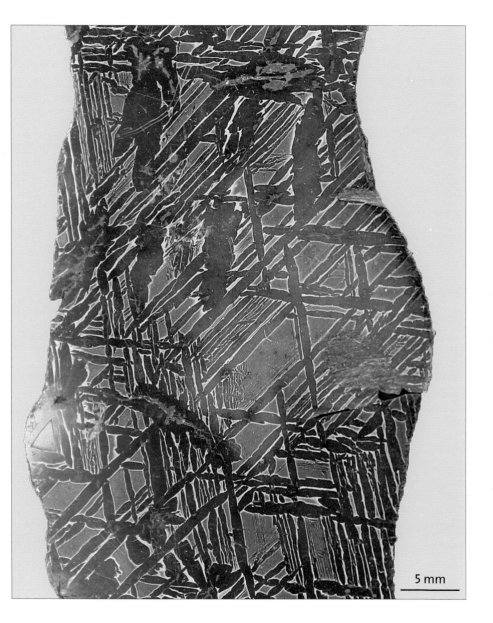

5 mm

METALLOGRAFIE VON METEORITEN.
Alois von Widmanstätten (1754–1849) untersuchte 1808 die Anlauffarben erhitzter Plättchen des Eisenmeteoriten Hraschina aus der Wiener Sammlung. Dabei entdeckte er die „Widmanstättenschen Figuren", regelmäßige Muster sich kreuzender Lamellen. Diese können bei den meisten Eisenmeteoriten sichtbar gemacht werden. Erst 1939 wurde bekannt, dass der Engländer G. Thomson (1761–1806) die „Figuren" bereits ein paar Jahre vor Widmanstätten entdeckt und beschrieben hatte.

METALLOGRAPHY OF METEORITES. *In 1808, Alois von Widmanstätten (1754–1849) performed flame heating experiments on a platelet of the iron meteorite Hraschina from the Vienna collection. He discovered the "Widmanstätten pattern" – an arrangement of intersecting lamellae. They are present in most iron meteorites. In 1939, it turned out that a few years before Widmanstätten, English geologist G. Thomson (1761–1806) had observed similar features.*

CHASSIGNY: DER ERSTE MARSMETEORIT. Am 3. Oktober 1815 fiel bei Chassigny, Frankreich, ein 4 kg schwerer Steinmeteorit, der zwar später als Achondrit klassifiziert wird, sich in seiner Zusammensetzung jedoch deutlich von Stannern unterscheidet. In den 1980er Jahren stellte sich heraus, dass der Meteorit Chassigny vom Planeten Mars stammt.

EIN BESONDERER KOHLIGER CHONDRIT. Am 14. Mai 1864 fielen bei Orgueil, Frankreich, ca. 20 Steine vom Himmel. Der französische Petrograf und Chemiker Auguste Daubrée (1814–1896) stellte einen noch höheren Kohlenstoffgehalt als bei anderen kohligen Chondriten fest. In den 1960er Jahren wurden im Orgueil-Meteoriten organische Verbindungen entdeckt – ein biologischer Ursprung dieser Substanzen konnte jedoch nicht nachgewiesen werden.

GUSTAV ROSE (1798–1873). Der Berliner Gustav Rose erstellte nach Studien mit dem Durchlichtmikroskop eine systematische Einteilung der Meteoriten. In einer 1863 publizierten Arbeit führte Gustav Rose erstmalig den Fachbegriff „Chondre" ein (aus dem Griechischen: chondros, Korn). Chondren sind submillimeter- bis millimetergroße Kügelchen und charakteristischer Bestandteil vieler Steinmeteoriten. Er prägte die Begriffe „Howardit" und „Eukrit".

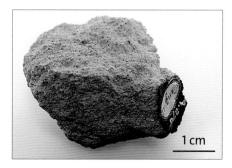

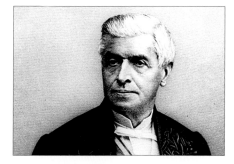

CHASSIGNY: THE FIRST MARTIAN METEORITE. On 3 October 1815, a stony meteorite weighing 4 kg fell at Chassigny, France. Although it was later classified as an achondrite, it is compositionally very different from Stannern. In the 1980s, it was found that the Chassigny meteorite came from the planet Mars.

AN EXTRAORDINARY CARBONACEOUS CHONDRITE. On 14 May 1864, about 20 stones fell near Orgueil, France. The French petrographer and chemist Auguste Daubrée (1814-1896) found that this sample had more carbon than other carbonaceous meteorites. In the 1960s, organic molecules were identified in the Orgueil meteorite. However, it was not possible to confirm a biological origin for these compounds.

GUSTAV ROSE (1798-1873). As a result of transmitted light microscopy studies, Gustav Rose in Berlin developed a systematic classification of meteorites. In his 1863 publication, Rose introduced for the first time the name "chondrule" (from the Greek: chondros = grain). Chondrules are sub-millimeter to millimeter-sized spherical objects that are a characteristic component of many stony meteorites. He is also credited with coining the terms "Howardite" and "Eucrite".

HENRY CLIFTON SORBY (1826–1908). Seit 1864 untersuchte der Engländer Henry Clifton Sorby Dünnschliffe von Meteoriten im Polarisationsmikroskop. Der „Vater der mikroskopischen Petrografie" zog daraus Rückschlüsse auf die Entstehung: Chondren weisen die Textur magmatischer Gesteine auf – sie sind erstarrte Schmelzkügelchen.

MIKROSKOPIE VON METEORITEN. Der Einsatz des Lichtmikroskops führte in der zweiten Hälfte des 19. Jahrhunderts zu großen Fortschritten in der Erforschung von Meteoriten. Die Herkunftsdebatte kreiste um die Frage: Sind Meteoriten ausschließlich Fragmente von Asteroiden, oder stammen manche auch aus dem interstellaren Raum?

GUSTAV TSCHERMAK (1836–1927). Ein bedeutender Beitrag zur Mikroskopie von Meteoriten stammt auch von Gustav Tschermak (Kurator der Wiener Meteoritensammlung von 1868–1877). 1885 erschien „Die mikroskopische Beschaffenheit der Meteoriten erläutert durch photographische Abbildungen".

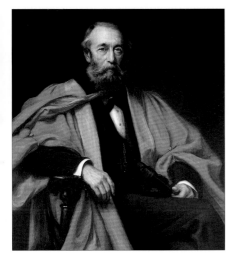

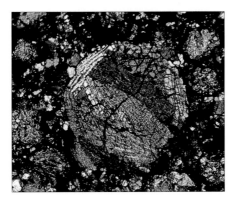

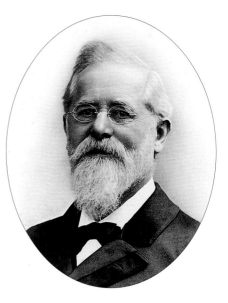

HENRY CLIFTON SORBY (1826–1908). Since 1864, the English scientist Henry Clifton Sorby used the polarizing microscope to study thin sections of meteorites. From these observations, the "father of microscopic petrography" concluded that chondrules have a magmatic texture – they are solidified melt droplets.

MICROSCOPY OF METEORITES. The use of the optical microscope opened a new era in meteorite research during the second half of the 19th century. The debate on the origin of meteorites was dominated by the question, if asteroids are the only source of meteorites, or do some of them originate in interstellar space?

GUSTAV TSCHERMAK (1836–1927). Gustav Tschermak (curator of the Viennese meteorite collection from 1868–1877) made important contributions to the microscopic study of meteorites. In 1885, his classical treatise "The microscopic properties of meteorites" was published.

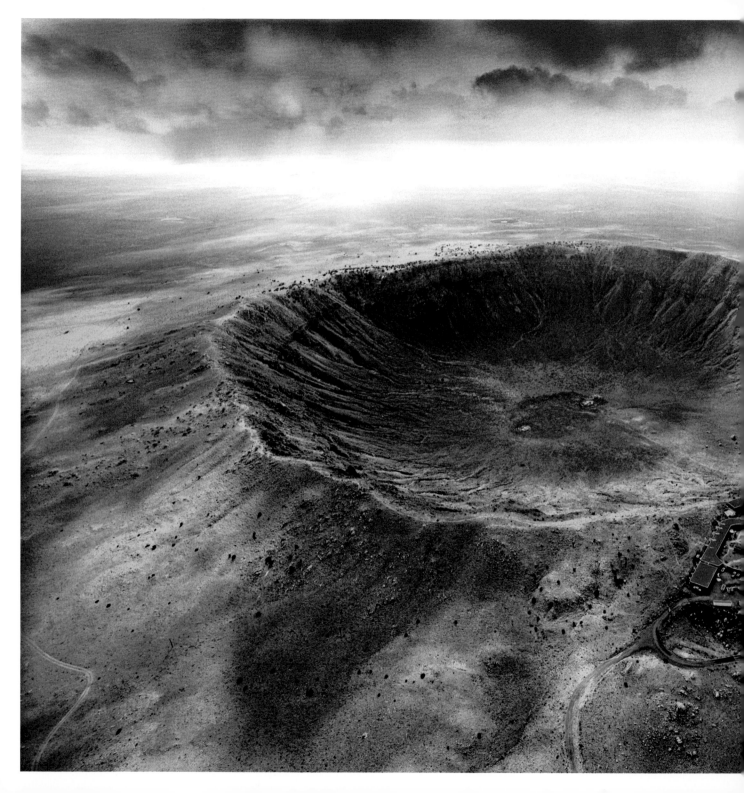

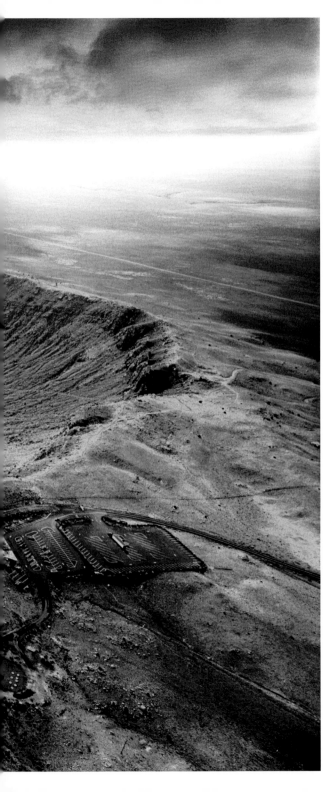

CANYON DIABLO. 1891 wurden im Bereich eines Kraters in Arizona, USA, zahlreiche Eisentrümmer gefunden – Teile des Canyon Diablo-Meteoriten. Die Entdeckung hatte weitreichende Folgen: Erstmalig fanden sich in einem Eisenmeteoriten Diamanten. Untersuchungen zur Verteilung der Meteoritentrümmer führten Anfang des 20. Jahrhunderts dazu, dass der Krater als Einschlagskrater erkannt wurde; genannt wurde er „Meteor Crater" oder, nach seinem Entdecker, „Barringer Crater".

Der amerikanische Bergbauingenieur Daniel Moreau Barringer (1860–1929) vermutete die Hauptmasse des Meteoriten unterhalb des Kraterbodens. Zwischen 1905 und 1928 versuchte er, diese durch Bohrungen zu lokalisieren. Ohne Erfolg: Wie man heute weiß, ist die Eisenmasse durch die extreme Hitzeentwicklung beim Einschlag fast komplett verdampft.

CANYON DIABLO. In 1891, numerous iron masses – fragments of the Canyon Diablo meteorite – were found in the vicinity of a crater in Arizona, USA. This discovery had far-reaching consequences: For the first time, diamonds were found in an iron meteorite. In the early 1900s, studies on the distribution of the iron masses led to the conclusion that the crater formed by impact – it is now called "Meteor Crater", or "Barringer Crater", after its discoverer.

The American mining engineer Daniel Moreau Barringer (1860–1929) speculated that the meteorite's main mass was buried under the crater floor. Between 1905 and 1928, he unsuccessfully tried to locate it by drilling. Today, we know that the enormous heat generated during impact caused evaporation of almost the entire iron mass.

DER SYLACAUGA-METEORIT. Am 30. November 1954 durchschlug ein Meteorit Dach und Zimmerdecke des Hauses von Ann E. Hodges in Sylacauga, Alabama, USA. Er beschädigte eine Radiokonsole und traf dann die Bewohnerin an der Hüfte. Ann E. Hodges war der erste Mensch, der nachweislich von einem Meteoriten getroffen und verletzt wurde.

NEUE AUFSEHENERREGENDE FUNDE und bahnbrechende wissenschaftliche Experimente wie die Expedition zu einem Asteroiden brachten neue Erkenntnisse über Herkunft und Zusammensetzung von Meteoriten – und damit auch über die Erde und das Sonnensystem.

NUMEROUS NEW SPECTACULAR FINDS and pioneering scientific experiments, such as the space mission to an asteroid, provide new insights into the origin and composition of meteorites – and thereby also shed new light on the formation of the Earth and the solar system.

THE SYLACAUGA METEORITE. On 30 November 1954, a grapefruit-sized meteorite crashed through the roof and ceiling of Ann E. Hodges' house in Sylacauga (Alabama, USA). It hit a radio console and Mrs. Hodges' hip, where it caused a large bruise. Mrs. Hodges became the first human to be struck and injured by a meteorite.

SCHÄTZE FÜR METEORITENFORSCHER. Am 8. Februar 1969 kam es bei Allende, Mexiko, auf einer Fläche von 150 km² zu einem gewaltigen Meteoritenschauer. Alle eingesammelten Steine wogen zusammen mehr als zwei Tonnen, einzelne Stücke bis zu 100 kg. Damit verfügte die internationale Meteoritenforschung erstmals über ausreichend Material eines kohligen Chondriten. Meteoriten vom Typ Allende enthalten unter anderem sogenannte Calcium-Aluminium-reiche Einschlüsse (CAIs), die aus der Frühzeit unseres Sonnensystems stammen. Sie stellen dessen älteste feste Materie dar. Diese Objekte können sogar Zentimetergröße erreichen.

TREASURE FOR METEORITE RESEARCHERS. On 8 February 1969, a huge meteorite shower, covering an area of 150 km², occured at Allende, Mexico. The total meteorite mass was more than 2 tons, with individual pieces weighing up to 100 kg. This is the first time that enough material of a carbonaceous chondrite became available for meteorite researchers all over the world. Allende-type meteorites contain so-called Calcium-Aluminum-rich inclusions (CAIs). They were formed at the beginning of our solar system and represent the earliest preserved solids. These objects can be as large as several centimeters in size.

DER ERSTE MONDMETEORIT. Im Jänner 1982 wurde auf dem Allan-Hills-Eisfeld in der Antarktis ein ca. 30 g schwerer Stein gefunden: ALH A81005 stammt nachweislich vom Hochlandgebiet des Erdmondes.

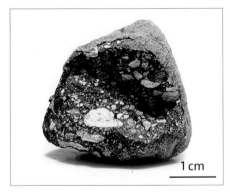

1 cm

THE FIRST LUNAR METEORITE. In January 1982, a stone weighing about 30 g was found on the Allan Hills ice field in Antarctica. Investigations clearly showed that ALH A81005 had originated from the highlands of the Earth's Moon.

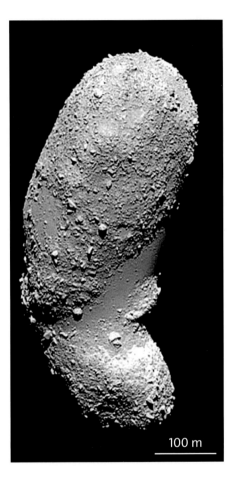

100 m

ERSTE LABORPROBE EINES ASTEROIDEN. Im Juni 2010 brachte die japanische Raumsonde Hayabusa Bodenproben vom Asteroiden Itokawa zur Erde. Im Wissenschaftsmagazin „Science" war nachzulesen, dass die Zusammensetzung der gesammelten Staubteilchen jener von bestimmten Steinmeteoriten sehr ähnlich ist.

THE FIRST SAMPLE OF AN ASTEROID. In June 2010, the Japanese spacecraft Hayabusa brought back a soil sample from the asteroid Itokawa to Earth. Research published in the scientific journal "Science" indicated that the composition of these collected dust grains is very similar to those of certain stony meteorites.

MIKROMETEORITEN. Mindestens 1 000 Tonnen extraterrestrischer Materie stürzen täglich auf die Erde. Der größte Teil davon entfällt auf kosmischen Staub in Form von Mikrometeoriten (ca. 0,05–0,2 mm im Durchmesser). Manche überstehen den Flug durch die Atmosphäre ohne nennenswerte Erhitzung.

MICROMETEORITES. At least 1 000 tons of extraterrestrial material falls to Earth every day. Most of this is cosmic dust consisting of micrometeorites (diameter range ~0.05–0.2 mm). Some of them survive the atmospheric passage without significant heating.

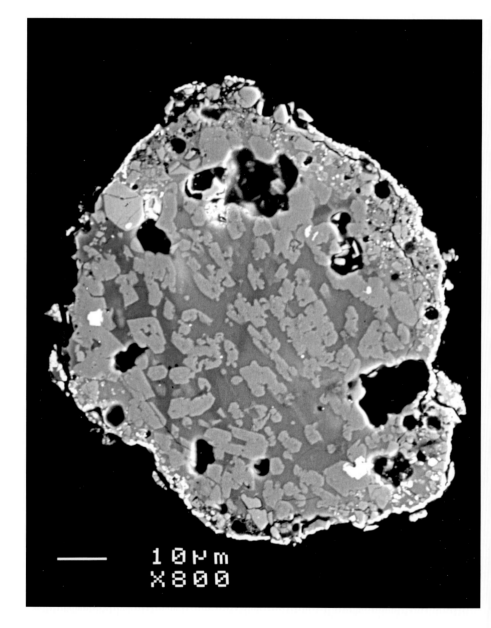

ERDE UND PLANETEN. Manche Mutterkörper der Meteoriten, die Asteroiden, sind schalenförmig aufgebaut – ein Metallkern umgeben von einer Gesteinshülle mit Mantel und Kruste. Aus Analogieschlüssen gewinnt man Erkenntnisse über Entstehung, inneren Aufbau und geologische Entwicklung anderer planetarer Körper – etwa über die Erde.

DAS SONNENSYSTEM. Das Sonnensystem ist vor knapp 4,6 Milliarden Jahren aus einer kollabierenden Gas-Staubwolke entstanden. Viele Meteoriten haben sich seit ihrer Entstehung vor 4,6 Milliarden Jahren nicht mehr verändert und enthalten Informationen aus dieser Zeit. Einige weisen sogar Einschlüsse auf, die älter als das Sonnensystem sind.

EINSCHLÄGE. Als „Bruchstücke von Bruchstücken" belegen viele Meteoriten, dass Kollisionen zwischen planetaren Objekten und Einschläge eine wichtige Rolle in der Geschichte des Sonnensystems spielen. In der geologischen Vergangenheit hatten Impaktereignisse großen Einfluss auf die Entwicklung des Lebens auf der Erde.

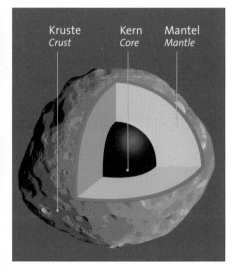

Kruste
Crust
Kern
Core
Mantle
Mantle

EARTH AND PLANETS. Some of the parent bodies of the meteorites, the asteroids, have a concentric structure – a metallic core surrounded by a rocky layer with a mantle and crust. This research also gives new insights into the formation, internal structure, and geological evolution of other planetary bodies – such as the Earth.

THE SOLAR SYSTEM. The solar system formed almost 4.6 billion years ago from a collapsing gas-dust cloud. Many meteorites are almost unchanged since their formation around 4.6 billion years ago and contain information about these early times. Some of them contain inclusions that are even older than the solar system.

IMPACTS. As "fragments of fragments", many meteorites reveal that collisions between planetary bodies and impacts play an important role in the history of the solar system. In the geological past, impact events had a significant influence on the evolution of life on Earth.

DIE WIENER METEORITENSAMMLUNG
THE VIENNA METEORITE COLLECTION

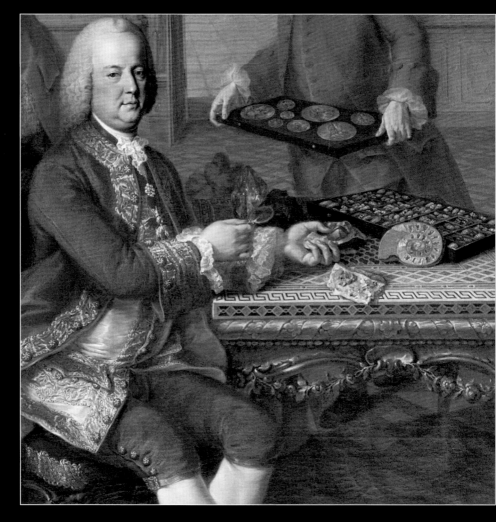

Kaiser Franz I. Stephan (1708–1765)
Emperor Franz I Stephan (1708–1765)

Von Anfang an und bis zum heutigen Tag wurde die Sammlung von herausragenden Persönlichkeiten geprägt. Im Jahr 1748 erwarb Kaiser Franz I. Stephan die Naturaliensammlung des Florentiner Edelmannes Johann von Baillou. Das Naturalien-Cabinet war im Augustinertrakt der kaiserlichen Hofburg untergebracht. Nach dem Tod ihres Gemahls, Kaiser Franz I. Stephan von Lothringen, schenkte Kaiserin Maria Theresia im Jahr 1765 die Sammlung dem Staat.

Es entstand das erste öffentliche Museum Österreichs.

From its foundation until now, the collections have been managed by distinguished personalities. In 1748, Emperor Franz I Stephan acquired the natural history collection of the Florentine nobleman Johann de Baillou. The Natural History Cabinet was located in the Augustinian wing of the Hofburg palace. After the death of her husband, Emperor Franz I Stephan, in 1765, Empress Maria Theresia presented the collection to the State.

The first public museum in Austria was established.

DIE WIENER METEORITENSAMMLUNG
THE VIENNA METEORITE COLLECTION

AUF ANORDNUNG DES KAISERS wurde der 39 kg schwere Eisenmeteorit Hraschina mit dem Fallprotokoll nach Wien gesandt. Er ist das Hauptstück des Meteoritenfalls von 1751 bei Zagreb, Kroatien, und wurde zum Gründungsobjekt der Wiener Meteoritensammlung.

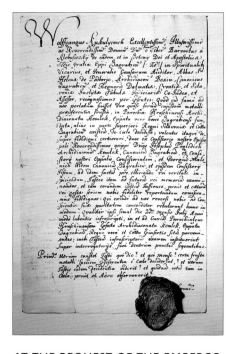

AT THE REQUEST OF THE EMPEROR, the "Hraschina" meteorite and the fall protocol were sent to Vienna. The 39 kg iron meteorite is the main mass of the meteorite fall, which took place in 1751 near Zagreb (Croatia). It became the founding object of the Vienna meteorite collection.

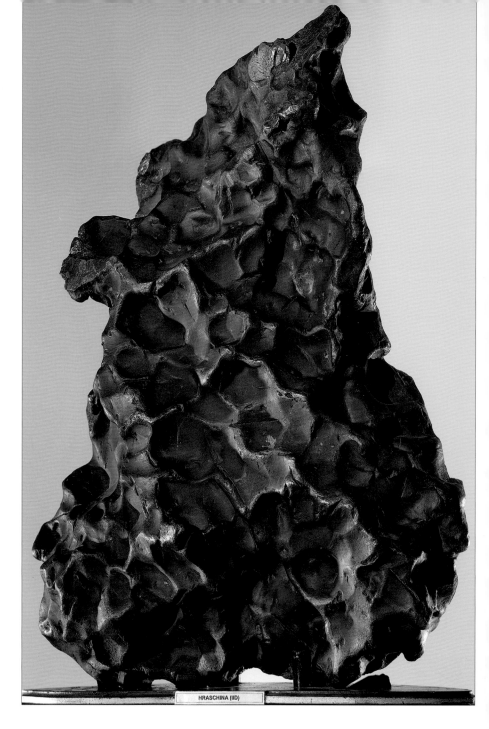

HRASCHINA (IID)

1798–1806: DER ERSTE KATALOG der Naturaliensammlung wurde von Abbe Andreas Xavier Stütz (1747–1806) von Hand verfasst („Catalogus Stützianus"). Während der Amtszeit von Andreas Xavier Stütz erhöhte sich die Sammlung auf insgesamt sieben Meteoriten.

DIE ÄRA CARL VON SCHREIBERS. Carl von Schreibers (1775–1852), Direktor des Vereinigten k. k. Naturalien-Cabinets von 1806–1851, begründete die wissenschaftliche Meteoritenkunde in Wien. 1808 ging ein Meteoritenschauer bei Stannern, heute Tschechien, nieder. Carl von Schreibers sammelte den größten Stein (ca. 6 kg) mit weiteren Stücken des Meteoritenfalls auf. 1820 verfasste Carl von Schreibers seine meteoritenkundliche Abhandlung. Erstmals stellte er die Sammlung in einem eigenen Saal aus.

THE ERA OF CARL VON SCHREIBERS. Carl von Schreibers (1775–1852), director of the Natural History Cabinet from 1806–1851, established the scientific study of meteorites in Vienna. In 1808, a meteorite shower occurred at Stannern (Czech Republic). Carl von Schreibers collected the largest stone (about 6 kg), as well as other pieces of this meteorite fall. In 1820, Carl von Schreibers published his treatise on meteorites. For the first time, he displayed the collection in its own room.

CARL VON SCHREIBERS studierte an der Universität Wien Medizin, wo er 1798 promovierte. Sein Hauptinteresse galt zunächst der Zoologie; erst nach dem Meteoritenfall von Stannern (1808) begann er, sich intensiv mit Meteoriten zu beschäftigen.

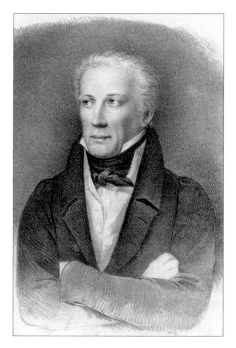

IN 1798, CARL VON SCHREIBERS received a medical degree from the University of Vienna. At first, his main interest was zoology. After the meteorite fall of Stannern (1808), he began to study meteorites.

ABBE ANDREAS XAVIER STÜTZ (1747–1806) produced the first hand-written catalogue of the natural history collection ("Catalogus Stützianus"). During the tenure of Stütz (1798–1806), the number of meteorites in the collection increased to seven.

DIE WIENER METEORITENSAMMLUNG
THE VIENNA METEORITE COLLECTION

1852–1856: DIE ÄRA PARTSCH. Paul Maria Partsch (1791–1856), seit 1824 am Vereinigten k. k. Naturalien-Cabinet angestellt, erweiterte die Mineraliensammlung. Nach dem Tod von Schreibers wurde das Naturalien-Cabinet getrennt und Partsch zum Direktor des Kaiserlich-königlichen Hof-Mineralien-Cabinets ernannt. 1843 verfertigte Partsch den ersten Katalog der Meteoritensammlung.

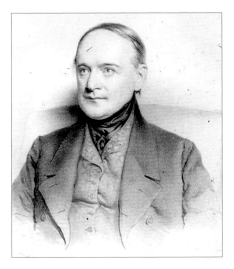

1852–1856: THE ERA OF PARTSCH. Paul Maria Partsch (1791–1856), who began working at the Natural History Cabinet in 1824, enlarged the collection. After Schreibers tenure, the Natural History Cabinet was split and Partsch became director of the Imperial Royal Mineralogical Court Cabinet. In 1843, Paul Maria Partsch published the first catalogue of the meteorite collection.

IM REVOLUTIONSJAHR 1848 brannte die Hofburg am Josefsplatz mit den darin befindlichen Sammlungen. Ein paar Tage zuvor wurden die wertvollsten Mineralien und Meteoriten ausgelagert und blieben daher unversehrt.

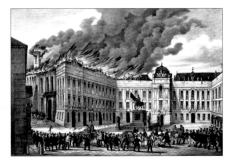

DURING THE 1848 REVOLUTION, the collections in the Imperial Palace on Josefsplatz were set on fire. The most valuable minerals and meteorites had been removed a few days before and thus remained unharmed.

1856–1868: DIE ÄRA MORIZ HÖRNES. Moriz Hörnes (1815–1868), Geologe und Paläontologe, wurde 1856 Nachfolger von Partsch. In der Amtszeit von Hörnes – er war bereits seit 1844 am Vereinigten k. k. Naturalien-Cabinet tätig – ist die Meteoritensammlung rasch gewachsen.

1856–1868: THE ERA OF MORIZ HÖRNES. In 1856, Moriz Hörnes (1815–1868), geologist and paleontologist, became the successor of Partsch. During the tenure of Hörnes – he worked at the Natural History Cabinet from 1844 onwards – the meteorite collection grew quickly.

1856–1876: DAS KAISERLICH-KÖNIGLICHE HOF-MINERALIEN-CABINET. Wilhelm Haidinger (1795–1871), Gründungsdirektor der k. k. geologischen Reichsanstalt.

METEOREISENFALL VON HRASCHINA. 1859 schrieb Wilhelm Haidinger eine erste umfassende Abhandlung über den Meteoreisenfall von Hraschina.

1868–1877: DIE ÄRA TSCHERMAK. Gustav Tschermak (1836–1927), Direktor des Kaiserlich-königlichen Hof-Mineralien-Cabinets von 1868 bis 1877. Als Professor für Mineralogie an der Universität Wien verfasste Gustav Tschermak 1885 ein bedeutendes Werk zur Meteoritenkunde.

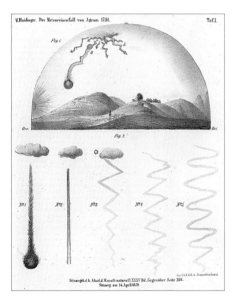

1856–1876: THE IMPERIAL ROYAL MINERALOGICAL COURT CABINET. *Wilhelm Haidinger (1795–1871), is the founding director of the Imperial Geological Survey.*

THE HRASCHINA METEORITE. *In 1859, Wilhelm Haidinger wrote the first comprehensive treatise on the fall of the Hraschina meteorite.*

1868–1877: THE ERA OF TSCHERMAK. *Gustav Tschermak (1836–1927), director of the Mineralogical Cabinet from 1868 to 1877. As professor of mineralogy at the University of Vienna, Tschermak published a classic book on meteorites in 1885.*

Maria-Theresia-Monument. K. k. naturhistorisches Ho,

seum.

Wien I.

1871–1889: Unter der Leitung der Architekten Gottfried Semper und Carl Hasenauer wurde das Museum in achtzehn Jahren gebaut und von Kaiser Franz Joseph I. 1889 feierlich eröffnet. Rechtlich ist es durch eine 1876 vom Kaiser unterzeichnete Urkunde begründet worden.

1871–1889: Under the supervision of the architects Gottfried Semper and Carl Hasenauer, the museum was built within the space of 18 years and was inaugurated in 1889. In 1876, Emperor Franz Joseph I. signed a document decreeing the foundation of the new museum.

DIE WIENER METEORITENSAMMLUNG
THE VIENNA METEORITE COLLECTION

DER BERÜHMTE EISENMETEORIT Cabin Creek, 1886 in Arkansas (USA) gefallen und 1890 erworben, ist ein Herzstück der Wiener Sammlung.

THE FAMOUS IRON METEORITE Cabin Creek, which fell in 1886 in Arkansas (USA) and was acquired in 1890, is a centerpiece of the Viennese collection.

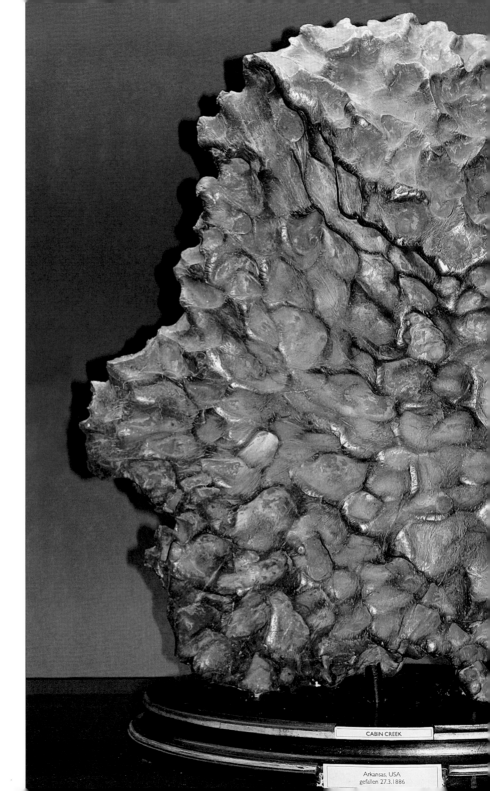

CABIN CREEK

Arkansas, USA
gefallen 27.3.1886

ARISTIDES BREZINA (1848–1909) leitete von 1878 bis 1895 die Meteoritensammlung und die neu gegründete Mineralogisch-Petrographische Abteilung. Er präsentierte nach der Eröffnung des Naturhistorischen Hofmuseums 1889 die Meteoritensammlung im neuen Saal.

VOR 1889 übersiedelte Aristides Brezina gemeinsam mit Friedrich Berwerth (1850–1918), dem Leiter der Mineralogisch-Petrographischen Abteilung von 1895–1918, die Meteoritensammlung aus der kaiserlichen Hofburg in das Naturhistorische Hofmuseum.

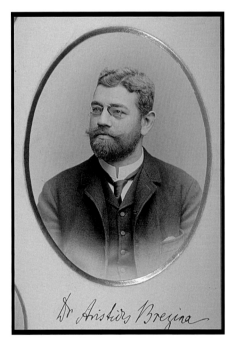

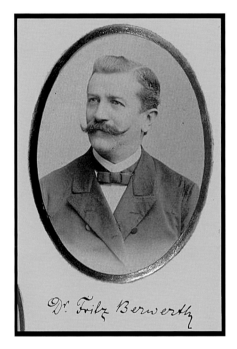

ARISTIDES BREZINA (1848–1909) was curator of the meteorite collection from 1878 to 1895 and head of the newly founded Mineralogical-Petrographical Department. In 1889, after the opening of the Natural History Museum, Aristides Brezina displayed the meteorite collection in the new hall.

PRIOR TO 1889, the meteorite collection was transferred from the imperial castle to the new Natural History Court Museum by Aristides Brezina, together with Friedrich Berwerth (1850–1918), head of the Mineralogical-Petrographical Department from 1895–1918.

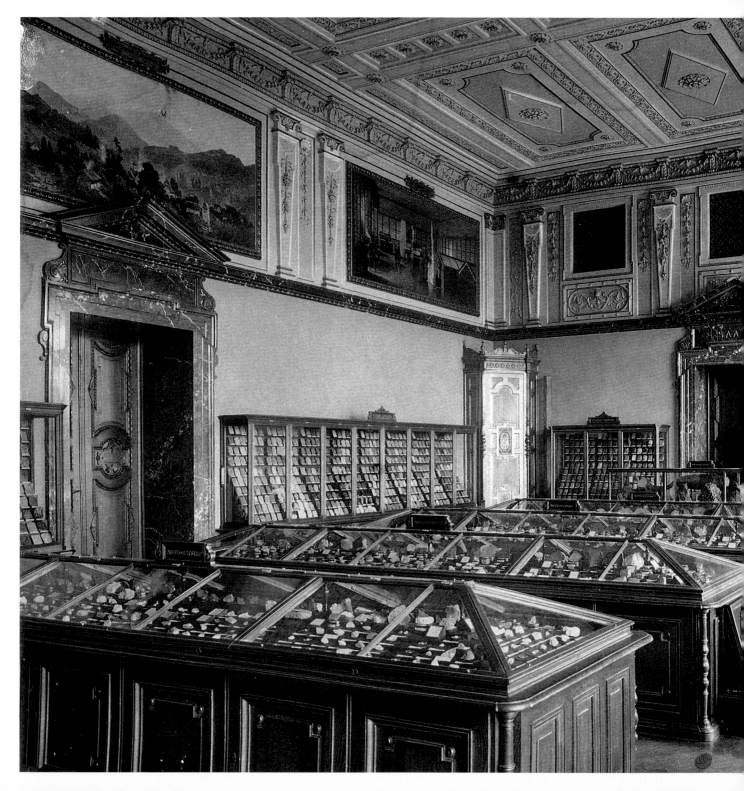

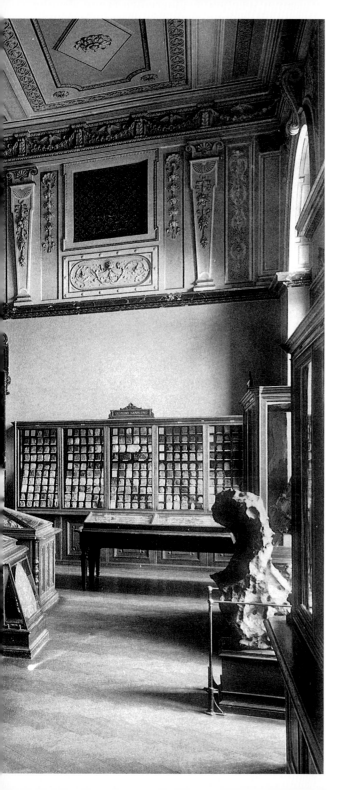

DER METEORITENSAAL, 1903. Zu Beginn des 20. Jahrhunderts waren in den Wandvitrinen, gemeinsam mit den Meteoriten, Dekorsteine ausgestellt. Diese befinden sich heute in Saal I.

THE METEORITE HALL, 1903. At that time, together with meteorites, some of the decorative stones (now displayed in Hall I) were set out in the wall cabinets.

DIE WIENER METEORITENSAMMLUNG
THE VIENNA METEORITE COLLECTION

ALFRED SCHIENER (1906–1962), leitete die Abteilung von 1953–1962.

HERMANN MICHEL (1888–1965), Direktor der Mineralogisch-Petrographischen Abteilung von 1923–1952 und des Naturhistorischen Museums von 1933–1938 und 1947–1951. Hermann Michel ist es zu verdanken, dass die Meteoritensammlung während des Zweiten Weltkriegs keinen wesentlichen Schaden oder Verlust erlitten hat.

HUBERT SCHOLLER (1901–1968), Abteilungsdirektor von 1964–1967. Nach dem Ende des Zweiten Weltkriegs zeigten die Besatzungsmächte in Wien großes Interesse an der Sammlung. Alfred Schiener und Hubert Scholler hielten die bestehende Sammlung erfolgreich zusammen.

HERMANN MICHEL (1888–1965), director of the Mineralogical-Petrographical Department from 1923–1952, and of the Natural History Museum from 1933–1938 and 1947–1951. Thanks to the efforts of Hermann Michel, the meteorite collection suffered no significant damage or loss during World War II.

ALFRED SCHIENER (1906–1962), head of the department from 1953–1962.

HUBERT SCHOLLER (1901–1968), head of the department from 1964– 1967. After World War II, the occupying forces expressed a strong interest in the collection. Alfred Schiener and Hubert Scholler were successful in keeping the collection intact.

GERO KURAT (1938–2009) war von 1968 bis 2003 für die Meteoritensammlung verantwortlich. Während seiner Zeit als Kustos verbesserten sich die Forschungseinrichtungen im Naturhistorischen Museum Wien erheblich.

LUDOVIC FERRIÈRE (1982–) ist seit 2011 Kurator der Gesteinssammlung und Ko-Kurator der Meteoritensammlung. Er hat weitgehend zur Vorbereitung der Neupräsentation der Meteoritensammlung und zur Reorganisation dieser Sammlung nach modernen Standards beigetragen.

FRANZ BRANDSTÄTTER (1953–) ist derzeit Direktor der Mineralogisch-Petrographischen Abteilung. Er ist seit 1982 wissenschaftlicher Mitarbeiter am Naturhistorischen Museum und seit 2004 Kurator der Meteoritensammlung.

GERO KURAT (1938–2009) was curator of the meteorite collection from 1968 to 2003. During his tenure, the research facilities at the Natural History Museum were significantly upgraded.

LUDOVIC FERRIÈRE (1982–), curator of the rock collection and co-curator of the meteorite collection since 2011. He contributed significantly to the preparation of the new presentation of the meteorite collection and to the reorganization of the collection according to modern standards.

FRANZ BRANDSTÄTTER (1953–) is currently director of the Mineralogical-Petrographical Department. He has been an academic staff member at the NHM since 1982 and curator of the meteorite collection since 2004.

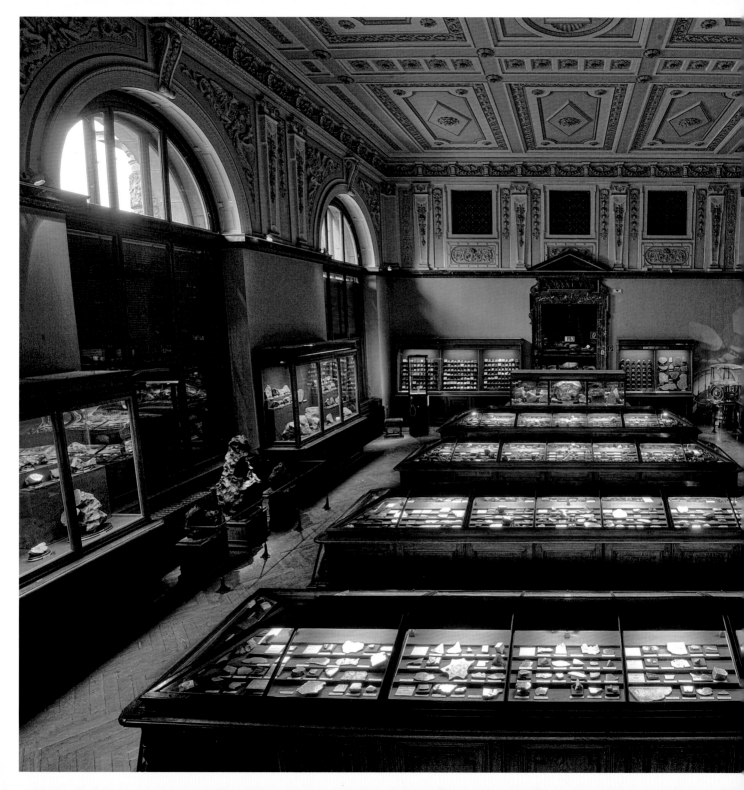

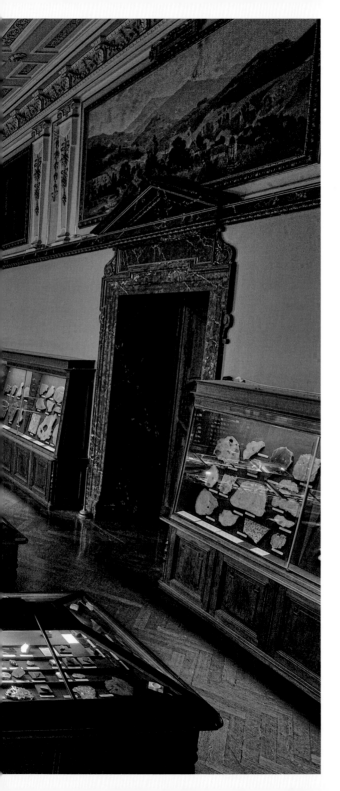

AUCH HEUTE wird die Wiener Meteoritensammlung ständig durch bedeutende Erwerbungen erweitert. Mit ihren rund 2 400 verschiedenen Meteoritenfällen und -funden ist sie für die internationale Forschung von unermesslichem Wert – und die mit Abstand größte Schausammlung der Welt. Das Foto zeigt den Blick auf die historische Aufstellung bis Ende 2011.

EVEN TODAY, the meteorite collection is continually growing. With about 2 400 different meteorites falls and finds in collection, it is a treasure trove for international meteorite research and the world's largest meteorite display by far. This photograph shows the original display as it was until the end of the year 2011.

WOHER KOMMEN DIE METEORITEN?
WHERE DO METEORITES COME FROM?

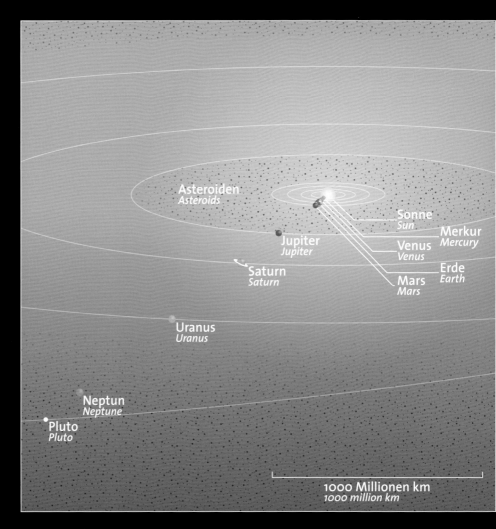

Asteroiden im Sonnensystem.
Asteroids in the solar system.

Viele dieser kleinen Himmelskörper bewegen sich annähernd auf der gleichen Ebene wie die Planeten unseres Sonnensystems. Einige kreuzen die Erdbahn und schlagen hin und wieder bei uns ein. Asteroiden sind Kleinplaneten. Bekannt sind derzeit die Bahnen von über 600 000 mit einer durchschnittlichen Größe von unter 1 bis 1 000 km. „Asteroid" bedeutet so viel wie sternengleich (vom griechischen asteroeides: aster, der Stern und eidos, die Form). Meteoroide nennt man sie, wenn die Gesteinsbrocken kleiner als 50 m im Durchmesser sind.

Many of these small bodies orbit the sun in the same plane as the Earth and other planets. Some cross the Earth's orbit and may collide with our planet. Asteroids are minor planets. The orbits of more than 600 000 asteroids with diameters ranging from less than 1 km to about 1 000 km are known to date. "Asteroid" means "star-like" and is derived from the Greek "asteroeides" ("aster" = star, "eidos" = shape). They are called meteoroids if they are less than 50 m in diameter.

WO UND WIE FINDET MAN METEORITEN?
WHERE AND HOW ARE METEORITES FOUND?

Ein neuer Fund in der Antarktis: der Mount DeWitt 03001 Meteorit.
A new find in Antarctica, the Mount DeWitt 03001 meteorite.

Wird ein Meteor beim Niederfallen beobachtet und ein Objekt am Boden gefunden, handelt es sich um einen – eher seltenen – „Fall". Jede andere Entdeckung ohne zuvorgehende „Fallbeobachtung" gilt als „Fund". Schätzungsweise rund 1 000 Tonnen Material fallen täglich auf die Erde – mit ganz wenigen Ausnahmen sind es meist bloß mikrometerkleine Staubkörner.

In the rare case that the fall of a meteor is witnessed and an object is found on the ground, the term "fall" is used. All other discoveries without a corresponding "fall observation" are called "finds". About 1 000 tons of material fall onto Earth every day – most of which consists of micrometer-sized dust grains.

METEORITEN FALLEN ÜBERALL AUF DIE ERDE. Am leichtesten zu finden sind sie aber in Wüstengebieten: etwa in der Antarktis, in Australien, im Oman und in Nordafrika. Die extreme Trockenheit – egal ob heiß oder kalt – verhindert einen schnellen Zerfall der oft fragilen Objekte. In unserem kontinentalen Klima verrosten viele Meteoriten, und die Vegetation überwuchert sie.

METEORITES FALL ALL OVER THE EARTH. However, they are most easily recovered from deserts – for example, in North Africa, Arabia, or Australia, and even Antarctica. The extreme arid environment – regardless of whether it is hot or cold – prevents rapid weathering of the often fragile objects. In our continental climate, many meteorites rust and are overgrown by vegetation.

WO UND WIE FINDET MAN METEORITEN?
WHERE AND HOW ARE METEORITES FOUND?

DER METEORITENBOOM der letzten Jahrzehnte (von 2 300 auf 40 000): Der erste antarktische Meteorit wurde 1912 vom australischen Geologen Douglas Mawson gefunden. Mitte der 1960er Jahre waren weltweit rund 2 300 Meteoriten bekannt, davon ca. 900 „Fälle". Seit den 1970er Jahren wurden von japanischen und US-amerikanischen Wissenschaftern Meteoriten-Expeditionen in der Antarktis durchgeführt. Seit den 1990ern sind vermehrt auch private „Meteoritenjäger" in den Wüsten Afrikas aktiv.

THE METEORITE BOOM of recent decades (from 2 300 to more than 40 000): In 1912, the first Antarctic meteorite was found by the Australian geologist Douglas Mawson. In the mid-1960s, about 2 300 meteorites, including about 900 falls, were known world-wide. Since the 1970s, Japanese and US scientists have organized meteorite search expeditions in Antarctica. Since the 1990s, more and more private "meteorite hunters" have been operating in African deserts.

FUNDE
Von der Gesamtzahl aller bekannten
Funde inklusive antarktischer Meteoriten
(über 40 000) entfallen auf:
Eisenmeteoriten 2,5 %
Stein-Eisen-Meteoriten 0,6 %
Steinmeteoriten 96,9 %

Von der Gesamtzahl aller bekannten
Funde ohne antarktische Meteoriten
(über 10 000) entfallen auf:
Eisenmeteoriten 7,4 %
Stein-Eisen-Meteoriten 1,4 %
Steinmeteoriten 91,2 %

FINDS
Breakdown of all known finds, including
Antarctic meteorites (more than 40 000):
Iron meteorites 2.5%
Stony-iron meteorites 0.6%
Stony meteorites 96.9%

Breakdown of all known finds, excluding
Antarctic meteorites (more than 10 000):
Iron meteorites 7.4%
Stony-iron meteorites 1.4%
Stony meteorites 91.2%

FÄLLE
Von der Gesamtzahl aller bekannten
Fälle (über 1 000) entfallen auf:
Eisenmeteoriten 4,5 %
Stein-Eisen-Meteoriten 1 %
Steinmeteoriten 94,5 %

Von der Gesamtmasse aller bekannten
Fälle (über 50 Tonnen) entfallen auf:
Eisenmeteoriten 48 %
Stein-Eisen-Meteoriten 2 %
Steinmeteoriten 50 %

FALLS
Breakdown of all known falls (more than
1 000):
Iron meteorites 4.5%
Stony-iron meteorites 1%
Stony meteorites 94.5%

The total mass of all known falls (more
than 50 tons) comprises:
Iron meteorites 48%
Stony-iron meteorites 2%
Stony meteorites 50%

WÜSTEN ALS „METEORITENRESERVOIRE"
70 % in kalten Wüsten
23 % in heißen Wüsten
7 % außerhalb von Wüstengebieten

DESERTS AS "METEORITE RESERVOIRS"
70% in cold deserts
23% in hot deserts
7% in non-desert areas

WO UND WIE FINDET MAN METEORITEN?
WHERE AND HOW ARE METEORITES FOUND?

AUSSERIRDISCHE STEINE in irdischen Streufeldern. Auch wenn viele Menschen zahlreiche Meteoritenstreufelder bereits durchkämmt haben: Es dürfte noch etwas zu finden sein! Probieren könnte man es zum Beispiel auf dem Imilac-Streufeld in Chile oder dem Jiddat-al-Harasis-Streufeld im Sultanat Oman. Auf Letzteres haben allerdings ausschließlich Wissenschafter Zugang – eine Einschränkung, die auch für die Antarktis, aufgrund der aufwendigen Logistik, gilt.

EXTRATERRESTRIAL STONES in terrestrial strewn fields. Although many meteorite strewn fields have already been thoroughly searched, there are still things to find! Just try the Imilac strewn field in Chile or the Jiddat al Harasis strewn field in the sultanate of Oman. The latter is only accessible to scientists; this is also true for Antarctica (due to the logistical problems).

WARUM DIE ANTARKTIS? Weil sich dort Meteoriten stellenweise „natürlich konzentrieren". Meteoriten werden im sogenannten „Blaueis" eingeschlossen und von diesem mitgetragen. Wenn dieser Eisfluss durch einen Berg behindert wird, kommen die Meteoriten mit dem Eis wieder nach oben. An der Oberfläche ist das Eis starken Fallwinden ausgesetzt, die mehrere Zentimeter Eis pro Jahr abtragen – und so die Meteoriten freigeben.

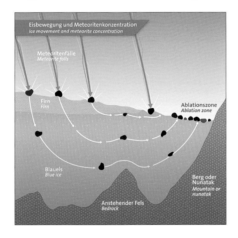

Eisbewegung und Meteoritenkonzentration
Ice movement and meteorite concentration

Meteoritenfälle
Meteorite falls

Firn
Firn

Ablationszone
Ablation zone

Blaueis
Blue ice

Berg oder Nunatak
Mountain or nunatak

Anstehender Fels
Bedrock

WHY ANTARCTICA? Meteorites are better preserved in Antarctica. They fall onto the ice and are buried over the years; then they are transported with the flowing ice. When the ice flow reaches a barrier, for example, a subglacial mountain, the meteorites are redirected towards the surface along with the ice. The ice is ablated by strong winds, exposing the "concentrated" meteorites on the surface of the "blue ice fields".

METEORITENFUNDSTELLEN in der Antarktis. Viele der bekannten Meteoritenfundstellen liegen am Rand der mächtigen Transantarktischen Gebirgskette. Diese Gebiete wurden vor allem von amerikanischen Expeditionen erforscht, während sich japanische Expeditionen auf die Yamato und Belgica Mountains konzentriert haben.

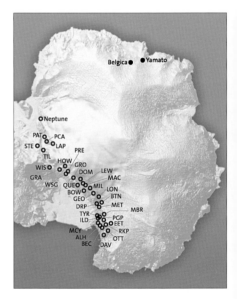

LOCATIONS OF ANTARCTIC METEORITES. Many of the known Antarctic meteorite sites are located along the extensive Transantarctic mountain range. These areas were explored mainly by American expeditions, whereas the Japanese expeditions focused on the Yamato and Belgica Mountains.

BEOBACHTUNG VON METEORITEN-FÄLLEN. Die Bestimmung der möglichen Fallgebiete erfolgt über sogenannte Feuerball-Netzwerke. Diese bestehen aus strategisch positionierten Videokameras, die den gesamten Nachthimmel erfassen. Der erste aufgezeichnete Fall eines Meteoriten mit Flugbahnberechnung, welche auch zum Auffinden von Fragmenten führte, war der Příbram-Meteorit im Jahr 1957, durchgeführt vom Ondřejov Observatory in Tschechien.

DER GRIMSBY-FEUERBALL, 2009. Dank überlappender Sichtbereiche mehrerer Kameras kann man die Flugbahn eines eintretenden Feuerballs verfolgen sowie Höhe und Geschwindigkeit schätzen. Über das Prinzip der Triangulation lässt sich das Fallgebiet bestimmen – wie es im September 2009 beim Grimsby-Feuerball in Ontario, Kanada, möglich war.

DER FALL DES ASTEROIDEN 2008 TC3. Am 6. Oktober 2008 wurde ein drei Meter großer Asteroid, knapp 20 Stunden vor seinem Einschlag auf der Erde, mit einem Teleskop entdeckt. Man gewann erstmals wertvolle Informationen über einen Asteroiden, der sich noch „in der Luft" befand. Zwei Monate später führte die Suche entlang der berechneten Eintrittskurve zu den Fragmenten des Falls. Der seltene Steinmeteorit, ein Ureilit, wurde nach seinem Fundort, einer Bahnstation im Sudan, Almahata Sitta getauft.

OBSERVATION OF METEORITE FALLS. Freshly fallen meteorites can be located via so-called fireball networks. These consist of cameras that are installed at various geographic locations and survey the entire sky during the night. The first meteorite that was found after determining its flight path from multiple photographs was the Příbram meteorite in 1957. Recording and calculation of the trajectory were performed by the Ondřejov observatory in the Czech Republic.

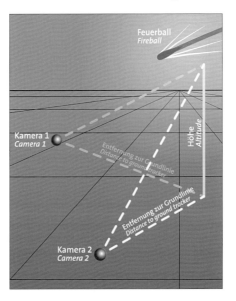

THE GRIMSBY FIREBALL, 2009. Overlapping fields of view of several cameras allow determination of the fireball's flight path and estimation of its altitude and velocity. Using triangulation, the fall area can be determined – as was accomplished successfully in September 2009 for the Grimsby fireball in Ontario, Canada.

THE FALL OF ASTEROID 2008 TC3. On 6 October 2008, a 3-meter-sized asteroid was detected with a telescope just 20 hours before it collided with the Earth. For the first time, it was possible to obtain valuable data on an asteroid "in flight". Two months later, a search along the calculated entry path led to the recovery of fragments of a stony meteorite. It belongs to the rare group of ureilites and was named Almahata Sitta after the closest geographic landmark, a railway station in Sudan.

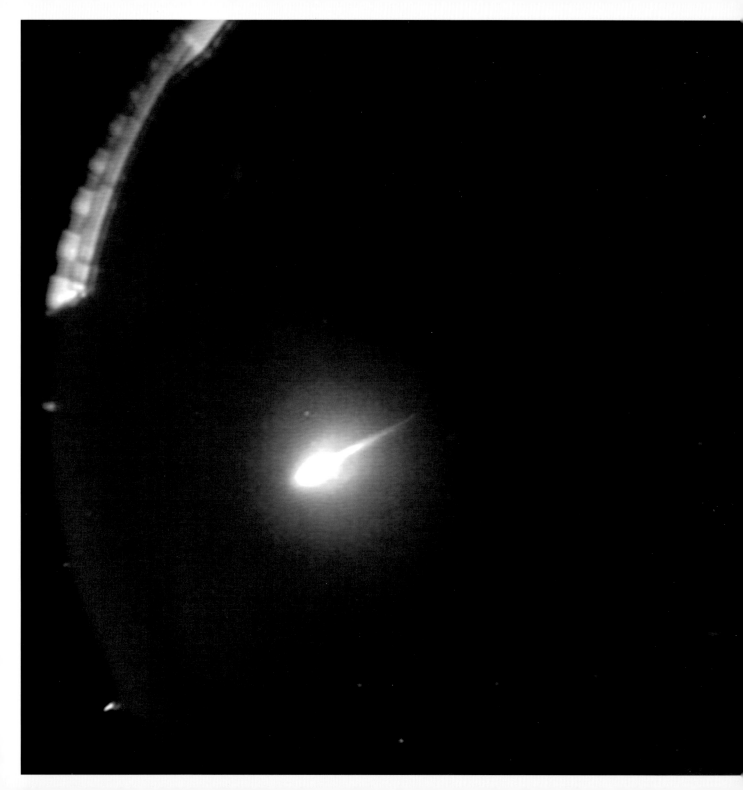

GRIMSBY-FEUERBALL, Ontario, Kanada, 2009. Dank überlappender Sichtbereiche mehrerer Kameras kann man die Flugbahn eines eintretenden Feuerballs verfolgen sowie Höhe und Geschwindigkeit schätzen.

GRIMSBY FIREBALL, *Ontario, Canada, 2009. Overlapping fields of view of several cameras allow determination of the fireball's flight path and estimation of its altitude and velocity.*

WO UND WIE FINDET MAN METEORITEN?
WHERE AND HOW ARE METEORITES FOUND?

WIE FINDE ICH METEORITEN? Sie sind oft gar nicht leicht zu erkennen. Wer Überreste älterer Fälle unter der Erde aufspüren will, muss zum Metalldetektor greifen. Auffällig ist die schwarze, manchmal dunkelbraune Schmelzkruste, die beim Eintritt in die Atmosphäre entsteht und die ein typisches Merkmal aller frisch gefallenen Meteoriten darstellt. Ein Meteorit sieht meist anders aus als die Steine im jeweiligen Suchgebiet. Aber ist das jetzt wirklich ein Meteorit? Einige einfache Untersuchungen können Klarheit darüber geben.

HOW DO I FIND A METEORITE? Meteorites are difficult to recognize. To recover buried meteorites from older falls, metal detectors can be useful. Freshly fallen meteorites have a distinct black to dark-brown fusion crust. This characteristic feature is produced during their passage through the Earth's atmosphere. Usually, a meteorite has a different appearance compared to terrestrial rocks. But is it really a meteorite? Some simple tests can help to determine the answer.

FELDSUCHE. Die Feldsuche wird eingesetzt, wenn ein bestimmtes Gebiet systematisch abgesucht werden soll. Die Suchenden durchmessen parallel gehend in einer Reihe das Gebiet – ihr Abstand voneinander beträgt zwischen 2 bis 3 m auf grasbedecktem Grund. In der Wüste sind bis zu 10 m Abstand üblich, in der Antarktis sogar mehr, wenn man auf Motorschlitten unterwegs ist.

FIELD SEARCH. In the field, large areas can be systematically searched. The members of the search team form a line with a few meters distance from each other (2-3 m on grassland and up to 10 m in deserts) and walk in the same direction. In Antarctica, distances are even larger when snowmobiles are used.

WO UND WIE FINDET MAN METEORITEN?
WHERE AND HOW ARE METEORITES FOUND?

DAS WICHTIGSTE: Immer den Fundort dokumentieren! Um wissenschaftlich verwertbare Informationen zu sichern, muss der Fundort genau erfasst werden – am besten mit GPS-Koordinaten und einem Foto des unberührten Fundes. In der Antarktis sind das standardisierte Abläufe: Nach der Basisdokumentation erhalten Meteoriten eine Nummer und werden steril verpackt. So werden sie ins Labor verschifft, wo sie für Untersuchungen vorbereitet werden.

MOST IMPORTANT: Always document the site of the find. In order to understand meteorite distribution, it is important to document the site of the find, preferably by means of GPS coordinates and a photograph of the untouched find. In Antarctica, a standard procedure is followed. After basic documentation, meteorites are assigned a field number, packed in sterile containers, and shipped to the laboratory for investigations.

NAMENSGEBER FUNDORT. Meteoriten sind nach ihrem Fundort benannt, oft nach einer nahe gelegenen Ansiedlung, wie etwa Brenham (Kansas, USA), oder auch nach einem Wald, wie der Mont Dieu-Meteorit aus den französischen Ardennen. Wo keine genaue Umgebung zu nennen ist, wird mit Buchstaben-Zahlen-Kombinationen gearbeitet (NWA für Nordwestafrika oder ALH für Allan Hills, Antarktis). Die nachfolgenden Ziffern bezeichnen das Fundjahr und/oder fortlaufende Nummerierungen.

NAMED AFTER THE SITE OF THE FIND. Meteorites are named after the site of the find – usually a nearby settlement or landmark, e.g., Brenham (Kansas, USA), or, in the case of the Mont Dieu meteorite, a forest in the French Ardennes. In the absence of identifiable geographical landmarks, a combination of letters and numbers is used (e.g., NWA for Northwest Africa or ALH for Allan Hills, Antarctica). Numbers after the letters denote the year of recovery and/or are sequential numbers.

Meteoritenfund im Oman.
Meteorite find in Oman.

WO UND WIE FINDET MAN METEORITEN?
WHERE AND HOW ARE METEORITES FOUND?

DER HOBA-METEORIT. Bereits 1929 besuchten deutsche Geologen den bis heute größten auf der Erde gefundenen Meteoriten in Namibia, Afrika. Seit 1979 ist der an die 60 t schwere Eisenmeteorit ein nationales Denkmal.

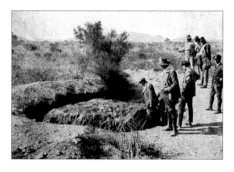

THE HOBA METEORITE. This is the largest iron meteorite ever found on Earth, weighing 60 tons. It was visited by German geologists as early as 1929, and has been a national monument in Namibia since 1979.

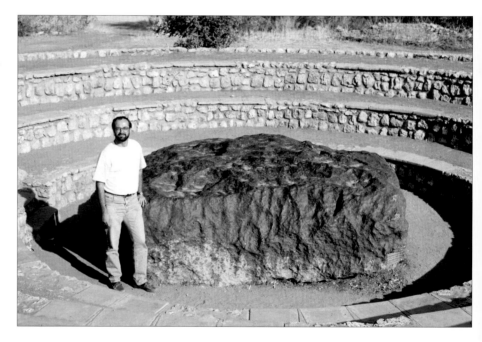

Christian Köberl und der Hoba-Meteorit, Namibia.
Christian Köberl and the Hoba meteorite, Namibia.

DER CAPE YORK-METEORIT. 1963 entdeckte der Däne Vagn F. Buchwald eines der Teile des insgesamt 58 t schweren und seit Jahrhunderten unter Inuits in Grönland bekannten Cape York-Eisenmeteoriten: Das Teilstück „Agpalilik" ist heute vor dem Geologischen Museum der Universität Kopenhagen in Dänemark zu sehen.

DER OLD WOMAN-METEORIT. Der 2 753 kg schwere Eisenmeteorit ist der zweitgrößte Fund in den USA. 1967 entdeckten ihn zwei Abenteurer auf der Suche nach einer sagenhaften spanischen Goldmine. Benannt ist er nach den Old Woman Mountains, ungefähr 270 km östlich von Los Angeles. US-Marines halfen bei der Bergung, heute ist er im Desert Discovery Center in Barstow, Kalifornien, zu sehen.

THE OLD WOMAN METEORITE. This iron meteorite is the second largest find in the USA, with a mass of 2 753 kg. It was discovered in 1967 by two adventurers searching for a legendary Spanish gold mine. The meteorite was named after the "Old Woman Mountains", about 270 km east of Los Angeles. US Marines helped with the recovery. The main mass is currently on display at the Desert Discovery Center in Barstow, California.

THE CAPE YORK METEORITE. In 1963, the Danish scientist Vagn F. Buchwald discovered this fragment of the Cape York iron meteorite, which has a total known mass of 58 tons and has been known to the Inuits for centuries. Today, the iron mass – called "Agpalilik" – is on display in front of the Geological Museum of the University of Copenhagen, Denmark.

WO UND WIE FINDET MAN METEORITEN?
WHERE AND HOW ARE METEORITES FOUND?

SO MANCHER METEORIT wartet noch auf seine Entdeckung.

***THERE ARE MANY METEORITES** waiting to be discovered.*

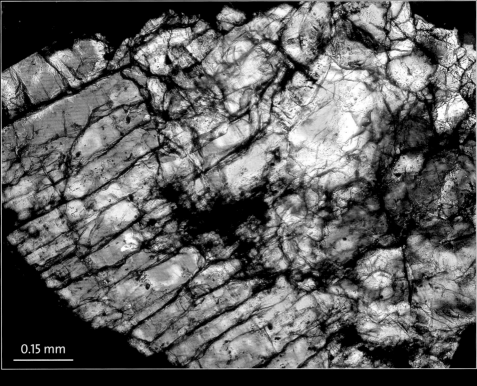

0.15 mm

Das Mineral Olivin im gewöhnlichen Chondriten Tieschitz
(mikroskopische Aufnahme mit polarisiertem Licht).

Alle Meteoriten sind Gesteine. Sie bestehen aus etwa 300 Mineralen (auf der Erde sind mehr als 5 000 bekannt). Ihre Hauptmasse wird jedoch nur von einigen wenigen Mineralen gebildet.

All meteorites are rocks. They consist of about 300 minerals (there are about 5 000 known minerals on Earth), but most meteorites are composed predominantly of just a few minerals.

WORAUS BESTEHEN METEORITEN?
WHAT ARE METEORITES MADE OF?

DAS SILIKAT OLIVIN. Das Eisen-Magnesium-Silikat ist der Hauptbestandteil vieler Stein- und Stein-Eisen-Meteoriten.

Yamato 791493. Olivin im Lodraniten Yamato 791493 (mikroskopische Aufnahme mit polarisiertem Licht) (rechts).

Lodran. Olivin (grüne Körner) in der silikatischen Grundmasse des Achondriten Lodran (unten).

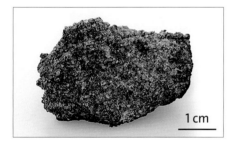

1 cm

Lodran. Olivine (green grains) within the silicate matrix of the achondrite Lodran *(top).*

Yamato 791493. Olivine in the lodranite Yamato 791493 (photomicrograph under polarized light) (right).

THE SILICATE OLIVINE. This iron-magnesium silicate is the main constituent of many stony and stony-iron meteorites.

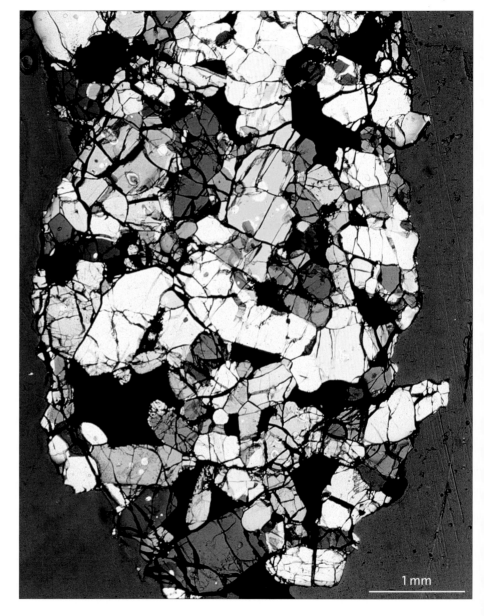

1 mm

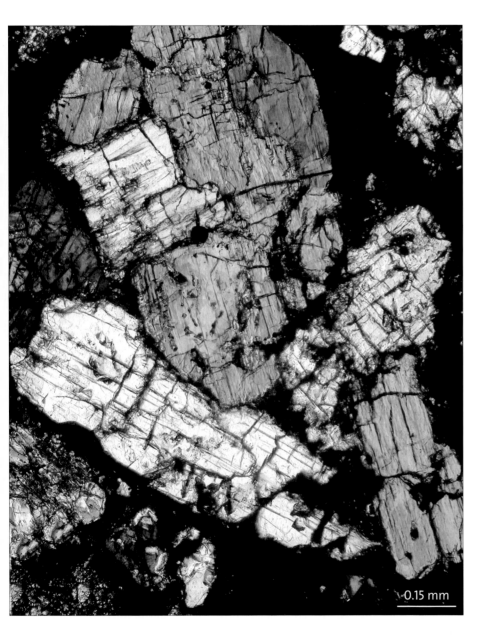

0.15 mm

DAS SILIKAT PYROXEN. Das Eisen-Magnesium-Calcium-Silikat ist neben Olivin das häufigste Silikat in vielen Steinmeteoriten.

Tieschitz. Pyroxen im gewöhnlichen Chondriten Tieschitz (mikroskopische Aufnahme mit polarisiertem Licht) (links).

Johnstown. Diogenit Johnstown mit dunkelgrünen Pyroxen-Kristallen in einer Matrix des gleichen Minerals (unten).

1 cm

Johnstown. The diogenite Johnstown with dark-green pyroxene crystals in a matrix of the same mineral (top).

Tieschitz. Pyroxene in the ordinary chondrite Tieschitz (photomicrograph under polarized light) (left).

THE SILICATE PYROXENE. Olivine and the iron-magnesium-calcium silicate pyroxene are the most abundant silicates in many stony meteorites.

WORAUS BESTEHEN METEORITEN?
WHAT ARE METEORITES MADE OF?

DAS SILIKAT FELDSPAT. Das Natrium-Calcium-Aluminium-Silikat ist ein wichtiger Bestandteil vieler Steinmeteoriten – und das häufigste Mineral der Erdkruste.

Millbillillie. Magmatisches Gefüge des Eukriten Millbillillie mit Feldspat (weißlich) und Pyroxen (dunkelgrau) in feinkörniger hellgrauer Matrix (unten).

1 cm

Millbillillie. Magmatic texture of the eucrite Millbillillie with feldspar (whitish) and pyroxene (dark gray) in fine-grained light gray matrix (top).

THE SILICATE FELDSPAR. This sodium-calcium-aluminum silicate is an important constituent of many stony meteorites – and the most abundant mineral in the Earth's crust.

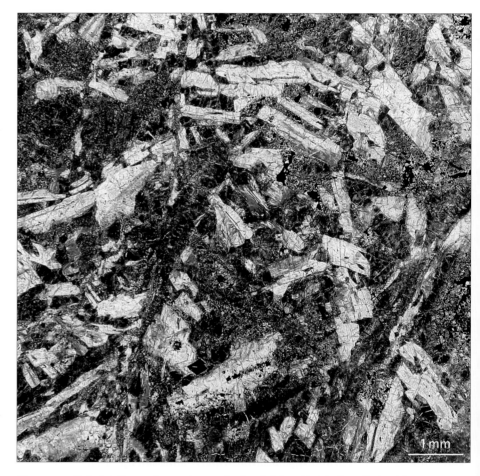

1 mm

Stannern. Gut sichtbare Verwachsung heller Feldspatkristalle mit dunklem Pyroxen im Eukriten Stannern.
Stannern. Intergrowth of light-colored feldspar crystals with dark pyroxene in the eucrite Stannern.

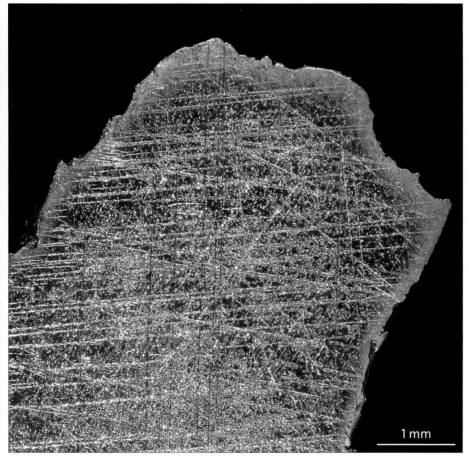

Mount Joy. Kamazit aus dem Eisenmeteoriten Mount Joy (Anschliff mit geätzter Oberfläche).
Mount Joy. Kamacite from the Mount Joy iron meteorite (polished slice with etched surface).

NICKELEISEN. Im Gegensatz zu den Gesteinen der Erdkruste enthalten viele Meteoriten Nickeleisenmetall oder bestehen fast ganz daraus. Die zwei wichtigsten Nickeleisenminerale sind Kamazit (nickelarm) und Taenit (nickelreich).

Toluca. Taenit aus dem Eisenmeteoriten Toluca. Die dünnen Platten wurden durch Wegätzen des Kamazits freigelegt (unten).

Toluca. Taenite from the Toluca iron meteorite (the thin plates were exposed after dissolution of kamacite) (top).

NICKEL-IRON METAL. In contrast to terrestrial rocks, many meteorites contain nickel-iron metal, or consist almost entirely of it. The two most important nickel-iron minerals are kamacite (nickel-poor) and taenite (nickel-rich).

EISENSULFID. Neben Nickeleisen ist das Eisensulfid Troilit Bestandteil vieler Stein-, Eisen- und Stein-Eisen-Meteoriten.

Troilit (hellbraun) verwachsen mit Kamazit (weiß) in silikatischer Matrix (graubraun); gewöhnlicher Chondrit Knyahinya (mikroskopische Aufnahme, reflektiertes Licht).

Zentimetergroße Troilit-Knolle im Oktaedriten Willamette.

Troilit (hellbraun) in Kamazit (weiß) im Eisenmeteoriten Acfer 234 (mikroskopische Aufnahme einer geätzten Platte).

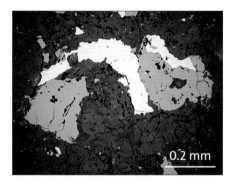

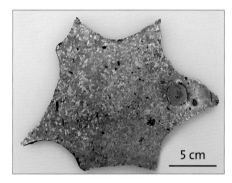

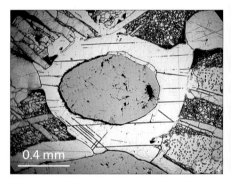

Troilite (light gray) intergrown with kamacite (white) in silicate matrix (grayish-brown), ordinary chondrite Knyahinya (photomicrograph, reflected light).

Centimeter-sized troilite nodule in the Willamette octahedrite.

Troilite (light gray) in kamacite (white) from the iron meteorite Acfer 234 (photomicrograph of etched slice).

IRON SULFIDE. Next to metal, the iron sulfide troilite is common in many stony, stony-iron, and iron meteorites.

TYPISCHE EINSCHLÜSSE sind das Eisen-Nickel-Phosphid Schreibersit, das Eisencarbid Cohenit und elementarer Kohlenstoff als Graphit (selten auch als Diamant).

Schreibersit-Kristalle in der Metallmatrix des Eisenmeteoriten Glorieta Mountain (mikroskopische Aufnahme).

Cohenit-Kristalle in der Metallmatrix des Eisenmeteoriten Youndegin (mikroskopische Aufnahme einer geätzten Platte).

Graphit als Einschluss im Eisenmeteoriten Silver Crown (mikroskopische Aufnahme).

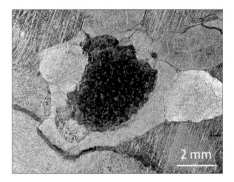

Schreibersite crystals in the metal matrix of the Glorieta Mountain iron meteorite (photomicrograph).

Cohenite crystals in the metal matrix of the Youndegin iron meteorite (photomicrograph of an etched plate).

Graphite inclusion in the Silver Crown iron meteorite (photomicrograph).

TYPICAL INCLUSIONS in iron meteorites are: the nickel-iron phosphide schreibersite, the iron carbide cohenite, and elemental carbon in the form of graphite (in rare cases as diamond).

KOHLIGE CHONDRITE enthalten diese millimeter- bis zentimetergroßen, fast 4,6 Milliarden Jahre alten Einschlüsse. Calcium und Aluminium sind typische Vertreter refraktärer (schwer flüchtiger) Elemente, die auch bei hohen Temperaturen noch als feste Verbindung vorliegen und eine wichtige Rolle bei der Entstehung des Sonnensystems gespielt haben.

Allende. Kohliger Chondrit Allende mit Ca-Al-reichem Einschluss (links oben im Bild).

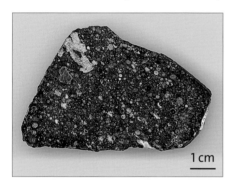

1 cm

Allende. Carbonaceous chondrite Allende with a Ca-Al-rich inclusion in the upper left of the image.

CARBONACEOUS CHONDRITES contain these millimeter- to centimeter-sized, almost 4.6 billion year old inclusions. Calcium and aluminum are typical examples of refractory elements (i.e., with high vaporization temperatures). Even at high temperatures they exist as solids and were important during the formation of the solar system.

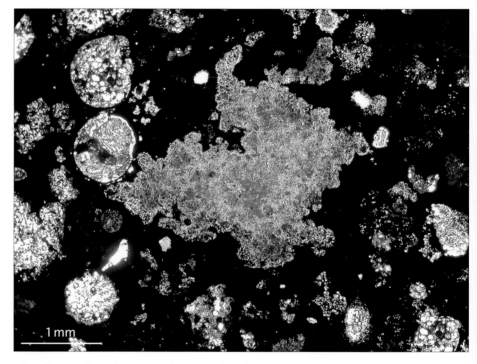

1 mm

Allende. Ca-Al-reicher Einschluss aus dem kohligen Chondriten Allende mit typisch unregelmäßigem Umriss (mikroskopische Aufnahme, polarisiertes Licht).
Allende. Ca-Al-rich inclusion in the carbonaceous chondrite Allende with typical irregular outline (photomicrograph, polarized light).

CHONDREN sind Bestandteile und Namensgeber der Chondrite. Die Kügelchen, die meist zwischen 0,2 bis einige Millimeter groß sind, bestehen hauptsächlich aus den Mineralen Olivin und Pyroxen sowie etwas Feldspat. Sie sind erstarrte Schmelztröpfchen und stellen Hochtemperaturbildungen dar.

Bjurböle. Bruchstück des Chondriten Bjurböle mit großer Chondre (Bildmitte).

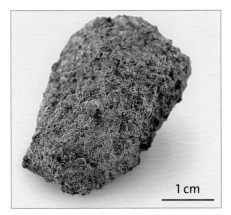

Bjurböle. Fragment of the Bjurböle chondrite with large chondrule in the center of the image.

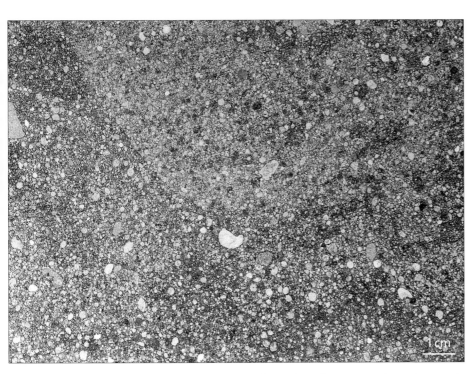

Mezö-Madaras. Schnittplatte des gewöhnlichen Chondriten Mezö-Madaras mit zahlreichen Chondren in bräunlicher Grundmasse.
Mezö-Madaras. Slice of the ordinary chondrite Mezö-Madaras with numerous chondrules in brownish matrix.

CHONDRITES are named after their characteristic constituents – the chondrules. These spherical objects are typically 0.2 to several mm in size and consist mainly of the minerals olivine, pyroxene, and some feldspar. They are solidified melt droplets representing high-temperature components.

WORAUS BESTEHEN METEORITEN?
WHAT ARE METEORITES MADE OF?

EIN CHARAKTERISTISCHER BESTANDTEIL aller (frisch) gefallenen Meteoriten ist ihre Schmelzkruste. Sie entsteht durch die enorme Hitzeeinwirkung während der Abbremsung des Meteoriten (Meteoroiden) in der Erdatmosphäre.

Mocs. Einzelstück des gewöhnlichen Chondriten Mocs. Die Bruchfläche zeigt das Innere des Meteoriten, das sich deutlich von der Schmelzkruste unterscheidet.

METEORITEN LEITEN HITZE SCHLECHT, daher ist die Kruste meist sehr dünn (oft unter 1 mm, selten bis zu 1 cm). Bei Steinmeteoriten besteht sie aus schwarzem, eisenhaltigem Glas, bei Eisenmeteoriten aus Eisenoxid.

Mocs. Ein Bruchstück des gewöhnlichen Chondriten Mocs mit schwarzer Schmelzkruste.

Mocs. Mikroskopische Aufnahme eines Dünnschliffs des Mocs-Meteoriten mit schwarzer, lichtundurchlässiger Kruste.

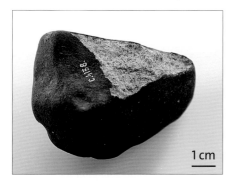

1 cm

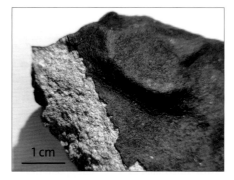

1 cm

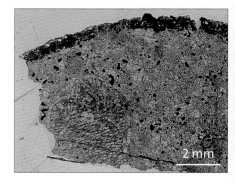

2 mm

Mocs. Individual fragment of the ordinary chondrite Mocs. The broken part exhibits the meteorite's interior, which is very distinct from the fusion crust.

A CHARACTERISTIC FEATURE of all (freshly) fallen meteorites is their fusion crust. It is formed by the enormous heat generated during the passage of the meteorite (meteoroid) through the Earth's atmosphere.

Mocs. Fragment of the ordinary chondrite Mocs with black fusion crust.

DUE TO THE LOW THERMAL CONDUCTIVITY OF METEORITES, the crust is usually very thin (often less than 1 mm, rarely up to 1 cm). The fusion crusts of stony meteorites consist of iron-rich black glass, those of iron meteorites of iron oxide.

Mocs. Photomicrograph of a thin section of the Mocs meteorite with a black opaque crust.

Mocs. Mikroskopische Aufnahme der Schmelzkruste (Durchlicht mit polarisiertem Licht). Lichtundurchlässige Bereiche erscheinen schwarz.

Mocs. Dieselbe Aufnahme im Auflicht zeigt zahlreiche Eisensulfidadern – daher auch die undurchsichtige schwarze Kruste der Steinmeteoriten.

Cochabamba. In der Detailaufnahme der Schmelzkruste des kohligen Chondriten Cochabamba ist die glasige Oberfläche mit deutlichen Fließstrukturen zu sehen.

Mocs. Microscopic close-up image of the fusion crust of the Mocs meteorite (transmitted polarized light). Opaque areas appear black.

Mocs. The same photomicrograph in reflected light shows the presence of numerous iron sulfide veins, explaining why fusion crusts are opaque.

Cochabamba. This close-up image of the fusion crust of the Cochabamba carbonaceous chondrite reveals the characteristic flow texture on the glassy surface.

WORAUS BESTEHEN METEORITEN?
WHAT ARE METEORITES MADE OF?

CHONDREN, CHONDRENBRUCHSTÜCKE und andere Mineralkörner sind in eine feinkörnige Grundmasse (Matrix) eingebettet. Diese besteht im Wesentlichen aus den gleichen Mineralen wie die größeren Bestandteile, enthält aber auch flüchtige Bestandteile und Kohlenstoff – ein Beleg für eine Tieftemperaturbildung (im Gegensatz zu den Chondren).

Tieschitz. Gewöhnlicher Chondrit. Mikroskopische Aufnahme mit Chondren, Nickeleisen und Eisensulfid in dunkler Matrix. Nur die silikatischen Minerale, hauptsächlich Olivin und Pyroxen, sind lichtdurchlässig (links). In polarisiertem Licht zeigen sie ihre charakteristischen Farben (rechts).

Tieschitz. Ordinary chondrite. Photomicrographs showing chondrules, nickel-iron metal, and iron sulfide in a dark matrix. Silicate minerals, mainly olivine and pyroxene, are transparent in the left photograph; they exhibit characteristic colors when seen in polarized light (right).

CHONDRULES, CHONDRULE FRAGMENTS, and mineral grains occur within a fine-grained matrix composed predominantly of the same minerals as the chondrules. In addition, the matrix contains volatile components (e.g., carbon), which provide evidence for low-temperature formation (in contrast to chondrules).

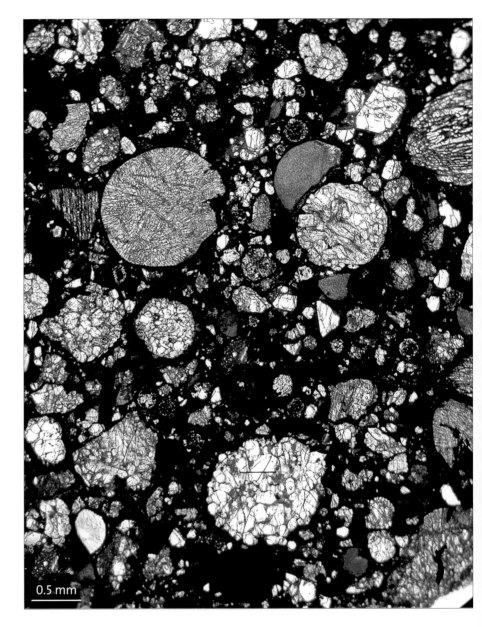

0.5 mm

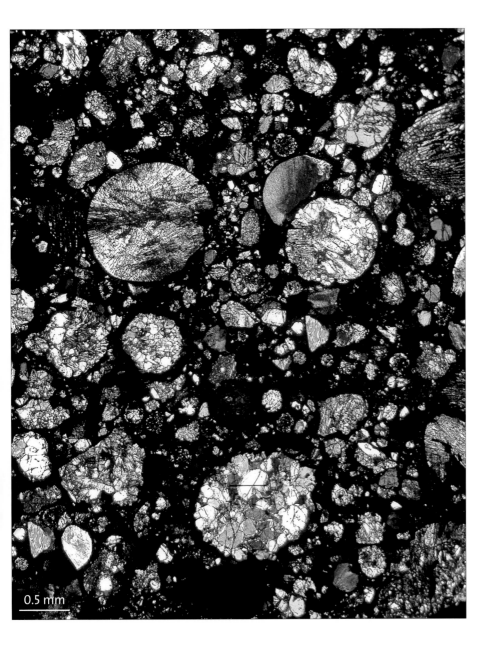

0.5 mm

MANCHE METEORITEN enthalten Minerale, die auf die Anwesenheit von Wasser bei deren Entstehung auf dem Mutterasteroiden hinweisen. Viele Chondrite sind somit Mischungen aus Hoch- und Niedertemperatur-Mineralen.

Zag. Blaues Steinsalz (Natriumchlorid) aus der Matrix des gewöhnlichen Chondriten Zag. Es entstand vermutlich durch Verdunsten von Salzlösungen in oberflächennahen Bereichen des Mutterkörpers (unten).

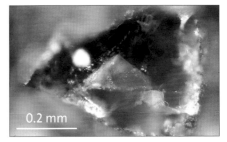

0.2 mm

Zag. Blue rock salt (sodium chloride) from the matrix of the Zag ordinary chondrite. It probably formed by evaporation of brines near the surface of the parent body (top).

SOME METEORITES contain minerals that indicate the presence of water during their formation on their parent asteroids. Many chondrites are mixtures of high- and low-temperature minerals.

WORAUS BESTEHEN METEORITEN?
WHAT ARE METEORITES MADE OF?

FAST ALLE METEORITEN SIND BREKZIEN – Gesteine, die aus Gesteinsbruchstücken zusammengesetzt sind. Viele sind durch Einschläge (Impakte) von Asteroiden auf dem Mutterkörper entstanden. Je nach Intensität des Impakts wird das getroffene Material aufgebrochen, vermischt, erhitzt, geschmolzen. Durch den Impakt wird das Gestein „geschockt". Dabei können dünne schwarze „Schockadern" aus geschmolzenem Gestein gebildet werden.

ALMOST ALL METEORITES ARE BRECCIAS – rocks made of rock fragments. Many of them formed during impacts of asteroids on the parent body. Depending on the force of the impact, the target material is fragmented, mixed, heated, and molten. The rock is "shocked" by the impact and "shock veins" consisting of molten rock can form.

Mocs. Schnittfläche des Mocs-Meteoriten (L-Chondrit) mit deutlich erkennbaren schwarzen Schockadern.

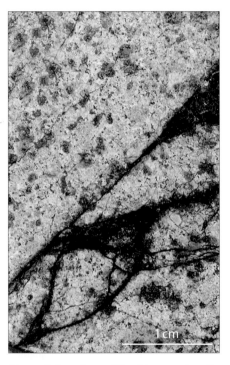

Mocs. Cut surface of the Mocs meteorite (L chondrite) with black shock veins.

Tenham. Der stark „geschockte" gewöhnliche Chondrit Tenham. Durch feinst verteiltes Eisensulfid erscheinen die Adern schwarz (mikroskopische Aufnahme, polarisiertes Licht).

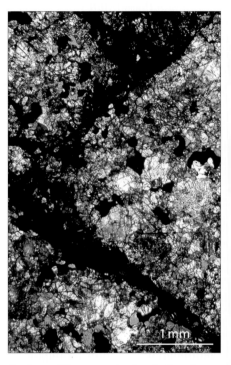

Tenham. The severely shocked ordinary chondrite Tenham. The veins appear black because of the presence of finely dispersed iron sulfide (photomicrograph, polarized light).

SCHOCKADER IM TENHAM-CHONDRITEN. Durch extrem hohen Druck wurde Olivin bereichsweise in eine dichtere Form umgewandelt: Die zwei violetten Körner bestehen aus dem Hochdruckmineral Ringwoodit (mikroskopische Aufnahme, polarisiertes Licht).

Detailaufnahme eines Ringwoodit-Kristalls.

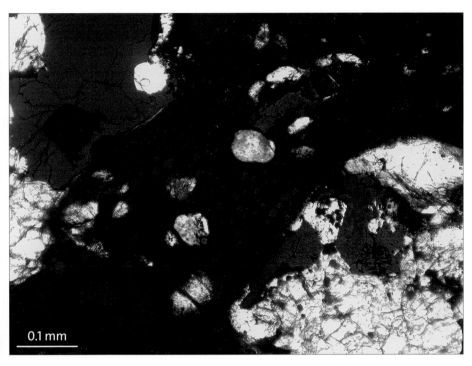

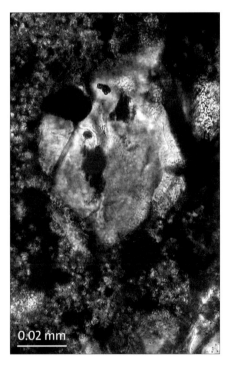

SHOCK VEIN IN THE TENHAM CHONDRITE. Due to the very high shock pressure, part of the olivine has been transformed into a denser variety: the two violet grains consist of the high-pressure mineral ringwoodite (photomicrograph, polarized light).

Close-up of a ringwoodite crystal.

WORAUS BESTEHEN METEORITEN?
WHAT ARE METEORITES MADE OF?

EINIGE CHONDRITE enthalten Einschlüsse, die älter als unser Sonnensystem sind. Die mikrometergroßen Diamant-, Graphit- oder Siliciumcarbideinschlüsse sind isotopisch völlig anders zusammengesetzt als „normale" meteoritische Minerale. Sie stammen aus den Atmosphären von Riesensternen oder aus Supernova-Explosionen und haben die Entstehung des Sonnensystem unverändert „überlebt".

Murchison. Präsolares Siliciumcarbidkorn aus dem kohligen Chondriten Murchison (elektronenmikroskopische Aufnahme, rechts).

Murchison. Presolar grain of silicon carbide from the Murchison carbonaceous chondrite (electron microscope image, right).

SOME CHONDRITES contain inclusions that are older than our solar system. The micrometer-sized diamond, graphite, or silicon carbide inclusions have completely different isotopic compositions compared to "normal" meteorite minerals. They come from the atmosphere of giant stars or from supernova explosions and "survived" the formation of the solar system.

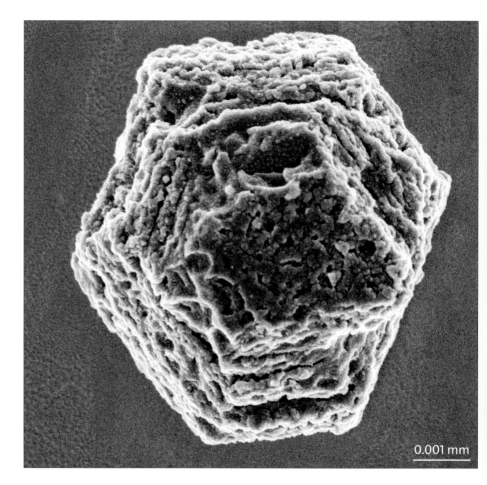

0.001 mm

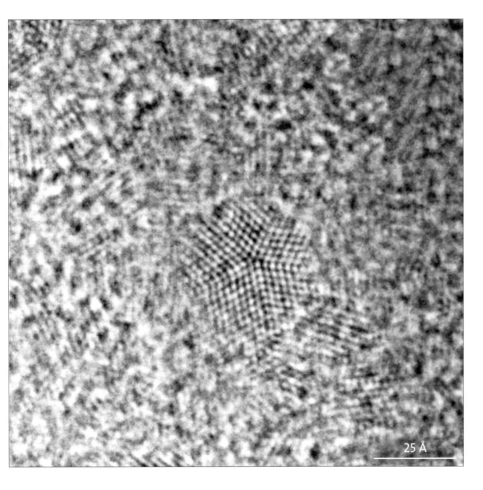

25 Å

CHEMISCHE UND ISOTOPISCHE Untersuchungen präsolarer Minerale bringen wichtige Informationen über die Entstehung der chemischen Elemente, die Herkunft des Ursprungsmaterials des Sonnensystems und die frühe Entwicklung des Sonnennebels.

Präsolarer Diamant. Im Elektronenmikroskop ist die Anordnung der Kohlenstoffatome erkennbar. Maßstab: 25 Ångström (1 Ångström = 1 zehnmillionstel mm) (links).

Presolar diamond. Under the electron microscope, one can see the arrangement of the carbon atoms. Scale: 25 Ångström (1 Ångström = 1 ten-millionth mm) (left).

CHEMICAL AND ISOTOPIC investigations of presolar minerals help us to understand the formation of the chemical elements, the origin of the solar system's precursor material, and the early evolution of the solar nebula.

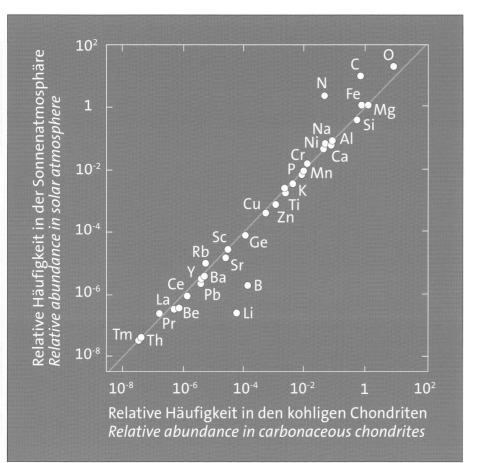

ES GIBT VIELE VERSCHIEDENE METEO-RITENTYPEN, doch alle leiten sich von einer gemeinsamen ursprünglichen Zusammensetzung ab. Diese ist am vollständigsten in kohligen Chondriten erhalten. Vergleicht man deren Zusammensetzung mit jener der Sonne, zeigen sich weitgehende Übereinstimmungen. Meteoriten sind somit die wichtigsten „Zeitzeugen" der Entstehung des Planetensystems und der Erde.

THERE ARE MANY DIFFERENT TYPES OF METEORITES, but all are derived from a common source; this primitive composition is still preserved to some degree in carbonaceous chondrites. A comparison of their composition with that of the sun reveals a very good match. Thus, meteorites are the most important witnesses of the formation of the planetary system and the Earth.

Ausgewählte Großobjekte von Stein- und Stein-Eisen-Meteoriten (oben)
und von Eisenmeteoriten (darunter).
Selected specimens of large stony and stony-iron (top)
and iron meteorites (below).

Meteoriten sind Gesteinsbruchstücke, die hauptsächlich aus silikatischen Mineralen und Nickeleisenmetall bestehen. Dem Verhältnis dieser Bestandteile entsprechend wird zwischen Stein-, Stein-Eisen- und Eisenmeteoriten unterschieden, jeweils weiter unterteilt nach mineralogisch-gesteinskundlichen Kriterien. Diese beschreibende Einteilung nimmt jedoch keinen Bezug auf die Entstehung der Meteoriten.

Die wissenschaftliche Klassifikation unterscheidet hingegen zwischen „undifferenzierten" und „differenzierten" Meteoriten. Diese genetische Einteilung beruht auf der „Abstammung" fast aller Meteoriten von Kleinplaneten, die während der Entstehung vor 4,6 Milliarden Jahren unterschiedlich stark erhitzt wurden.

Meteorites are rock fragments that mainly consist of silicate minerals and iron-nickel metal. Depending on the relative proportions of these components, one can distinguish between stony, stony-iron, and iron meteorites, with additional subdivisions based on mineralogical, petrographical, and chemical criteria. However, this descriptive classification bears no relation to the origin of meteorites.

The scientific classification distinguishes between "undifferentiated" and "differentiated" meteorites. This genetic classification is based on the fact that almost all meteorites "originate" from minor planets, which were internally heated to various degrees during their formation almost 4.6 billion years ago.

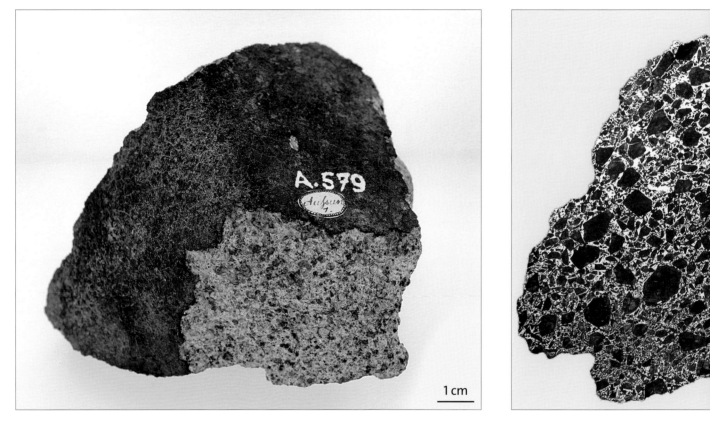

1 cm

Steinmeteorit (Chondrit) Ausson
Stony meteorite (chondrite) Ausson

Stein-Eisen-Meteorit (Pallasit) Eagle St:
Stony-iron meteorite (pallasite) Eagle Sta

2 cm

1 cm

Eisenmeteorit Canyon Diablo
Iron meteorite Canyon Diablo

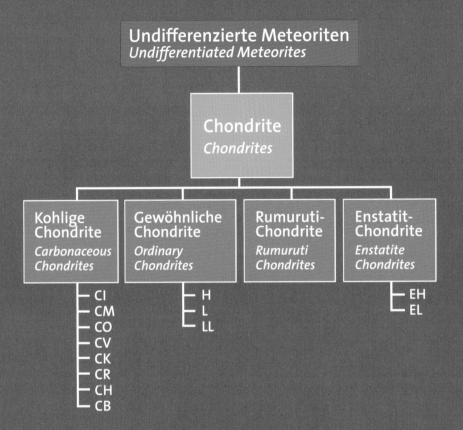

UNDIFFERENZIERTE METEORITEN stammen von Kleinplaneten, die nicht bis zu ihrer Schmelztemperatur aufgeheizt wurden. In ihrem Inneren kam es zu keiner nennenswerten stofflichen Trennung. Undifferenzierte Meteoriten sind jene Steinmeteoriten, die als Chondrite bezeichnet werden. Namensgeber sind die Chondren, aus Silikaten bestehende Kügelchen, meist 0,2 mm bis mehrere mm groß. Sie sind in fast allen undifferenzierten Meteoriten vorhanden. Chondrite werden in vier Grundtypen unterteilt und zur Vereinfachung mit Buchstaben bezeichnet (zum Beispiel CI, LL, R, EH).

UNDIFFERENTIATED METEORITES originated from minor planets that did not reach melting temperatures and thus no segregation of components occurred in their interiors. Undifferentiated stony meteorites are called "chondrites". The name is derived from the spherical objects called chondrules, which consist of silicates and generally are 0.2 to several mm in size. Chondrules are present in almost all undifferentiated meteorites. Chondrites are divided into four basic types, which are designated with letters (e.g., CI, LL, R, EH).

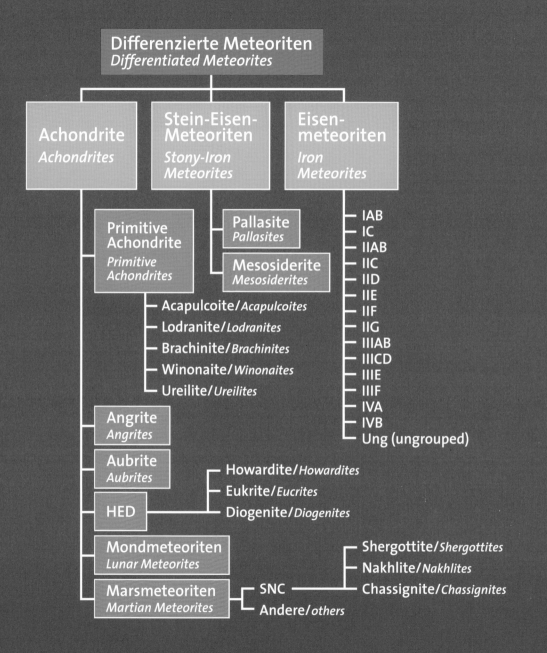

DIFFERENZIERT nennt man die Abkömmlinge jener Kleinplaneten, deren Inneres so weit aufgeschmolzen wurde, dass es zu einer großräumigen stofflichen Trennung kam: die schweren Metalle Eisen und Nickel im Zentrum, umgeben von einem Mantel aus basaltischem Gestein.

Unterschieden werden Achondrite (primitive und differenzierte), Stein-Eisen-Meteoriten und Eisenmeteoriten.

DIFFERENTIATED METEORITES originate from minor planets that were once molten in their interiors so that their various components were separated: the heavy metals iron and nickel accumulated in the center, surrounded by a mantle of basaltic rock.

Subgroups of differentiated meteorites are the achondrites (primitives and differentiated), stony-iron meteorites, and iron meteorites.

STEINMETEORITEN
STONY METEORITES

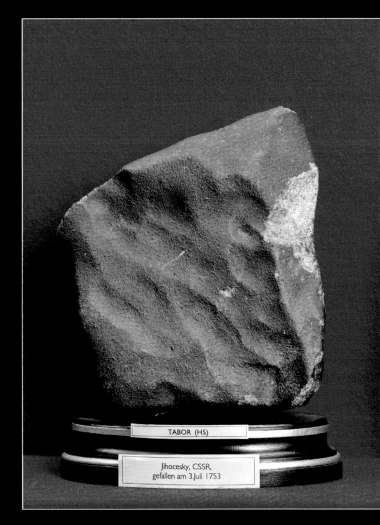

TABOR (H5)

Jihocesky, CSSR,
gefallen am 3.Juli 1753

Der Tabor-Steinmeteorit kam 1778 in die Wiener Sammlung.
The Tabor stony meteorite entered the Vienna collection in 1778.

Die meisten Meteoriten (95 % aller bekannten Fälle) sind Steinmeteoriten. Sie bestehen größtenteils aus Silikatmineralen und werden in Chondrite und Achondrite unterteilt. Erstere stellen das „primitive" Ursprungsmaterial des Sonnensystems dar, Letztere hingegen sind durch magmatische Umwandlung dieses Materials entstanden.

Most meteorites (95% of all observed falls) are stony meteorites, which mostly consist of silicate minerals. They are classified into chondrites and achondrites. The former are virtually unaltered remnants of the formation of the solar system, whereas the latter are the product of magmatic differentiation within minor planets.

STEINMETEORITEN
STONY METEORITES

CI-CHONDRITE sind nach dem Meteoriten Ivuna benannt. Sie bestehen fast ausschließlich aus einer feinkörnigen Grundmasse (Matrix) und enthalten keine Chondren – so auch Orgueil, der bekannteste Vertreter dieser Meteoritengruppe (rechts). Sie sind die ursprünglichsten, am wenigsten veränderten Meteoriten. Einige enthalten flüchtige Substanzen wie Wasser, Schwefel und organische Verbindungen. Es wird angenommen, dass in der Frühgeschichte der Erde durch starkes Meteoritenbombardement viele dieser Komponenten auf die Erde kamen. Auf diese Weise wurden wichtige Grundlagen für die Entstehung des Lebens geliefert.

CI CHONDRITES, named after the meteorite Ivuna – including Orgueil, the best known representative of this group (right) – consist almost exclusively of a fine-grained matrix and do not contain chondrules. These are the most primitive, least altered meteorites. Some of them contain volatile components, such as water, sulfur, and organic compounds. It is assumed that such material accreted onto the early Earth, providing components essential for the formation of life.

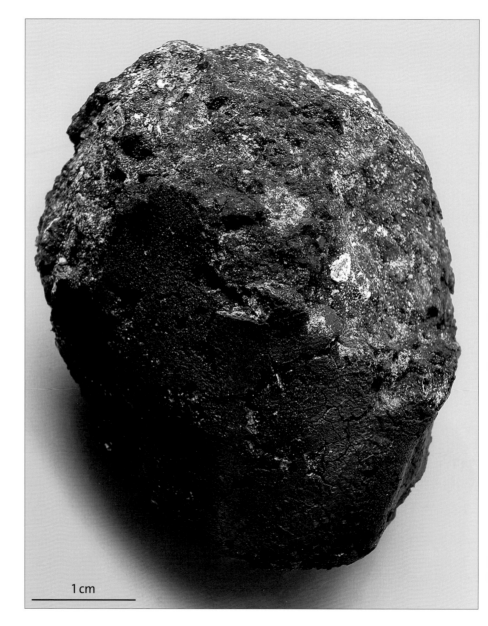

1 cm

KOHLIGE CHONDRITE – der Name bezieht sich auf ihre schwarze Farbe – sind die ursprünglichsten, am wenigsten veränderten Meteoriten. Einige enthalten viele flüchtige Substanzen wie Wasser, Schwefel und organische Verbindungen in einer feinkörnigen Grundmasse (Matrix), ein Beleg für eine zugrunde liegende Tieftemperaturbildung – im Gegensatz zu den Chondren und den Eisen-Magnesium-Silikaten Olivin und Pyroxen, die Hochtemperaturbildungen darstellen. Sie werden in acht Gruppen unterteilt (Bezeichnung: C + Initiale des jeweiligen Hauptvertreters).

CARBONACEOUS CHONDRITES – the name refers to their black color – are the most primitive meteorites. They are divided into eight subgroups (designated C + the first letter of the main representative). Some of them contain various volatile components, such as water, sulfur, and organic compounds in a fine-grained matrix; this is evidence for a low-temperature origin of the matrix, as opposed to a high-temperature origin for the chondrules and the iron-magnesium silicates olivine and pyroxene.

CM-CHONDRITE bestehen zu ca. 50 % aus Matrix und enthalten nur wenige Chondren. In der Grundmasse treten verschiedene Silikateinschlüsse auf, die Hochtemperaturbildungen darstellen.

Bruchstück des CM-Chondriten **Nogoya**. In der schwarzen, an flüchtigen Elementen reichen Grundmasse sind zahlreiche helle Einschlüsse erkennbar, die hauptsächlich aus den Silikatmineralen Olivin und Pyroxen bestehen.

CO-CHONDRITE bestehen zu etwa einem Drittel aus Matrix und zu zwei Drittel aus Hochtemperatureinschlüssen; ca. die Hälfte davon sind winzige Chondren (Durchmesser 0,1–0,4 mm).

Bruchstück des CO-Chondriten **Ornans**, des Namensgebers der Meteoritengruppe.

1 cm

1 cm

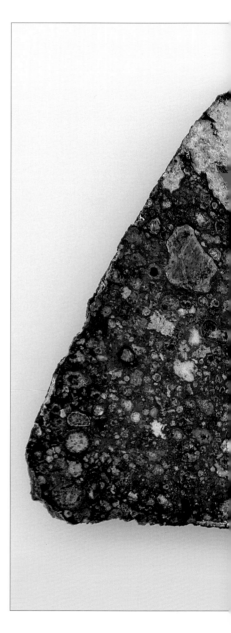

*Fragment of the CM chondrite **Nogoya**. Numerous light-colored inclusions (consisting mostly of the silicates olivine and pyroxene) occur within the dark, volatile-rich matrix.*

***CM CHONDRITES** consist of about 50% matrix and contain only a few chondrules. The matrix also contains various high-temperature silicate inclusions.*

*Fragment of the CO chondrite **Ornans**, the main representative of this group.*

***CO CHONDRITES** consist of about one part matrix and two parts high-temperature inclusions, half of which are small (0.1–0.4 mm diameter) chondrules.*

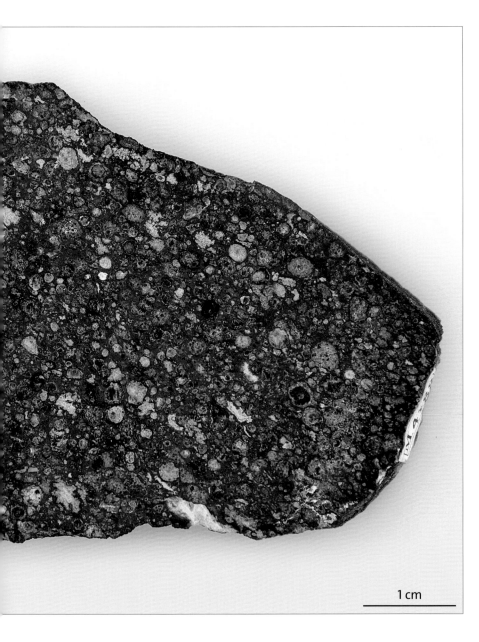

1 cm

CV-CHONDRITE bestehen ungefähr zu gleichen Teilen aus Matrix und Chondren, die jedoch im Vergleich zu jenen der CO-Chondrite deutlich größer sind (Durchmesser bis einige mm). Auffallend bei CV-Chondriten sind die weißlichen, bis mehrere cm großen Calcium-Aluminium-reichen Einschlüsse. Diese Einschlüsse sind das älteste feste Material das im Sonnensystems entstanden ist.

Platte des Meteoriten **Allende**, des bekanntesten Vertreters der CV-Chondrite (links).

*Polished slice of the meteorite **Allende**, the best known representative of the CV chondrites (left).*

CV CHONDRITES consist of about equal parts of matrix and chondrules, which are larger than those in the CO chondrites (up to several mm in diameter). Very prominent are the white Calcium-Aluminum-rich Inclusions (CAIs) that are up to several cm in size. These inclusions represent the oldest material that formed in the solar system.

CK-CHONDRITE bestehen zu rund zwei Drittel aus feinkörniger Matrix. Die Hochtemperatureinschlüsse sind hauptsächlich millimetergroße Chondren. CK-Chondrite sind stark oxidiert und enthalten kein freies Metall (Nickeleisen).

Bruchstück des Meteoriten **Karoonda**, Namensgeber der CK-Chondrite.

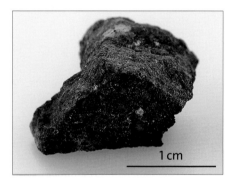

1 cm

*Fragment of the meteorite **Karoonda**, the main representative of the CK chondrites.*

CK CHONDRITES. The matrix makes up about two thirds of the mass of these meteorites. High-temperature inclusions are mainly represented by millimeter-sized chondrules. CK chondrites are strongly oxidized and do not contain any free metal (nickel-iron).

CR-CHONDRITE bestehen zu etwa gleichen Teilen aus Matrix und Chondren. Sie enthalten einen signifikanten Anteil Nickeleisen (5–8 %), das typischerweise konzentriert um die Chondren auftritt.

Bruchstück des Meteoriten **Renazzo**, Hauptvertreter und Namensgeber der CR-Chondrite. Zahlreiche Chondren und ein hellblauer Calcium-Aluminium-reicher Einschluss sind zu erkennen (rechts).

*Fragment of the meteorite **Renazzo**, the main representative of the CR chondrites. Abundant chondrules and a light-blue calcium-aluminum-rich inclusion are clearly visible (right).*

CR CHONDRITES consist of matrix and chondrules in about equal parts. They do contain a significant proportion of nickel-iron metal (5-8 wt%), which typically is concentrated around the chondrules.

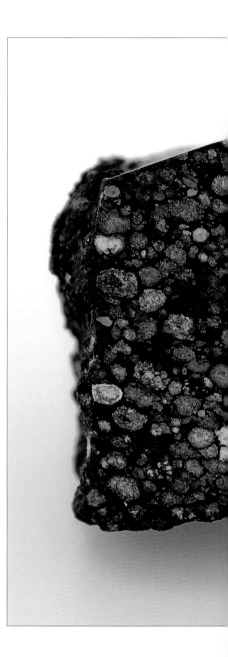

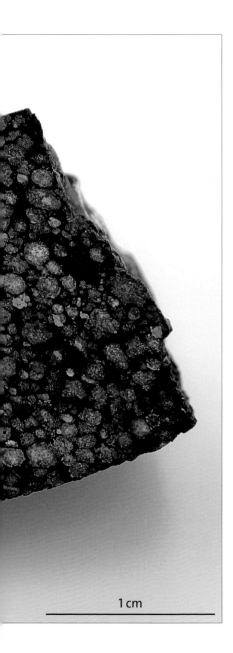

1 cm

CH-CHONDRITE – H steht für „hohen Metallgehalt" – sind eine seltene Gruppe kohliger Chondrite, die chemisch mit CR- und CB-Chondriten verwandt sind. Sie bestehen aus einer Grundmasse silikatischer Fragmente, viel Nickeleisen (rund 20 %) und winzigen Chondren (Durchmesser < 0,1 mm). Allan Hills 85085 war der erste Vertreter der CH-Chondriten.

Bruchstück des CH3-Chondriten **Acfer 214**.

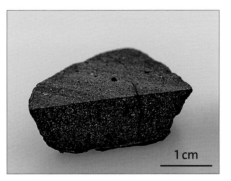

1 cm

*Fragment of the CH3 chondrite **Acfer 214**.*

CH CHONDRITES (the H stands for "high metal content") are a rare group of carbonaceous chondrites that are chemically similar to CB and CR chondrites. They are composed of a matrix of silicate mineral fragments, abundant nickel-iron metal (ca. 20 wt%), and tiny chondrules (<0.1 mm). Allan Hills 85085 was the first representative of the CH chondrites.

CB-CHONDRITE sind eine ungewöhnliche Gruppe kohliger Chondrite, die charakteristischerweise zu mehr als der Hälfte aus Nickeleisen bestehen, das meistens in Form rundlicher Einschlüsse auftritt. Einige dieser Meteoriten enthalten auch zentimetergroße chondrenähnliche Objekte (wie hier im Bild).

Der CB-Chondrit **Gujba**; Platte mit Metall (hellgrau) und Silikat (grünlich-grau).

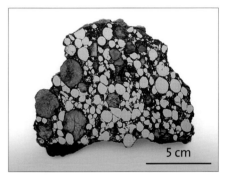

5 cm

*Polished slice of the CB chondrite **Gujba**, with light gray metal and greenish-gray silicate minerals.*

CB CHONDRITES are an unusual group of carbonaceous chondrites that consist of more than 50% nickel-iron metal, which most often occurs in the form of spherical inclusions. Some of them (e.g., the one in the image above) also contain centimeter-sized chondrule-like objects.

STEINMETEORITEN
STONY METEORITES

H-CHONDRITE weisen einen sehr hohen Gehalt an Gesamteisen und Metall auf, H steht hier für „high iron", „hohes Gesamteisen".

H-Chondrit **Menow**. In der Schnittfläche ist der für H-Chondrite typische hohe Gehalt an Nickeleisen erkennbar (weiß reflektierende Körner) (rechts).

*The H chondrite **Menow**. The cut surface exposes the high abundance of nickel-iron metal (highly reflective white grains) that is typical for H chondrites (right).*

H CHONDRITES have high contents of total iron and native metal; H stands for "high total iron content".

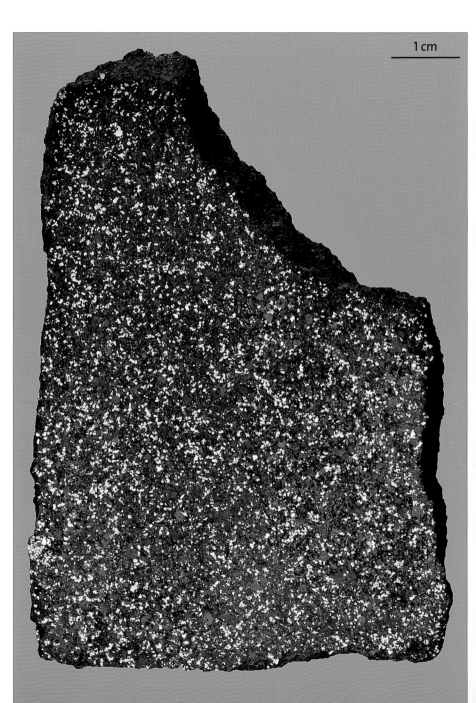

1 cm

GEWÖHNLICHE CHONDRITE sind die mit Abstand größte Gruppe der Steinmeteoriten. Sie bestehen hauptsächlich aus den Eisen-Magnesium-Silikaten Olivin und Pyroxen. Zusätzlich enthalten sie noch variable Anteile an Nickeleisen. Nach ihrem Gesamteisengehalt und dem Gehalt an freiem Metall (Nickeleisen) werden sie in drei „chemische Klassen" unterteilt: H-, L- und LL-Chondrite.

ORDINARY CHONDRITES are by far the largest group of stony meteorites. They consist mainly of the iron-magnesium silicates olivine and pyroxene. In addition, they also contain various amounts of nickel-iron metal. They are divided into three chemical subgroups according to their total iron and native metal (nickel-iron) content, namely H, L, and LL chondrites.

L-CHONDRITE – L steht für „low iron",
„niedriges Gesamteisen" – enthalten
weniger Gesamteisen und weniger
Metall als die H-Chondrite.

L-Chondrit **Bruderheim**. In der Schnitt-
fläche ist ein im Vergleich zu H-Chond-
riten geringerer Gehalt an Nickeleisen-
metall erkennbar (weiß reflektierende
Körner) (rechts).

The L chondrite **Bruderheim**. *The cut
surface exposes highly reflective whitish
nickel-iron metal grains (right).*

*L CHONDRITES (L stands for "low iron")
contain less total iron and less native
metal than H chondrites.*

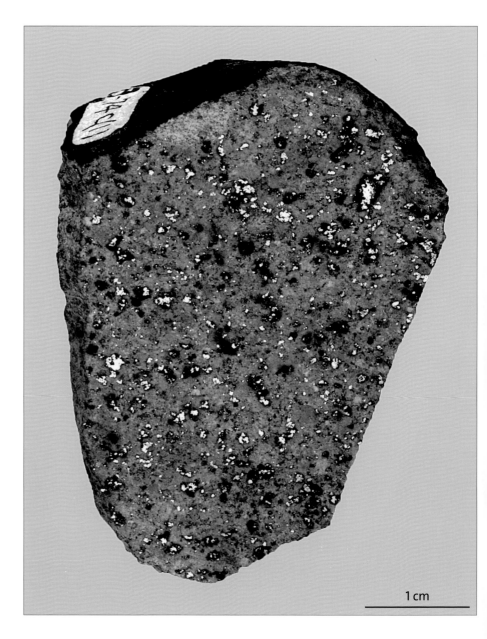

1 cm

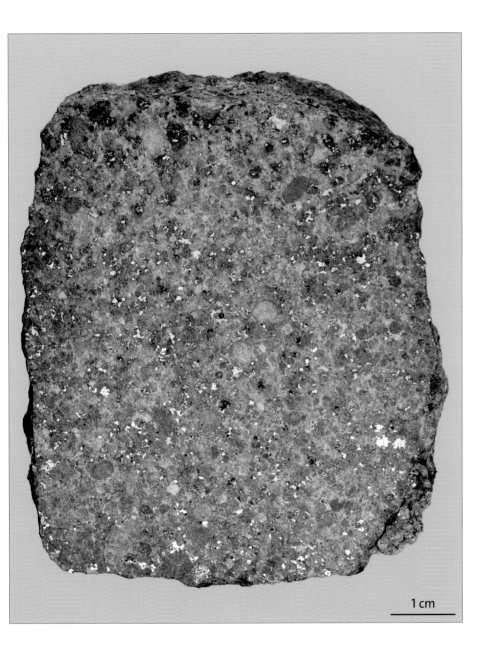

1 cm

LL-CHONDRITE haben den geringsten Metallgehalt (LL steht für „low iron, low metal", „niedriges Gesamteisen, niedriger Metallgehalt").

LL-Chondrit **Dhurmsala**. In der Schnittfläche ist im Vergleich zu den L-Chondriten nur ein geringer Gehalt an Nickeleisen erkennbar (weiß reflektierende Körner). Die braunen Stellen sind durch Rost verfärbte Eisensulfid- und Metallkörner (links).

The LL chondrite Dhurmsala. The cut surface exposes a few highly reflective whitish metal grains. The brownish spots are due to rusted metal and iron sulfide grains (left).

LL CHONDRITES have an even lower metal content than H and L chondrites (LL stands for "low iron, low metal").

STEINMETEORITEN
STONY METEORITES

Allegan. Gewöhnlicher Chondrit. Bruchstück mit teilweise vorhandener Schmelzkruste. Meteoriten leiten Hitze schlecht: Während der äußerste Millimeter beim Eintritt in die Atmosphäre aufschmilzt, bleibt das Innere kalt. Brüche, die beim Aufprall auf die Erdoberfläche entstehen, geben das Innere des Meteoriten frei.

Pultusk. Gewöhnlicher Chondrit, teilweise mit Schmelzkruste. Die braunen Rostspuren weisen auf einen hohen Eisengehalt hin. Chondrite sind Bruchstücke von Kleinplaneten. Sie entsprechen dem Material, aus dem unser Sonnensystem entstanden ist, und haben sich seit ihrer Entstehung nahezu nicht verändert.

Mocs. Gewöhnlicher Chondrit, mit schwarzer Schmelzkruste. Die Bruchfläche des Einzelstücks weist Rostspuren auf.

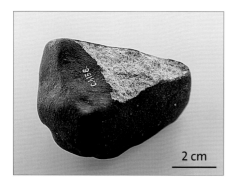

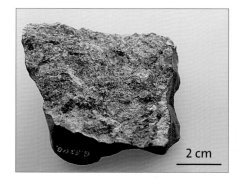

2 cm

Mocs. Ordinary chondrite, with black fusion crust. The broken surface shows some rust spots.

Allegan. Ordinary chondrite. Fragment with partial fusion crust. Meteorites are poor heat conductors. Even though their outermost layer, a millimeter or so thick, melts during passage through the atmosphere, the inside remains cold. The interior of meteorites is revealed when they break on impact with the Earth's surface.

Pultusk. Ordinary chondrite, with partial fusion crust. The brown rust spots indicate a high iron content. Chondrites are fragments of minor planets. They represent material that has remained virtually unchanged since the formation of the solar system.

Ragland. Gewöhnlicher Chondrit. Die Schnittfläche des Teilstücks weist zahlreiche Chondren auf. Diese aus Silikaten bestehenden, meist zwischen 0,2 mm bis einige mm großen Kügelchen sind charakterischer Bestandteil und Namensgeber der Chondrite.

Sahara 97210. Gewöhnlicher Chondrit. Platte mit vielen Chondren. Chondren entstanden durch Aufschmelzprozesse im frühen Sonnennebel und wurden danach zum Bestandteil der Mutterkörper der Chondrite.

Mezö-Madaras. Schnittplatte eines gewöhnlichen Chondriten mit zahlreichen millimetergroßen Chondren und Chondrenbruchstücken.

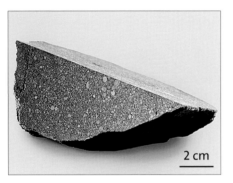

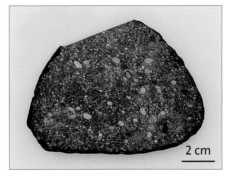

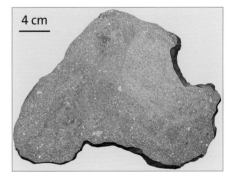

Ragland. Ordinary chondrite. The cut surface exposes many chondrules. Chondrules are spherical objects consisting of silicate minerals and are typically 0.2 to several mm in size. They gave chondrites their name and are a typical component of these meteorites.

Sahara 97210. Ordinary chondrite. Slice with abundant chondrules. Chondrules formed as molten or partially molten droplets in the early solar nebula before being incorporated into the chondrite parent bodies.

Mezö-Madaras. Cut surface of an ordinary chondrite with many millimeter-sized chondrules and chondrule fragments.

NWA 5731. Mikroskopische Aufnahme eines gewöhnlichen Chondriten. Die zahlreichen Chondren enthalten hauptsächlich Olivin und Pyroxen (Eisen-Magnesium-Silikate). Zusammen mit etwas Nickeleisen und Eisensulfid sind sie in eine feinkörnige Masse (Matrix) des gleichen Materials eingebettet. Die Matrix enthält zusätzlich noch leicht flüchtige Komponenten. Nickeleisen, Eisensulfid und Matrix erscheinen, da sie lichtundurchlässig sind, schwarz. Die bräunliche Verfärbung resultiert aus irdischer Verwitterung.

NWA 5731. Microphoto of an ordinary chondrite. The abundant chondrules consist mostly of the iron-magnesium silicates olivine and pyroxene. Together with minor amounts of nickel-iron metal and iron sulfide, they occur within a fine-grained matrix consisting of the same components. In addition, some volatile compounds are present in the matrix. Under plain-polarized light, metal, sulfide, and matrix appear black because they are opaque. The brownish color results from terrestrial weathering processes.

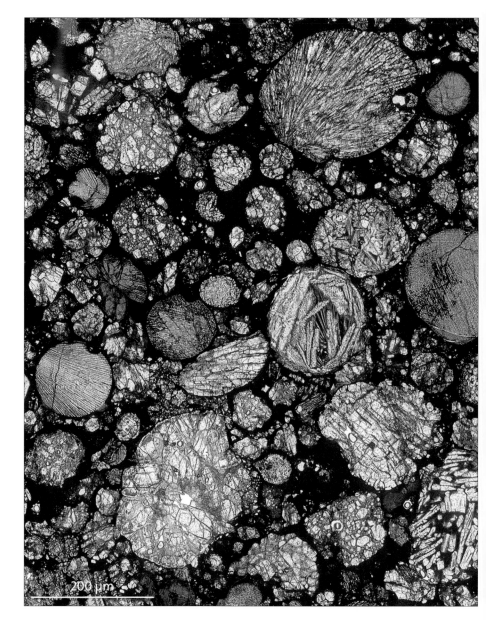

200 µm

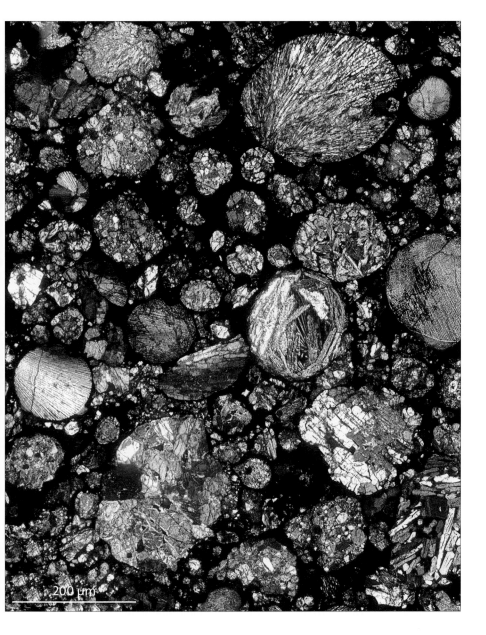

200 µm

NWA 5731. Die gleiche mikroskopische Aufnahme unter Verwendung von polarisiertem Licht präsentiert viele Minerale (z. B. Olivin und Pyroxen) in charakteristischen Farben, anhand derer sie einfacher zu identifizieren sind.

NWA 5731. Characteristic colors appear when the same area is viewed under cross-polarized light, which makes mineral identification easier.

Peekskill. Platte eines gewöhnlichen Chondriten mit ausgeprägter Schmelzkruste. Alle gewöhnlichen Chondrite sind „Brekzien", d. h. aus Gesteinsbruchstücken zusammengesetzte Gesteine – dies ist hier besonders deutlich zu erkennen (rechts).

Peekskill. Polished slice of an ordinary chondrite, rimmed with a distinct fusion crust. All ordinary chondrites are "breccias", i.e., they are composed of fragments of (different) rocks, as is clearly apparent in this sample (right).

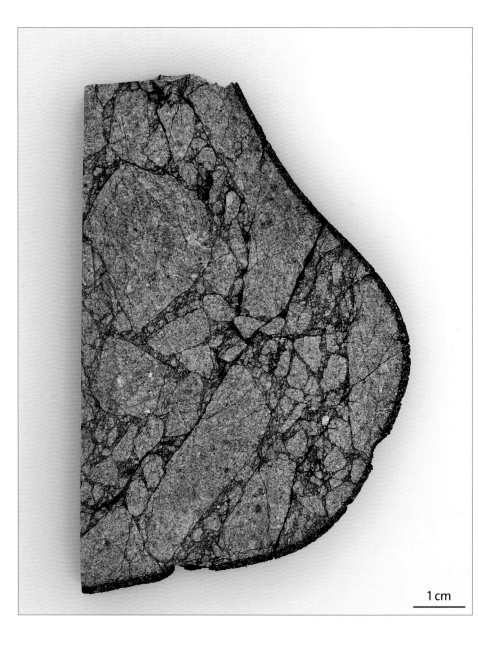

1 cm

Naryilco. Gewöhnlicher Chondrit. Der Schnitt durch diesen Chondriten zeugt von heftigen Kollisionen im frühen Sonnensystem. Dabei wurde das Ausgangsgestein (helle Partien) zertrümmert und durch pulverisiertes, stark erhitztes Material (dunkle Bereiche) zusammengeschweißt.

NWA 820. Platte eines gewöhnlichen Chondriten. Er besteht aus zentimetergroßen Fragmenten verschiedener chondritischer Gesteine – ist also eine Brekzie. Durch fein verteiltes Eisensulfid erscheinen manche Einschlüsse schwarz.

Portales Valley. Gewöhnlicher Chondrit. Die Platte besteht aus eckigen Gesteinsbruchstücken, verbunden durch einst geschmolzenes Nickeleisen.

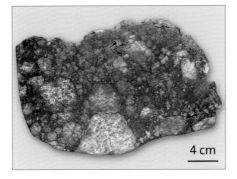

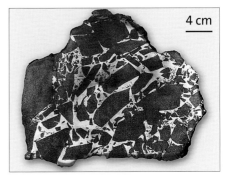

NWA 820. Polished plate of an ordinary chondrite. It is a breccia that is composed of many centimeter-sized chondritic rock fragments. Some inclusions appear dark because of finely dispersed iron sulfide inclusions.

Naryilco. Ordinary chondrite. The brecciation of these meteorites is the result of collision events in the early solar system. Light-colored rock fragments are cemented in a strongly heated dark matrix.

Portales Valley. Ordinary chondrite. This sample consists of angular rock fragments in a matrix of once-molten nickel-iron metal.

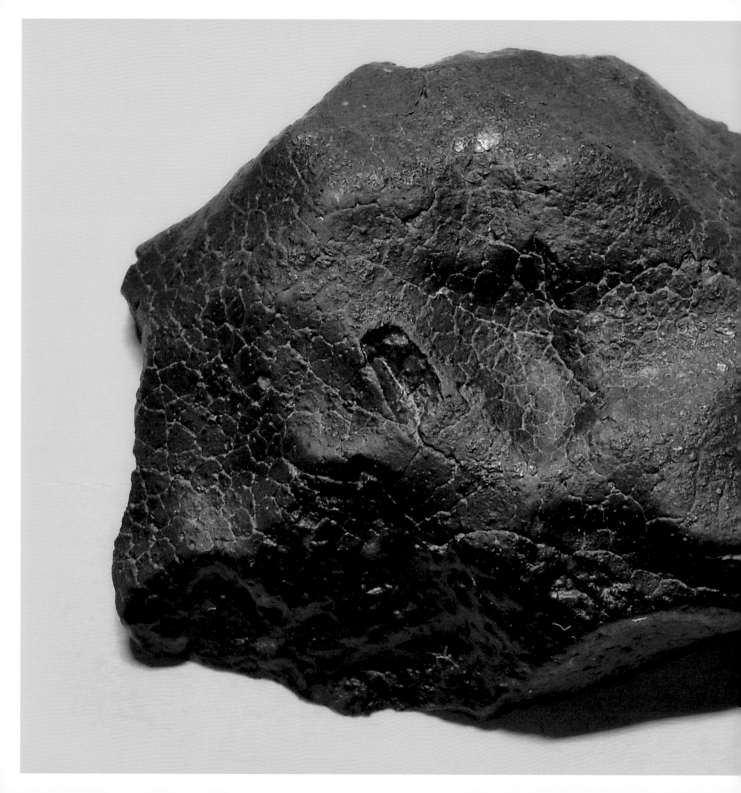

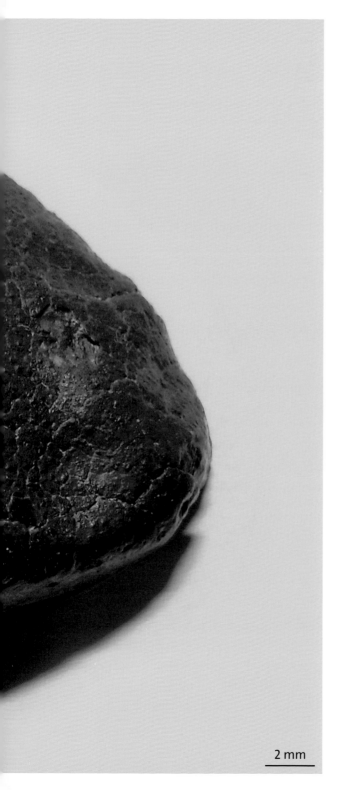

2 mm

DIE R-CHONDRITE – R steht für den Meteoriten Rumuruti – sind eine seltene Gruppe von Chondriten mit einem relativ hohen Gehalt an Gesamteisen (vergleichbar mit den H-Chondriten). Sie sind aber viel stärker oxidiert und enthalten kein Metall (Nickeleisen).

Der R-Chondrit **Rumuruti**. Bruchstück mit teilweise erhaltener Schmelzkruste (links).

*Fragment of the R chondrite **Rumuruti**, partially covered with a fusion crust (left).*

THE R CHONDRITES *(R stands for the meteorite Rumuruti) are a rare group of chondrites with a relatively high content of total iron (similar to the H chondrites). But they are much more oxidized and do not contain metal (nickel-iron).*

Die **EL-CHONDRITE** – L steht für „low iron" – haben einen geringeren Gehalt an Gesamteisen und auch weniger Metall als die EH-Chondrite.

Der EL-Chondrit **Hvittis**. In der silikatischen Grundmasse der polierten Platte sind zahlreiche Metallkörner – die hellen Pünktchen – erkennbar (rechts).

*The EL chondrite **Hvittis**. Abundant bright metal grains are set in a darker silicate matrix (right).*

EL CHONDRITES (L stands for "low iron") have a lower total iron and native metal content than the EH chondrites.

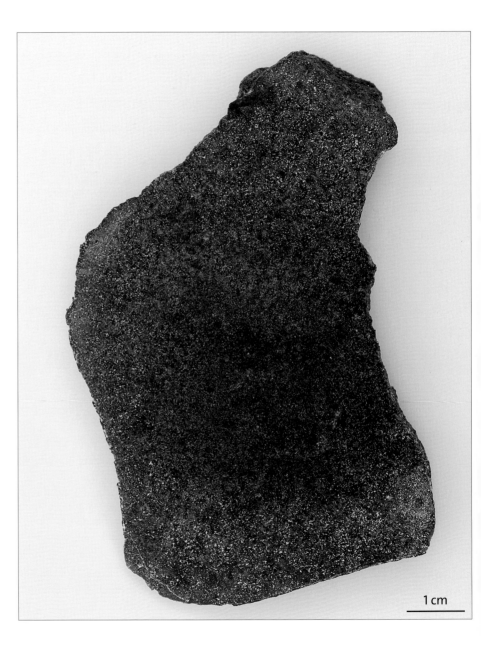

1 cm

DIE ENSTATIT-CHONDRITE (E-Chondrite) bestehen aus dem nahezu eisenfreien Magnesiumsilikat Enstatit, jedoch mit mehr Metall als die H-Chondrite. Zusätzlich enthalten sie seltene Minerale, die auf eine Entstehung unter speziellen, sauerstoffarmen Bedingungen hinweisen. Nach ihrem Gesamteisengehalt werden sie in zwei Gruppen (EH, EL) unterteilt.

ENSTATITE CHONDRITES (E chondrites) are predominantly composed of the almost iron-free silicate mineral enstatite, but contain more native metal than H chondrites. They also contain some rare minerals that point towards their origin under oxygen-poor conditions in the solar nebula. According to their total iron content, they are divided into two groups, EH and EL.

Pillistfer. Bruchstück eines Enstatit-Chondriten. Diese Gruppe der Chondrite enthält eine Reihe von seltenen Mineralen, die als Indiz dafür gelten, dass diese Meteoriten unter speziellen, sauerstoffarmen Bedingungen im frühen Sonnennebel gebildet wurden.

Indarch. Enstatit-Chondrit, Bruchstück. Dieser Chondrit war ein beobachteter Fall im Jahr 1891 und Gegenstand vieler wissenschaftlicher Arbeiten. Ein neues Mineral, Roedderite, wurde in diesem Meteoriten entdeckt.

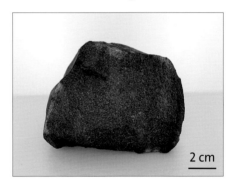

2 cm

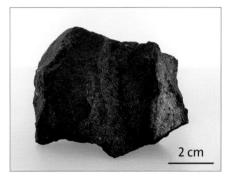

2 cm

Pillistfer. Fragment of an enstatite chondrite. This chondrite type contains some rare minerals that bear witness to their formation in specific, oxygen-poor regions of the solar nebula.

Indarch. Fragment of enstatite chondrite. This chondrite stems from a witnessed fall in 1891 that was the subject of many scientific studies; a new mineral, called Roedderite, was first described in this meteorite.

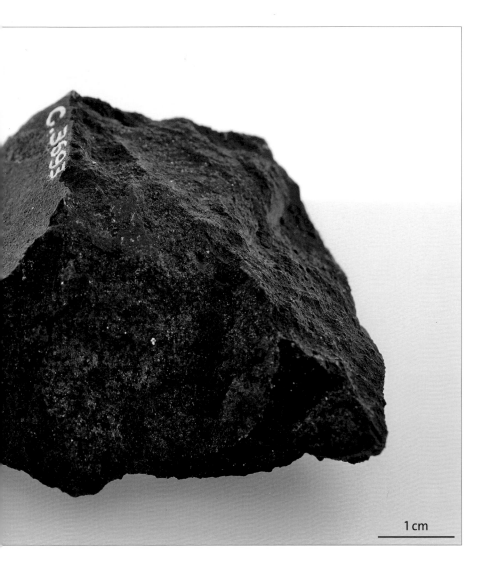

1 cm

EH-CHONDRITE – H steht für „high iron" – haben einen hohen Gehalt an Gesamteisen und auch einen hohen Metallgehalt.

Bruchstück des EH-Chondriten **Indarch** (links).

*Fragment of the EH chondrite **Indarch** (left).*

EH CHONDRITES (H stands for "high iron") have high total iron and native metal contents.

PRIMITIVE ACHONDRITE stammen von Kleinplaneten, die nur so weit erhitzt wurden, bis ein teilweises Schmelzen einsetzte. Dieser Vorgang reichte nicht aus, im Mutterkörper dieser Meteoriten einen Metallkern entstehen zu lassen. Sie werden in fünf Gruppen unterteilt.

ACAPULCOITE. Schnittplatte des Acapulcoiten Dhofar 125. Diese feinkörnigen silikatischen Meteoriten (Korngröße < 0,5 mm) sind nach dem Meteoriten Acapulco benannt und enthalten mehr Pyroxen als Olivin (rechts).

ACAPULCOITES. Cut plate of acapulcoite Dhofar 125. These fine-grained (grain size < 0.5 mm) silicate-rich meteorites are named after the meteorite Acapulco and contain more pyroxene than olivine (right).

PRIMITIVE ACHONDRITES come from a parent body that was only partially molten, so that no iron core could form. They are divided into five subgroups.

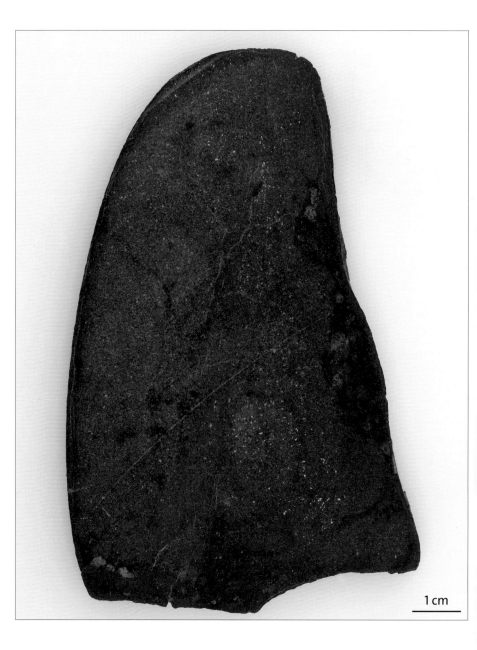

1 cm

LODRANITE. Bruchstück des Meteoriten **Lodran**, des Namensgebers der Lodranite. In der im Vergleich zu Acapulcoiten grobkörnigeren silikatischen Grundmasse dominiert das Mineral Olivin (grüne Körner).

WINONAITE. Oberflächlich stark verwittertes Fragment des Meteoriten **Winona**, des Namensgebers der Winonaite. Winonaite sind mineralogisch und chemisch den Chondriten ähnlich; sie zeigen auch eine Verwandtschaft zu bestimmten Silikateinschlüssen in Eisenmeteoriten.

UREILITE. Bruchstück mit Schnittfläche des Meteoriten **Novo-Urei**, des Namensgebers der Ureilite. Ureilite unterscheiden sich von allen anderen Achondriten durch ihren hohen Kohlenstoffgehalt und das Auftreten von Diamanten – in sehr geringer Menge und mikroskopisch klein. Aufgrund ihrer Zusammensetzung nimmt man an, dass sie aus kohligen Chondriten entstanden sind.

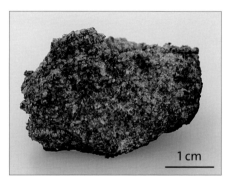

1 cm

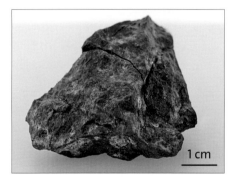

1 cm

1 cm

*LODRANITES. Fragment of the meteorite **Lodran**, the main representative of the lodranites. Compared to the acapulcoites, these meteorites are coarser grained and contain more olivine (green crystals).*

*WINONAITES. Fragment of the meteorite **Winona** (the main representative of the winonaites) with weathering traces on the surface. Winonaites show some chemical and mineralogical similarities to chondrites and to certain silicate inclusions in iron meteorites.*

*UREILITES. Fragment with cut surface of the meteorite **Novo-Urei**, after which the ureilites are named. In contrast to all other achondrites, ureilites have a high carbon content and even contain small amounts of microscopic diamonds. Their composition indicates that they may have originated from carbonaceous chondrites.*

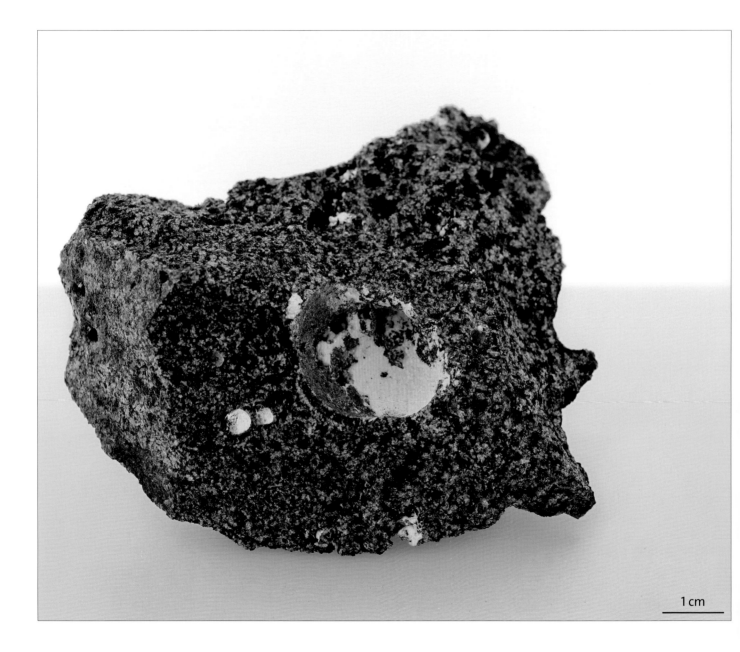

1 cm

ANGRITE (benannt nach dem Meteoriten Angra dos Reis) sind basaltische Gesteine, oftmals porös. Diese seltenen Achondrite weisen, bedingt durch den hohen Calcium-Gehalt, eine ungewöhnliche mineralische Zusammensetzung auf.

Bruchstück des Meteoriten D'Orbigny, der sich durch bis zu zentimetergroße Blasenhohlräume in der basaltischen Grundmasse auszeichnet (links).

Fragment of the meteorite D'Orbigny, which is characterized by centimeter-sized spherical voids within the basaltic matrix (left).

ANGRITES – named after the meteorite Angra dos Reis – are basaltic rocks, often having porosity. These rare achondrites show an unusual mineralogical composition, which is due to the high calcium content of this meteorite.

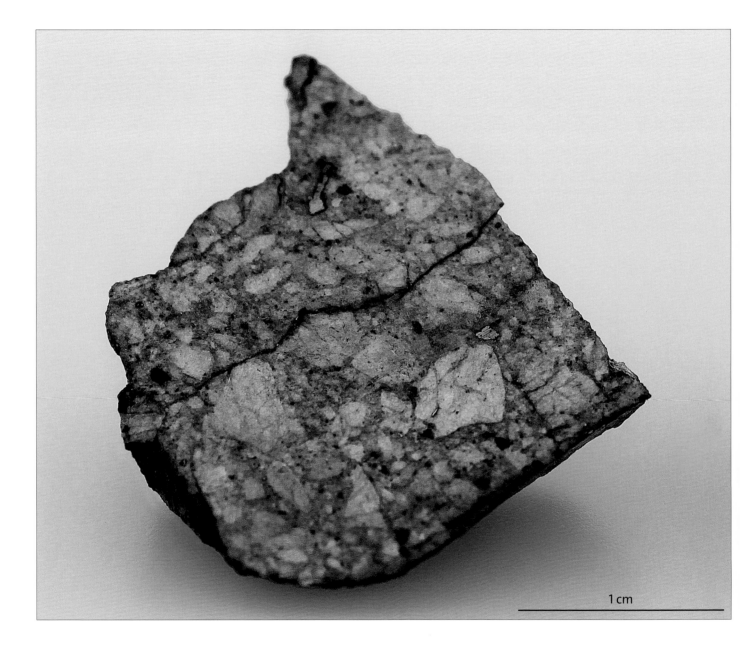

1 cm

AUBRITE werden oft auch als Enstatit-Achondrite bezeichnet. Man nimmt an, dass sie durch Schmelz- und Differenzierungsprozesse aus Enstatit-Chondriten entstanden sind.

Bruchstück des Meteoriten Aubres (Namensgeber der Aubrite) – einer Brekzie, die typischerweise fast nur aus dem Magnesiumsilikat Enstatit besteht (links).

Fragment of the meteorite Aubres (the main representative of the aubrites) – a breccia that consists almost exclusively of the magnesium silicate enstatite (left).

AUBRITES are often also called "enstatite achondrites". It is assumed that they formed from enstatite chondrites by melting and differentiation.

ZU DEN DIFFERENZIERTEN METEORITEN
zählen auch die Howardite, Eukrite und Diogenite – die bei weitem größte Gruppe der Achondrite. Es handelt sich dabei um meteoritische Basalte, (vulkanische Gesteine: die Eukrite), Kumulatgesteine (Gesteine, die durch Akkumulation von Kristallen am Boden einer Gesteinsschmelze entstehen: die Diogenite) und Brekzien (bestehend aus Fragmenten verschiedener Gesteine: die Howardite). Diese Meteoriten haben eine Zusammensetzung, die irdischen Basalten ähnlich ist. Man vermutet, dass sie vom 530 km großen Asteroiden Vesta stammen (links: ein Bild der Vesta, von der Dawn-Raumsonde im Jahr 2011 aufgenommen).

THE DIFFERENTIATED METEORITES also include the eucrites, diogenites, and howardites, which are by far the most common achondrites. These are, respectively, meteoritic basalts (volcanic rocks), cumulates (formed by the accumulation of crystals on the bottom of a melt phase), and breccias (formed from fragments of other rock types). They have a mineralogical composition similar to terrestrial basalts and are thought to come from the 530-km-diameter asteroid Vesta (here, left, an image of Vesta taken by the Dawn spacecraft, 2011).

STEINMETEORITEN
STONY METEORITES

EUKRITE (aus dem Griechischen für „gut unterscheidbar") sind basaltische Gesteine, die hauptsächlich aus den Mineralen Pyroxen und Feldspat bestehen.

Einzelstück des Meteoriten **Stannern**. Er ist mit einer für Eukrite typischen schwarz glänzenden Schmelzkruste überzogen (rechts).

Single stone of the meteorite Stannern. It is covered with a thin and shiny black fusion crust that is typical for eucrites (right).

EUCRITES (the name is derived from the Greek word for "easily distinguishable") are basalts that consist mainly of the minerals pyroxene and feldspar.

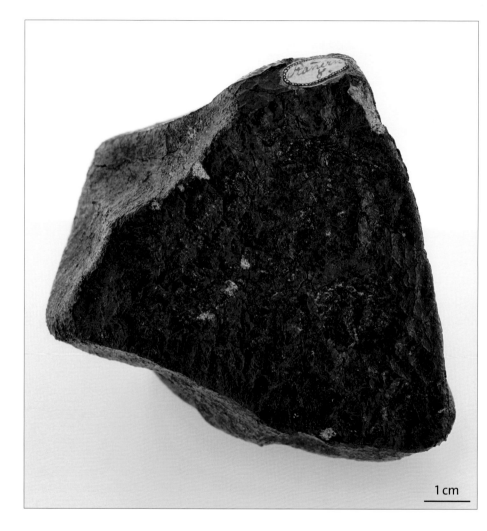

1 cm

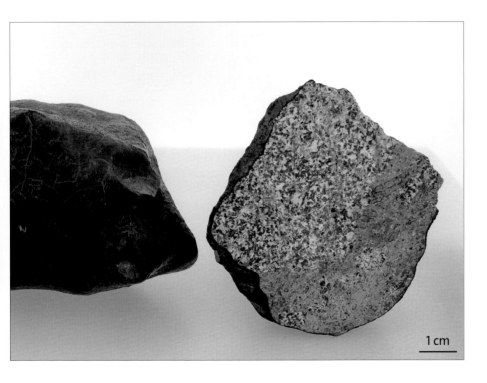

1 cm

Millbillillie. Komplettes Einzelstück und ein Bruchstück mit Schnittfläche. Im Anschnitt ist deutlich das magmatische Gefüge eines Eukriten erkennbar (mit hell weißlichem Plagioklas und dunklem Pyroxen) (links).

Millbillillie. Complete stone and fragment. The cut surface exposes the magmatic texture (composed of light plagioclase and dark pyroxene) that is typical of eucrites (left).

Stannern. Die mikroskopische Aufnahme des Eukriten Stannern zeigt das typische Gefüge magmatischer, d. h. aus einer Gesteinsschmelze entstandener Gesteine. Er besteht hauptsächlich aus den Mineralen Plagioklas (Calcium-Aluminium-Silikat) und Pyroxen (Calcium-Magnesium-Eisen-Silikat). Ersteres bildet helle, leistenförmige Kristalle, die von dunklem Pyroxen umschlossen sind. Dessen „wolkiges" Aussehen ist auf zahlreiche winzige Einschlüsse anderer Minerale zurückzuführen (rechts).

Stannern. This microphoto of the Stannern eucrite shows the characteristic texture of magmatic rocks – i.e., rocks that formed by melting. This meteorite is composed mainly of the minerals plagioclase (a calcium-aluminum silicate) and pyroxene (a calcium-magnesium-iron silicate). The former is present as bright, lath-shaped crystals, surrounded by pyroxene that is dark because it contains numerous tiny mineral inclusions (right).

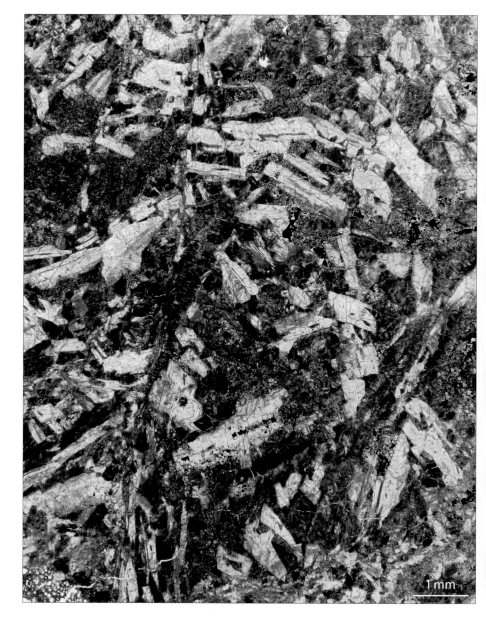

1 mm

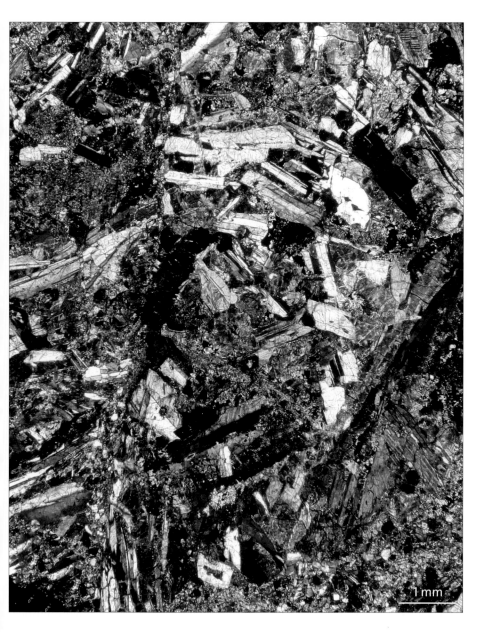

Stannern. Die gleiche mikroskopische Aufnahme von Stannern mit polarisiertem Licht zeigt die Minerale des Eukriten in charakteristischen Farben, mit deren Hilfe sie identifiziert werden können (links).

Stannern. Characteristic colors appear when the same area is viewed under cross-polarized light, which makes mineral identification easier (left).

DIOGENITE – benannt nach dem griechischen Naturphilosophen Diogenes von Apollonia – bestehen fast ausschließlich aus dem Mineral Pyroxen.

Fragment des Diogeniten **Shalka** mit teilweise noch vorhandener Schmelzkruste (rechts).

*Fragment of the diogenite **Shalka**, with partial fusion crust (right).*

DIOGENITES (which are named after the Greek natural philosopher Diogenes of Apollonia) consist almost exclusively of the mineral pyroxene.

1 cm

1 cm

Johnstown. Das gesamte Bruchstück besteht fast ausschließlich aus Pyroxen: große dunkelgrüne Kristalle in einer helleren Matrix des gleichen Minerals (links).

Johnstown. This fragment is almost completely made up of pyroxene: large dark green crystals in a fine-grained light-colored matrix of the same mineral (left).

STEINMETEORITEN
STONY METEORITES

HOWARDITE – benannt nach dem eng-
lischen Chemiker E. C. Howard – sind
Brekzien, bestehend aus Gesteins- und
Mineralfragmenten. Sie sind vermutlich
durch Einschläge an der Oberfläche ihres
Mutterkörpers entstanden.

Zmenj. Bruchstück mit Schmelzkruste.
In der relativ feinkörnigen Grundmas-
se treten Bruchstücke verschiedener
Eukrite, Diogenite und Gesteinsgläser
auf (rechts).

*Fragment of the howardite Zmenj, with
partial fusion crust. The fine-grained
matrix contains fragments of various
eucrites, diogenites, and impact melt
rocks (right).*

*HOWARDITES (which are named after
the British chemist E. C. Howard) are
breccias, consisting of rock and mineral
fragments. They are thought to have
formed by impacts on the surface of their
parent asteroid.*

1 cm

2 cm

DAG 779. Platte eines Howarditen. In einer vom Mineral Pyroxen dominierten hellen, relativ feinkörnigen Grundmasse sind die für diese Meteoritenklasse typischen Gesteinsbruchstücke zu sehen (links).

DAG 779. Cut surface of a howardite. The light-colored fine-grained matrix is dominated by the mineral pyroxene and contains some darker rock fragments, as is typical of this class of meteorite (left).

DIE SEHR SELTENEN MOND- UND MARSMETEORITEN zählen ebenfalls zu den Achondriten. Allerdings kommen sie nicht von den Asteroiden zur Erde, sondern vom Erdmond beziehungsweise vom Planeten Mars, von wo aus sie bei großen Einschlagsereignissen ausgeworfen wurden und später als Meteoriten auf die Erde gefallen sind. Die Interpretation der Abstammung von Mond und Mars basiert auf der deutlich unterschiedlichen Zusammensetzung im Vergleich zu anderen Meteoriten, dem jüngeren Entstehungsalter und der Ähnlichkeit mit Mond- und Marsgesteinen.

THE VERY RARE MARTIAN AND LUNAR METEORITES are also achondrites; however, they do not come from asteroids, but from Mars and the Moon. They have been ejected in large impact events and eventually fell on Earth as meteorites. These meteorites are thought to be from Mars and the Moon because they differ significantly from most other meteorites; they are much younger than the other meteorites and they have a chemical composition that is similar to that of the surface of Mars and the Moon.

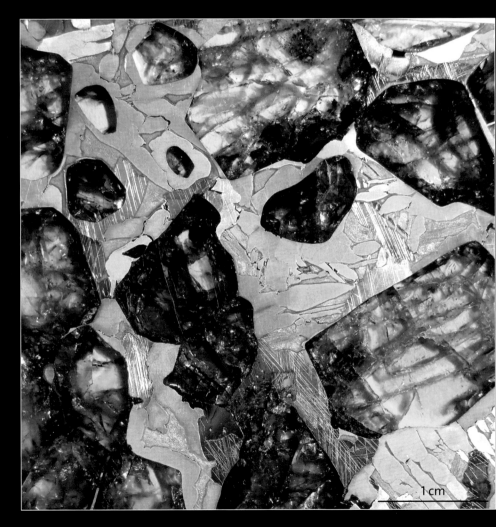

Fukang. Pallasit. Gelbe Olivinkristalle in einer Matrix aus Nickeleisen.
Fukang. Pallasite. Yellow olivine crystals occur in a matrix of nickel-iron metal.

Nur rund 1 % aller Meteoritenfälle sind Stein-Eisen-Meteoriten, die zu ungefähr gleichen Teilen aus Nickeleisen und Silikatmineralen bestehen. Viele stammen aus dem Grenzbereich zwischen Metallkern und Silikatmantel aufgeschmolzener Kleinplaneten. Die wichtigsten Gruppen sind die Pallasite und Mesosiderite.

Only about 1% of all meteorites are stony-iron meteorites. They are composed of about equal parts nickel-iron metal and silicate minerals. Many are derived from the intermediate zone between the metallic core and silicate mantle of a differentiated minor planet. The most important types are pallasites and mesosiderites.

1 cm

PALLASITE – benannt nach dem deutschen Naturgelehrten P. S. Pallas – bestehen aus zahlreichen zentimetergroßen Olivinkristallen (Magnesium-Eisen-Silikat), die in einer Metallmatrix aus Nickeleisen „schwimmen".

Polierte Platte des Pallasiten **Esquel**.

*Polished plate of the pallasite **Esquel**.*

PALLASITES *(named after the German naturalist P. S. Pallas) consist of numerous centimeter-sized olivine crystals (a magnesium-iron silicate) within a metallic nickel-iron matrix.*

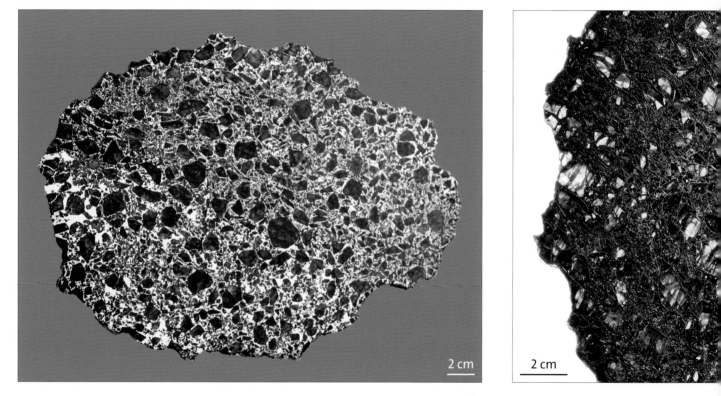

Eagle Station. In der Metallmatrix aus Nickeleisen „schwimmen" zahlreiche unregelmäßig geformte Olivinkristalle. Im Auflicht erscheinen das Metall weiß und die Olivine bräunlich.
Eagle Station. Many irregularly shaped olivine crystals "floating" in a nickel-iron metal matrix. In reflected light, the metal appears white and the olivine brownish.

Eagle Station. Im Durchlicht wird das Me tall dunkel, und die Olivine leuchten gelb
Eagle Station. In translucent light, th metal is dark and the olivines are yellow

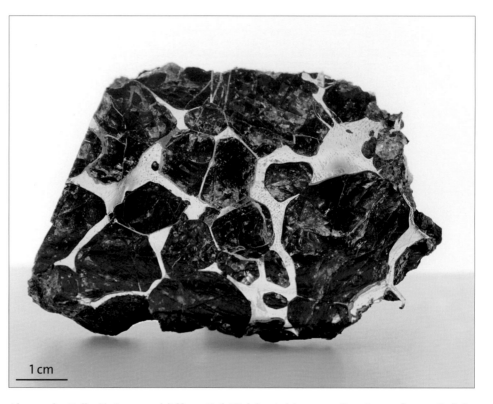

1 cm

Ahumada. Pallasit. Das geschliffene Teilstück besteht aus zentimetergroßen, grünlich-braunen Olivinkristallen in einer Metallmatrix aus Nickeleisen.
Ahumada. Pallasite. The cut and polished fragment consists of centimeter-sized, yellow-brownish olivine crystals in a nickel-iron metal matrix.

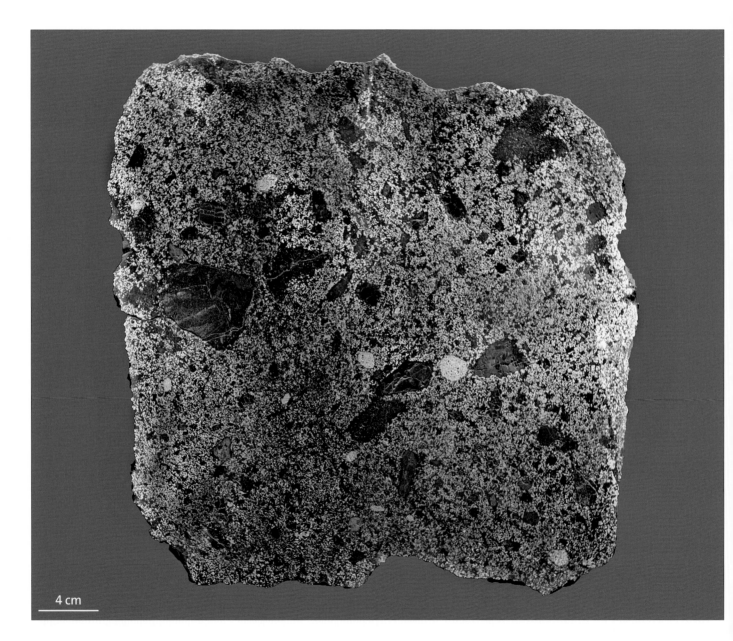

4 cm

MESOSIDERITE – aus dem Griechischen: mesos = halb, sideros = Eisen – bestehen wie die Pallasite hauptsächlich aus Silikaten und Metall, sind jedoch viel feiner und unregelmäßiger verwachsen.

Polierte Platte des Mesosideriten **Mincy** mit chaotischer Verwachsung von silikatischen Bruchstücken aus den Mineralen Olivin, Pyroxen und Feldspat (dunkel) sowie Nickeleisenmetall (hellgrau bis weiß) (links).

*Polished plate of the mesosiderite **Mincy**, showing a chaotic mixture of dark silicate fragments (comprising the minerals olivine, pyroxene, and feldspar) and light-colored nickel-iron metal (left).*

MESOSIDERITES (from the Greek: mesos = half, sideros = iron) consist, similar to pallasites, mainly of silicate minerals and metal, but both components are more fine-grained and densely intergrown.

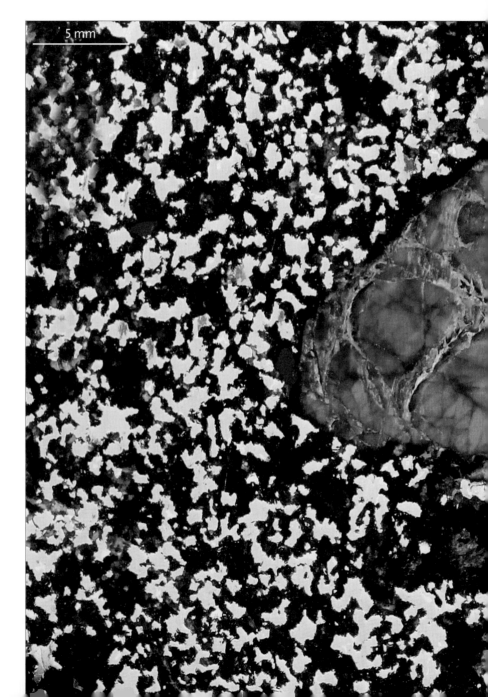

5 mm

Mincy. Dieser Anschliff zeigt irreguläre Verwachsungen zwischen Mineral- und Gesteinsfragmenten (hier ein grünliches zentimetergroßes Silikat-Fragment) und der für Mesosiderite typischen feinkörnigen Nickel-Eisen-Metallmatrix (hellgrau). Die Silikate bestehen hauptsächlich aus den Mineralen Olivin, Pyroxen und Feldspat (rechts).

Mincy. This section shows the irregular intergrowth of silicate mineral and rock fragments (here a centimeter-sized silicate fragment; greenish) and a fine-grained nickel-iron metal matrix (light gray) that is typical of mesosiderites. The silicates are made up predominantly of the minerals olivine, pyroxene, and feldspar (right).

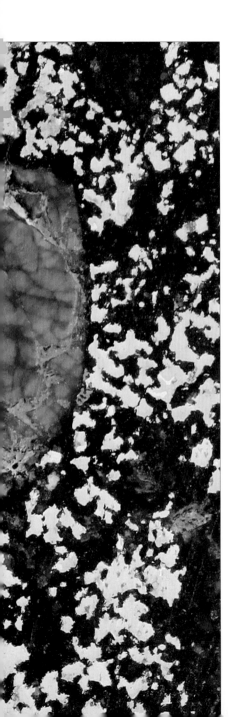

Dong Ujimqin Qi. In diesem Mesoside-
riten ist das Metall (hellgrau) teilweise
in Knollen konzentriert beziehungsweise
in der Grundmasse mit Silikaten (dun-
kelgrau) unregelmäßig verwachsen.

NWA 2924. Mesosiderit. Zentimeter-
große Metallknolle (silber bis weiß) in
feinkörniger Metall-Silikat-Matrix. Sili-
kate (dunkelbraun bis schwarz) bilden
auch in der Knolle kleine Einschlüsse.

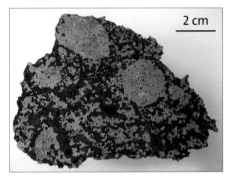

*Dong Ujimqin Qi. In this mesosiderite,
the metal (light gray) occurs partly in the
form of near-spherical accumulations,
and partly as irregular intergrowths with
the silicate minerals (dark gray).*

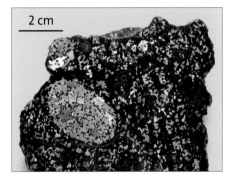

*NWA 2924. Mesosiderite. A centimeter-
sized metallic nodule (silver-white) is set in
a fine-grained metal-silicate matrix; small
silicate inclusions (dark brown to black)
also occur within the nodule.*

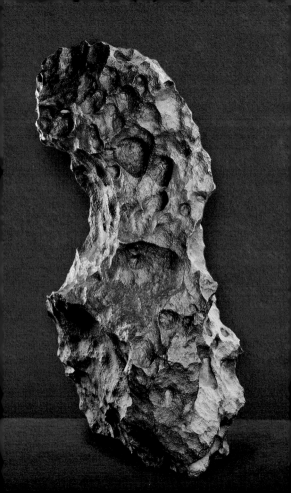

Etwa 4,5 % aller Meteoritenfälle sind Eisenmeteoriten; das sind zumeist Fragmente aus dem Metallkern aufgeschmolzener Kleinplaneten. Eisenmeteoriten bestehen zu mehr als 90 % aus Nickeleisen. Der Rest sind Einschlüsse aus dem Eisensulfidmineral Troilit, dem Eisen-Nickel-Phosphid Schreibersit, aus Graphit sowie verschiedenen Silikaten. Sie werden in 14 chemische Gruppen unterteilt. Die Kriterien dafür sind hauptsächlich die Gehalte der chemischen Elemente Nickel, Gallium, Germanium und Iridium. Mehr als 10 % aller Eisenmeteoriten gelten als „ungruppiert".

About 4.5% of all meteorite falls are iron meteorites, which are mostly fragments of the metallic core of a differentiated minor planet. Iron meteorites consist of more than 90% nickel-iron metal. The rest is made up of inclusions of the iron sulfide troilite, the iron-nickel phosphide schreibersite, graphite, and various silicates. They are divided into 14 chemical groups, based mainly on the contents of the elements nickel, gallium, germanium, and iridium. About one tenth of all iron meteorites are ungrouped.

Der Youndegin-Eisenmeteorit. Mit 110 x 65 cm und 909 kg das größte Objekt der Wiener Meteoritensammlung.
The Youndegin iron meteorite – 110 x 65 cm and 909 kg – the largest specimen of the Vienna meteorite collection.

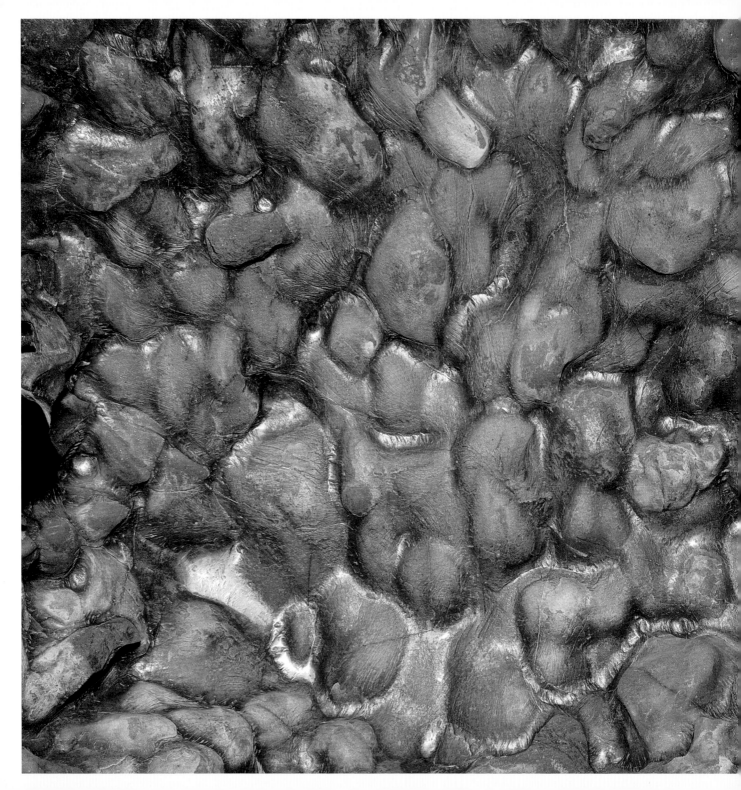

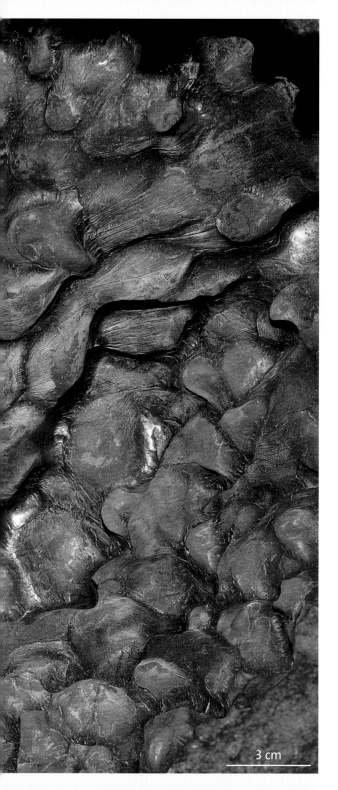

3 cm

DIE „KLASSISCHE" EINTEILUNG der Eisenmeteoriten in die Strukturklassen Oktaedrite, Ataxite und Hexaedrite basiert auf ihrer makroskopischen Struktur. Diese ist abhängig vom Nickelgesamtgehalt und erscheint nach Säureätzung bei den meisten Eisenmeteoriten in Form charakteristischer Lamellen, den „Widmanstättenschen Figuren".

Cabin Creek. Detail der Schmelzspuren an der Oberfläche dieses Eisenmeteoriten.

Cabin Creek. Close-up of the surface of this iron meteorite, shaped by melting processes during the fall.

THE "CLASSICAL SUBDIVISION" of iron meteorites into octahedrites, ataxites, and hexahedrites is based on their macroscopic structure, which depends on the nickel content. After etching with acid, most iron meteorites display characteristic lamellae, the "Widmanstätten patterns".

EISENMETEORITEN
IRON METEORITES

POLIERTES PLÄTTCHEN aus meteoritischem Nickeleisen. Die rechte untere Hälfte wurde poliert und mit Säure geätzt, um die „Widmanstättenschen Figuren" sichtbar zu machen. Diese Figuren sind das Resultat von Entmischungsvorgängen zwischen nickelarmem Kamazit und nickelreichem Taenit in langsam abkühlenden metallischen Kernen von Asteroiden. Kamazit bildet hier dünne helle Lamellen, die von dunklem Taenit umgeben sind und sich in einer hellgrauen Plessitmatrix befinden. Die „Widmanstättenschen Figuren" entstehen nur bei Nickelgehalten zwischen 6 und 20 Gewichtsprozent; je höher der Nickelgehalt, desto dünner sind die Lamellen (rechts).

"WIDMANSTÄTTEN PATTERNS" on a polished platelet of meteoritic nickel-iron metal. The lower half of this platelet has been polished and acid etched to reveal the "Widmanstätten patterns". These patterns form during exsolution processes in slowly cooling metallic cores of asteroids, resulting in nickel-poor kamacite and nickel-rich taenite. Kamacite forms here thin white lamellae that are surrounded by black taenite, in a matrix of light-gray plessite. "Widmanstätten patterns" only form for nickel contents between 6 and 20 wt%; the higher the nickel content, the thinner the lamellae (right).

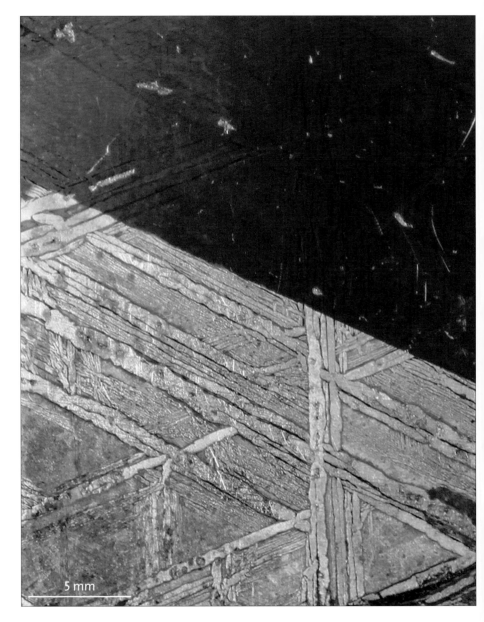

5 mm

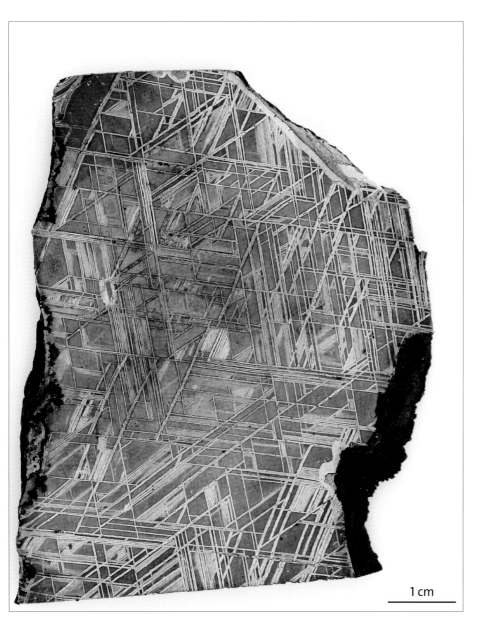

1 cm

OKTAEDRITE sind Eisenmeteoriten, in denen sich der nickelarme Kamazit in einer nickelreichen Taenit-Matrix parallel zu den Flächen eines Oktaeders abscheidet.

Carlton. „Widmanstättensche Figuren" an der Oberfläche dieses Oktaedriten wurden durch Säureätzung sichtbar gemacht (links).

Carlton. Etched surface of an octahedrite, showing Widmanstätten patterns (left).

OCTAHEDRITES are iron meteorites in which the iron-poor kamacite grows along octahedral surfaces within a nickel-rich taenite matrix.

EISENMETEORITEN
IRON METEORITES

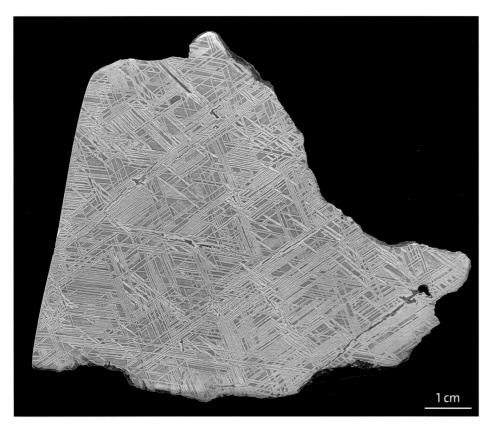

1 cm

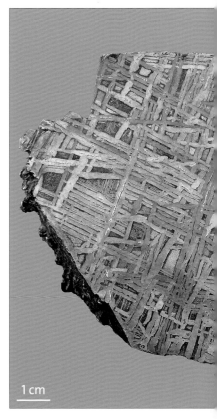

1 cm

Feiner Oktaedrit Lamesa
Fine octahedrite Lamesa

Mittlerer Oktaedrit Lenarto
Medium octahedrite Lenarto

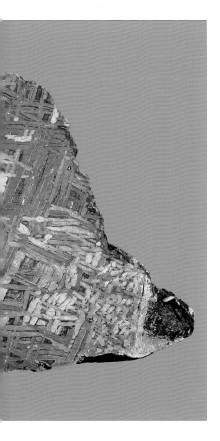

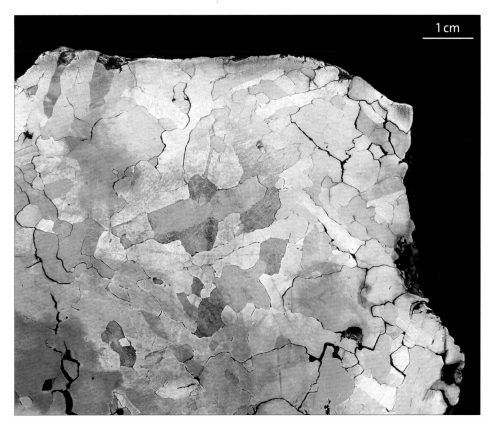

1 cm

Grober Oktaedrit Campo del Cielo
Coarse octahedrite Campo del Cielo

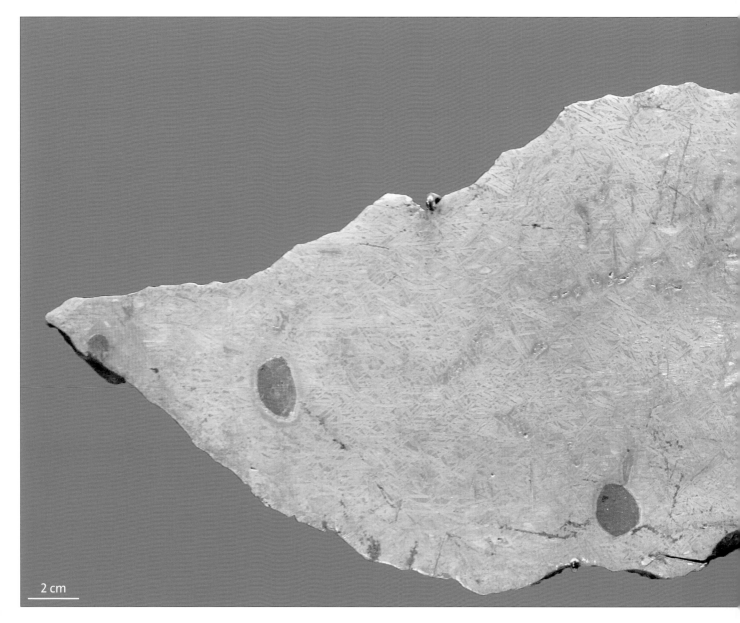

2 cm

Mount Edith. Polierte Schnittfläche eines Oktaedriten mit zentimetergroßen Troilitknollen.
Mount Edith. Cut and polished surface of an octahedrite with centimeter-sized troilite nodules.

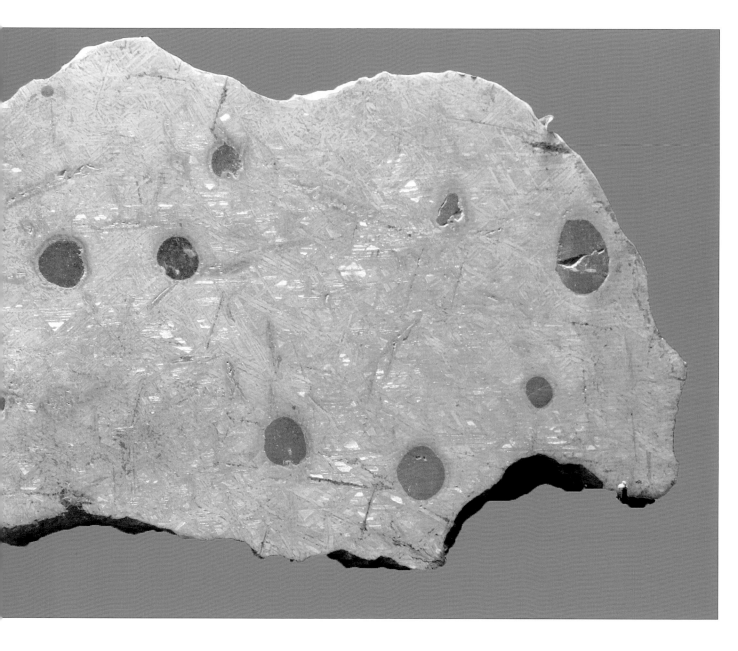

EISENMETEORITEN
IRON METEORITES

Mundrabilla. Oktaedrit. Dieser Meteorit weist eine für Eisenmeteoriten ungewöhnliche Verwachsung von Metall (weiß) und Troilit (dunkel) auf (rechts).

Mundrabilla. Octahedrite. This meteorite is characterized by an intergrowth of metal (white) and troilite (dark), which is unusual for iron meteorites (right).

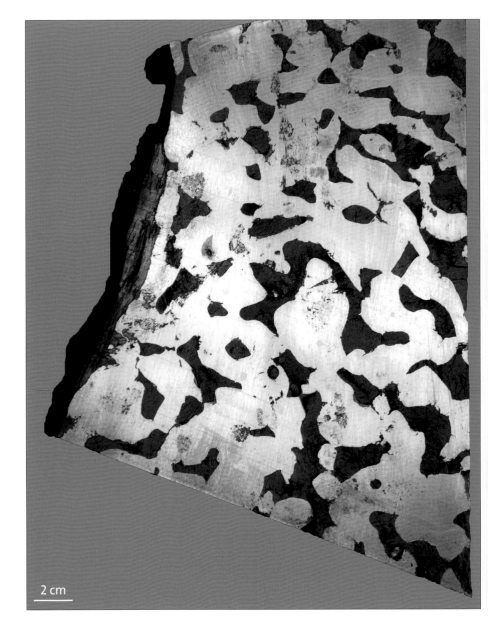

2 cm

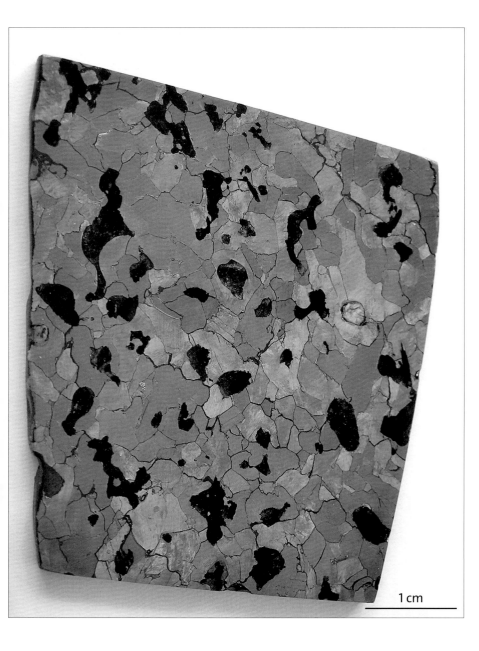

1 cm

Miles. Oktaedrit. Dieser Meteorit enthält zahlreiche dunkelbraune Einschlüsse, die aus den Silikatmineralen Pyroxen und Feldspat bestehen. Auch Silikatglas tritt darin auf (links).

Miles. Octahedrite. This meteorite contains numerous dark brown inclusions that consist of the silicate minerals pyroxene and feldspar, with some silicate glass (left).

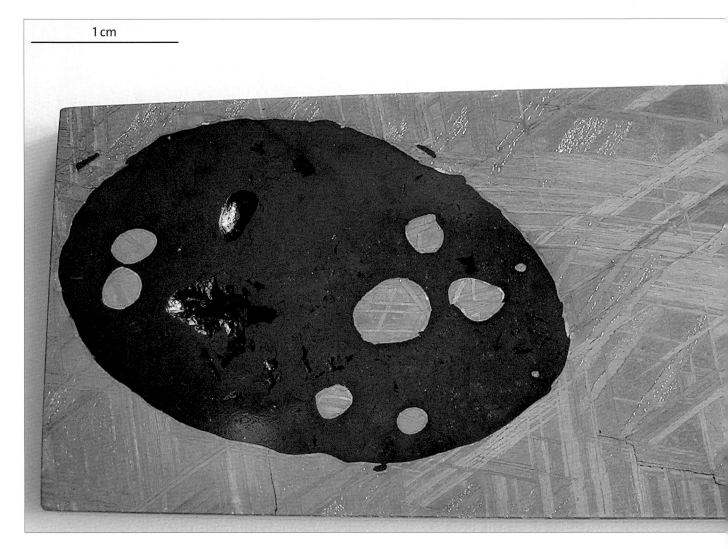

1 cm

Muonionalusta. Geätzte und polierte Schnittfläche eines Oktaedriten mit großem Troiliteinschluss.
Muonionalusta. Etched and polished surface of an octahedrite with a large troilite inclusion.

Nantan. Geätzte und polierte Schnitt-
fläche eines Oktaedriten. Die großen
Troiliteinschlüsse weisen einen Saum
aus Schreibersit auf. Dieses Mineral ist
nach Carl von Schreibers (1775–1852),
dem Begründer der Meteoritenkunde
in Wien, benannt.

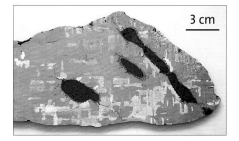

*Nantan. Etched and polished cut surface
of an octahedrite. The large troilite inclu-
sions have a rim of schreibersite. This
mineral is named after Carl von Schreib-
ers (1775-1852), the founder of meteorite
research in Vienna.*

Canyon Diablo. Geätzte und polierte
Oberfläche eines Oktaedriten. In der
Metallmasse befinden sich mehrere
zentimetergroße Troiliteinschlüsse und
eine große Knolle, die reich an Graphit
ist (links im Bild).

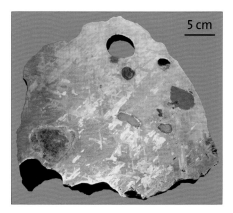

*Canyon Diablo. Etched and polished
surface of an octahedrite. This meteorite
contains several centimeter-sized troilite
inclusions, as well as (on the left side) a
large graphite-bearing nodule.*

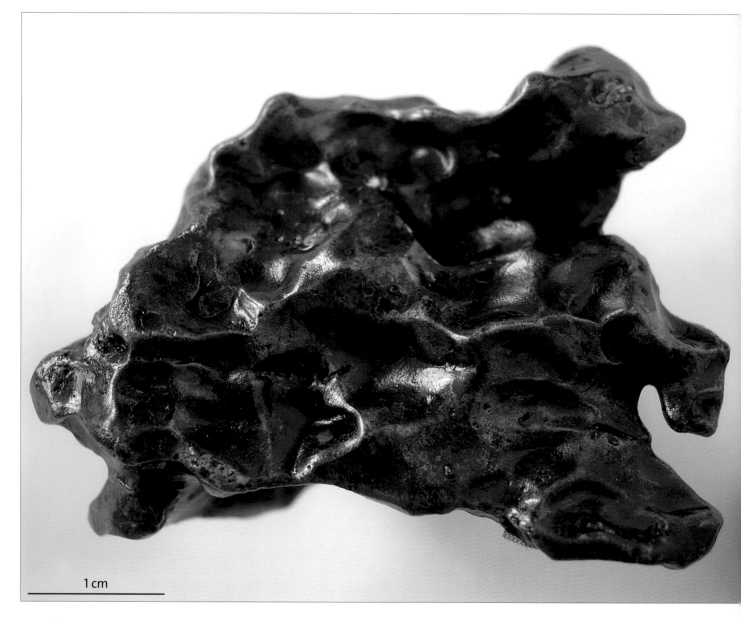

1 cm

Sikhote-Alin. Oktaedrit.
Sikhote-Alin. Octahedrite.

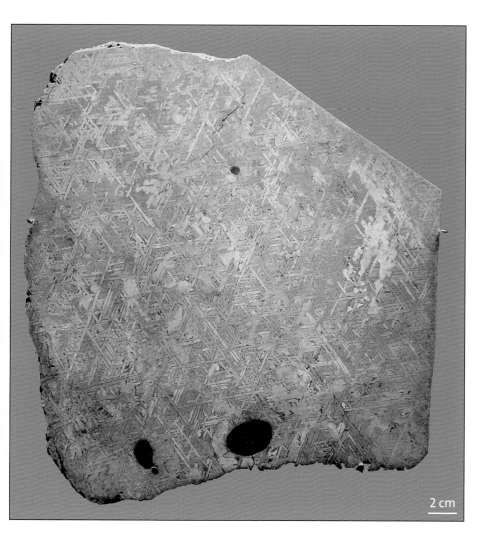

Paneth's Iron. Oktaedrit mit Troilitknollen (unten). Das Ätzgefüge der Schnittfläche zeigt, dass die Orientierung der Kamazitlamellen über dezimetergroße Bereiche unverändert bleibt (links).

Paneth's Iron. Octahedrite with troilite nodules (at the bottom). The etch pattern on the cut surface shows that the orientation of the kamacite lamellae remains unchanged over decimeters (left).

2 cm

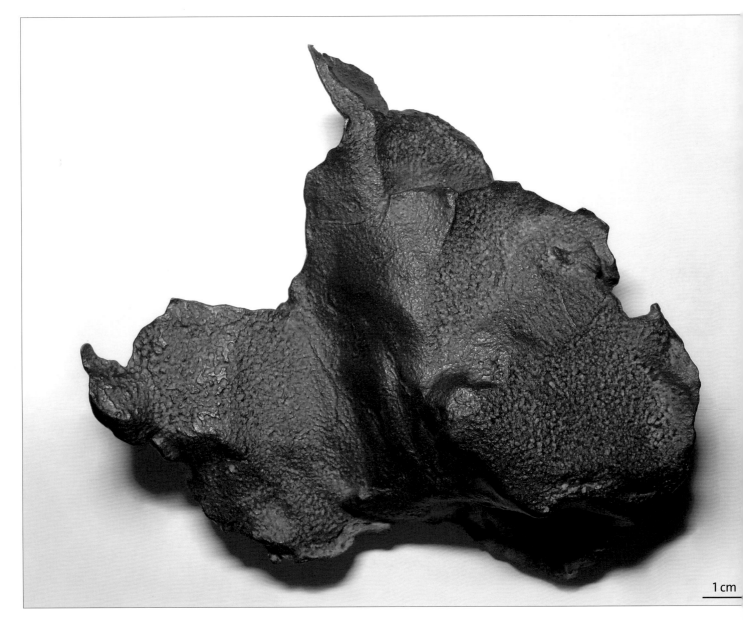

1 cm

Gebel Kamil. Ataxit.
Gebel Kamil. Ataxite.

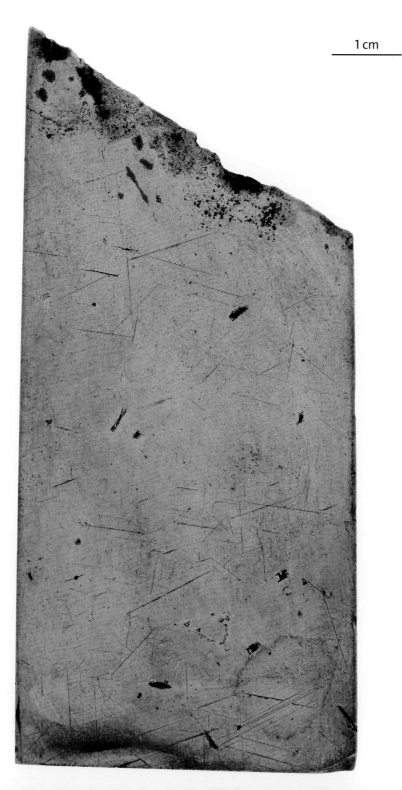

1 cm

ATAXITE. In Eisenmeteoriten mit Nickelgehalt von über 20 % ist keine Lamellenstruktur mehr erkennbar: Sie werden als Ataxite (griechisch = ohne Struktur) bezeichnet.

Lime Creek. Die geätzte Schnittfläche zeigt keine makroskopische Struktur. Manche der feinen nadelförmigen Einschlüsse enthalten das Mineral Schreibersit (links).

Lime Creek. No macroscopic structure is visible on the etched surface. The mineral schreibersite is present in some of the thin, needle-shaped inclusions (left).

ATAXITES. Iron meteorites with more than 20 wt% nickel do not show any lamellar structure and are called ataxites (from the Greek: without structure).

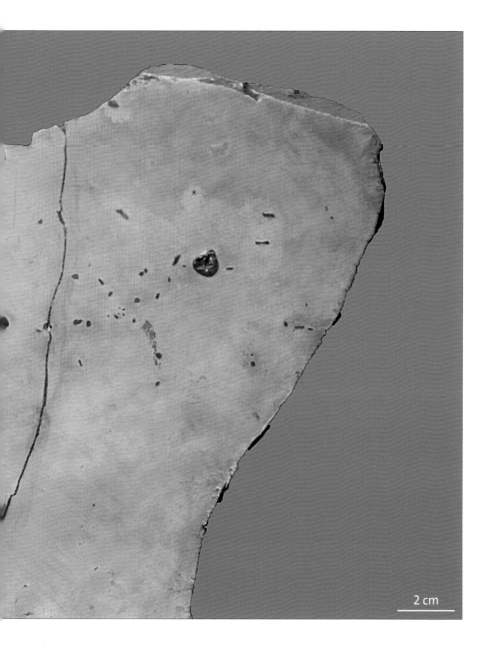

2 cm

HEXAEDRITE. Bei Hexaedriten liegt der Nickelgehalt unter 6 %; es kommt zu keiner Entmischung der Bestandteile während der Entstehung. Sie heißen so, da sie parallel zu den Flächen eines Würfels (Hexaeder) gut spaltbar sind.

Coahuila. Mit Säure geätzte Platte. Die Oberfläche zeigt keine makroskopische Struktur. Die kleinen runden Einschlüsse bestehen aus Troilit.

Coahuila. Acid-etched plate. No macroscopic structure is visible on the etched surface. The small roundish inclusions are troilite.

HEXAHEDRITES. No exsolution pattern forms in iron meteorites with a nickel content of less than 6 wt%; they are called hexahedrites because they show cleavage along the surfaces of a cube (hexahedron).

EISENMETEORITEN
IRON METEORITES

Avce. Hexaedrit, geätztes Plättchen. Die mikroskopische Aufnahme zeigt ein typisches Merkmal der Hexaedrite: die „Neumannschen Linien". Das sind Querschnitte durch sehr dünne Platten, die „Zwillingslamellen". Sie entstehen durch mechanische Beanspruchung, zum Beispiel bei Kollisionen der Meteoritenmutterkörper.

Avce. Hexahedrite; etched platelet. The microphoto shows a typical feature of hexahedrites, the so-called "Neumann bands". These very narrow parallel bands, so-called "twin lamellae", form as a result of shock during collisions between the asteroid parent bodies.

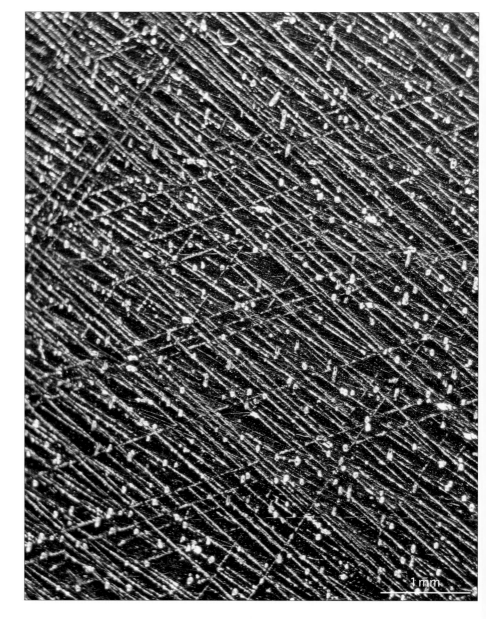

1 mm

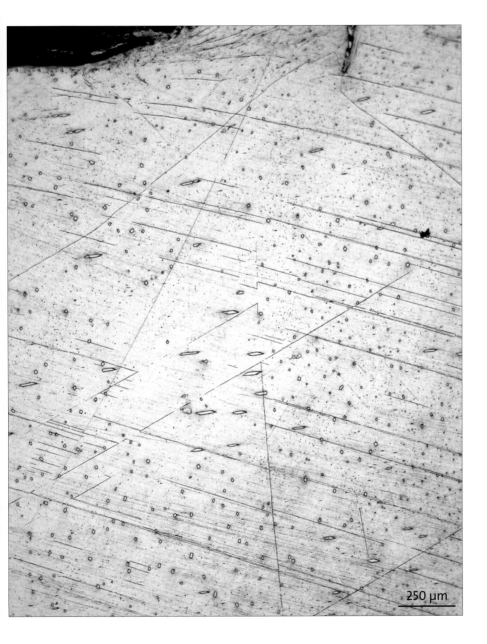

Hexaedrit (Fund, Madagaskar). Die geätzte Platte zeigt in der mikroskopischen Aufnahme die „Neumannschen Linien" und winzige Einschlüsse von Schreibersit.

Hexahedrite (find, Madagascar). The microphoto of the etched surface shows "Neumann bands", as well as tiny schreibersite inclusions.

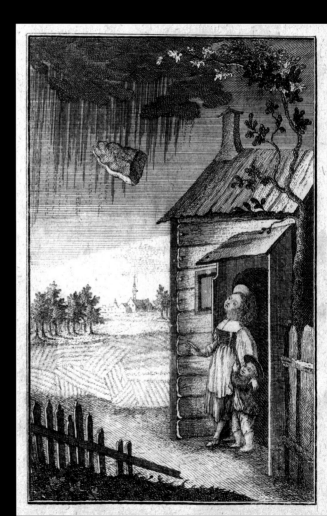

Insgesamt sind bisher sieben Meteoriten bekannt, die nach Orten des österreichischen Staatsgebietes benannt sind. Sie umfassen vier beobachtete Fälle und drei Funde, die zwischen 1768 und 2008 als Meteoriten erkannt wurden. Alle wurden als „gewöhnliche Chondrite" (häufigster Typ der Steinmeteoriten) klassifiziert. Die Gesamtmasse der österreichischen Meteoriten beträgt knapp 45 kg; davon sind rund 20 kg in der Sammlung des Naturhistorischen Museums Wien.

So far, seven meteorites have been found that are named after locations on the territory of Austria. They comprise four observed falls and three finds, which were recognized as meteorites between 1768 and 2008. They are all stony meteorites and are all classified as ordinary chondrites. The total mass of these Austrian meteorites is almost 45 kg, with 20 kg in the collection of the Natural History Museum Vienna.

Zeitgenössische Darstellung des Meteoritenfalls von Mauerkirchen aus einer Abhandlung von 1769.
Contemporary drawing of the Mauerkirchen meteorite fall as published in 1769.

ÖSTERREICHISCHE METEORITEN
AUSTRIAN METEORITES

❶ Ischgl
❷ Mühlau
❸ Mauerkirchen
❹ Prambachkirchen
❺ Ybbsitz
❻ Lanzenkirchen
❼ Minnichhof

Tschechien
Czech Republic

Slowakei
Slovakia

Deutschland
Germany

Niederösterreich
Lower Austria

Wien
Vienna

Oberösterreich
Upper Austria

• Linz

• St. Pölten

• Eisenstadt

• Salzburg

Bregenz

Vorarlberg

Tirol
Tyrol

• Innsbruck

Salzburg

Steiermark
Styria

Burgen-
land

Ungarn
Hungary

Italien
Italy

Kärnten
Carinthia

• Graz

• Klagenfurt

Slowenien
Slovenia

1 cm

Ischgl, Tirol.
Gewöhnlicher Chondrit LL6.
Gefunden 1976 bei einer Bergstraße;
erst 2008 als Meteorit erkannt.
Gesamtmasse: ~1 kg [NHM: 0,7 kg]

Ischgl, Tyrol.
Ordinary chondrite LL6.
Found in 1976 beside a mountain road;
only recognized as a meteorite in 2008.
Total mass: ~1 kg [NHM: 0.7 kg]

Mühlau, Tirol.
Gewöhnlicher Chondrit.
Im Jahr 1877 wurde zwischen der Wei-
herburg und Mühlau (heute zur Stadt
Innsbruck gehörend) ein kleiner Stein
gefunden.
Gesamtmasse: ~5 g [NHM: 4 g]

Mühlau, Tyrol.
Ordinary chondrite.
In 1877, a small stone was found between
Weiherburg and Mühlau (today part of
Innsbruck).
Total mass: ~5 g [NHM: 4 g]

1 cm

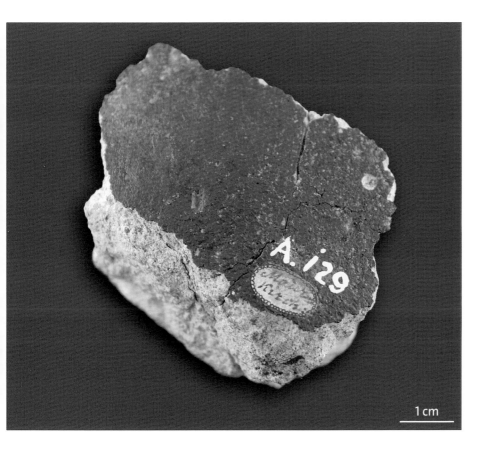

1 cm

Mauerkirchen, Oberösterreich.
Gewöhnlicher Chondrit L6.
Nach Detonationen fiel am 20. November 1768 um 16 Uhr ein großer Stein.
Gesamtmasse: ~19 kg [NHM: 636 g]

Mauerkirchen, Upper Austria.
Ordinary chondrite L6.
Detonations accompanied the fall of a large stone on 20 November 1768 at 16:00 hrs.
Total mass: ~19 kg [NHM: 636 g]

Prambachkirchen, Oberösterreich.
Gewöhnlicher Chondrit L6.
Am 5. November 1932 fiel um 21:55 Uhr
ein handgroßer Stein.
Gesamtmasse: 2,13 kg [NHM: 7 g]

Prambachkirchen, Upper Austria.
Ordinary chondrite L6.
A fist-sized stone fell on 5 November 1932
at 21:55 hrs.
Total mass: 2.13 kg [NHM: 7 g]

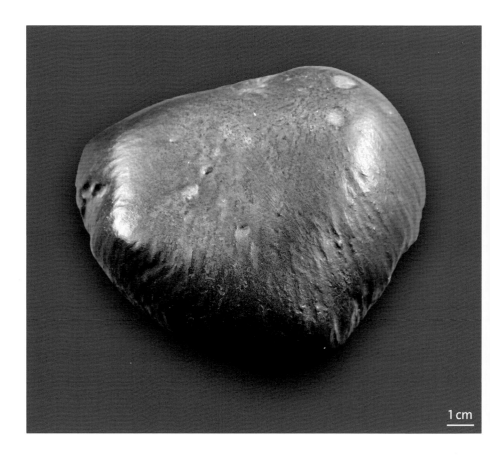

1 cm

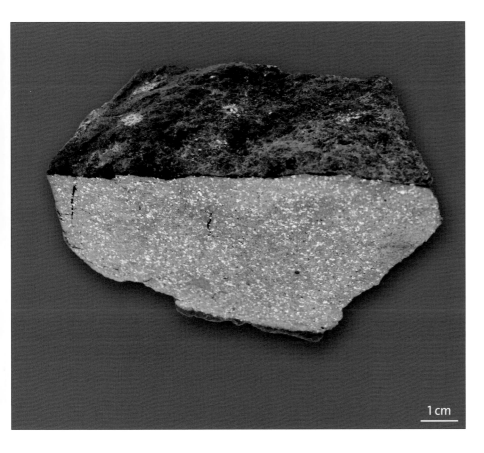

1 cm

Ybbsitz, Niederösterreich.
Gewöhnlicher Chondrit H4.
Gefunden 1977 von einem Geologen
auf einem steilen Berghang; erst 1979
als Meteorit erkannt.
Gesamtmasse: ~15 kg [NHM: 12,5 kg]

Ybbsitz, Lower Austria.
Ordinary chondrite H4.
Found in 1977 by a geologist during field
work on a steep mountain slope and
recognized as a meteorite in 1979.
Total mass: ~15 kg [NHM: 12.5 kg]

ÖSTERREICHISCHE METEORITEN
AUSTRIAN METEORITES

Lanzenkirchen, Niederösterreich.
Gewöhnlicher Chondrit L4.
Am 28. August 1925 um 19:25 Uhr nach
einer Feuerballerscheinung gefallen
(5 kg); ein zweiter Stein (2 kg) wurde am
7. Oktober 1925 rund 2,5 km nordöstlich
des ersten Stücks gefunden.
Gesamtmasse: ~7 kg [NHM: 6 kg]

Lanzenkirchen, Lower Austria.
Ordinary chondrite L4.
Fell at 19:25 hrs on 28 August 1925, fol-
lowing observation of a fireball; one
stone (5 kg) was found the next day;
another stone (2 kg) was recovered on 7
October 1925, about 2.5 km to the NE of
the first piece.
Total mass: ~7 kg [NHM: 6 kg]

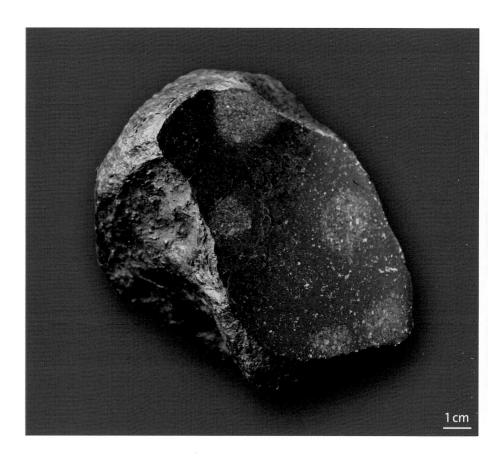

1 cm

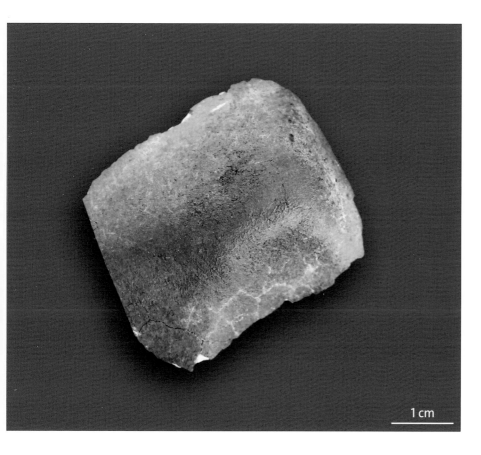

1 cm

Minnichhof, Burgenland.
Gewöhnlicher Chondrit.
Am 27. Mai 1905 fiel um 10:45 Uhr ein
Stein bei der Ortschaft Kroatisch Minihof.
Gesamtmasse: ~550 g [NHM: 43 g]

Minnichhof, Burgenland.
Ordinary chondrite.
At 10:45 hrs on 27 May 1905, a stone fell
near the village of Kroatisch Minihof.
Total mass: ~550 g [NHM: 43 g]

FOSSILE METEORITEN
FOSSIL METEORITES

Fossiler Meteorit im Thorsberg-Steinbruch, Schweden.
Fossil meteorite in the Thorsberg quarry, Sweden.

Unter normalen Umweltbedingungen verwittern oder verrosten Meteoriten relativ rasch; bei tropischer oder gemäßigter Witterung bleiben kleinere Steinmeteoriten nur wenige hundert Jahre erhalten, Eisenmeteoriten etwas länger. In trockenen Wüstengebieten (z. B. in der Sahara oder in der Antarktis) können Meteoriten auch mehrere zehn- bis hunderttausend Jahre auf der Erde erhalten bleiben. In ganz seltenen Fällen kann es zur Bildung von fossilen Meteoriten kommen, die dann auch hunderte Millionen Jahre bestehen bleiben.

Under normal environmental conditions, meteorites rapidly weather or rust away; in tropical or moderate climates, small stony meteorites survive only a few hundred years – iron meteorites a little longer. In dry deserts (such as the Sahara or Antarctica), meteorites are preserved for up to several hundred thousand years. In some very rare cases, meteorites can become fossilized and can survive several hundred million years.

1 cm

FOSSILE METEORITEN: Vor 470 Millionen Jahren, während des Ordoviziums, sind im Gebiet des heutigen Skandinaviens viele Meteoriten in ein etwa 200 m tiefes Meer gefallen und wurden in den Sedimenten eingebettet. Diese verfestigten sich zu Kalkstein, und die Meteoriten wurden zu Fossilien. Das Meer hat sich mit der Zeit zurückgezogen, und heute wird der Kalkstein im Thorsberg-Steinbruch in Südschweden abgebaut. Dort haben Arbeiter gemeinsam mit Wissenschaftern der Universität Lund, Schweden, im Lauf der letzten 20 Jahre mehr als 100 solcher fossiler Meteoriten gefunden – dies sind fast alle heute bekannten fossilen Meteoriten. Einer dieser fossilen Meteoriten ist im Bild links zu sehen.

Alle diese Meteoriten sind Steinmeteoriten und gehören zu den gewöhnlichen Chondriten des L-Typs. Sie sind nach einer Asteroidenkollision, die zum Aufbrechen des Meteoritenmutterkörpers führte, auf die Erde gelangt. Heute ist fast das gesamte Meteoritenmaterial durch andere Minerale ersetzt, ähnlich wie bei versteinertem Holz. Nur winzige ursprüngliche Kristalle des Minerals Chromit sind noch erhalten.

FOSSIL METEORITES: About 470 million years ago, during the Ordovician period, in what is Scandinavia today, a number of meteorites fell in a 200-m-deep ocean and were embedded in the sea floor sediments. Over time, these sediments hardened to limestone, the meteorites became fossilized, the sea withdrew and today this limestone is quarried in the Thorsberg quarry in southern Sweden. In this quarry, the workers, together with scientists at Lund University, have recovered more than 100 fossil meteorites during the past 20 years. Together, these make up almost all the fossil meteorites known to science. One of those fossil meteorites is shown in the image on the left.

All these meteorites are ordinary chondrites (L type) and are the result of a collision that resulted in the breakup of the parent asteroid. Today, most of the meteoritic material has been replaced by other minerals, whilst the original shape of the meteorite has been retained – a similar process to what happens in the formation of petrified wood. All that remains of the original meteoritic material are tiny crystals of the mineral chromite.

MARS UND MARSMETEORITEN
MARS AND MARTIAN METEORITES

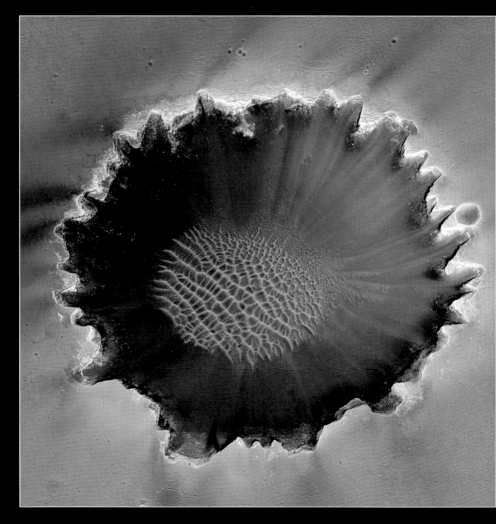

Victoria-Impaktkrater, Mars.
Victoria impact crater, Mars.

Der Mars ist halb so groß wie die Erde, hat eine Umlaufzeit von 1,9 Jahren und eine Rotationsperiode von 24 Stunden und 37 Minuten, wobei die Rotationsachse 25° gegen die Bahn geneigt ist; daher hat der Mars Jahreszeiten. Der Mars besitzt zwei kleine Monde mit ca. 15–22 km Durchmesser: Phobos und Deimos.

Marsmeteoriten sind extrem selten und wertvoll. Von den mehreren zehntausend bekannten Meteoriten stammen weniger als hundert vom Planeten Mars.

Mars is half as large as Earth, takes 1.9 years to orbit the Sun, and has a rotation period of 24 hours and 37 minutes; the rotation axis is inclined by 25° from the vertical and thus there are seasons on Mars. The planet has two small moons, Phobos and Deimos, 15–22 km in diameter.

Mars meteorites are extremely rare and precious. Of the several tens of thousands of known meteorites, less than one hundred come from the planet Mars.

MARS UND MARSMETEORITEN
MARS AND MARTIAN METEORITES

Chassigny. Chassignit. Nach Detonationen fiel am 3. Oktober 1815 im Nordosten Frankreichs ein Meteorit. Obwohl der Stein ursprünglich rund 4 kg wog, sind heute von diesem Fall nur noch insgesamt weniger als 600 g erhalten. Chassigny ist der namensgebende Vertreter der als Chassignite bezeichneten Meteoritengruppe.

Shergotty. Shergottit. Nach Detonationen fiel am 25. August 1865 im indischen Bundesstaat Bihar in der Nähe der Stadt Sherghati ein Stein; er ist der namensgebende Vertreter der als Shergottite bezeichneten Meteoritengruppe, die einen magmatischen Usprung hat.

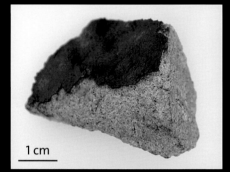

1 cm

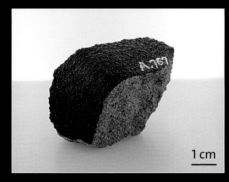

1 cm

Chassigny. Chassignite. On 3 October 1815, a stone was observed to fall in north-east of France after detonations were heard. Even though the meteorite originally weighed ~4 kg, less than 600 g remain today. This meteorite gave its name to the "chassignite" Martian meteorites.

Shergotty. Shergottite. Fell on 25 August 1865 near a town called Shergahti in Bihar State, India, after detonations were heard. This witnessed fall is the first example of the "shergottites", the largest group of Martian meteorites.

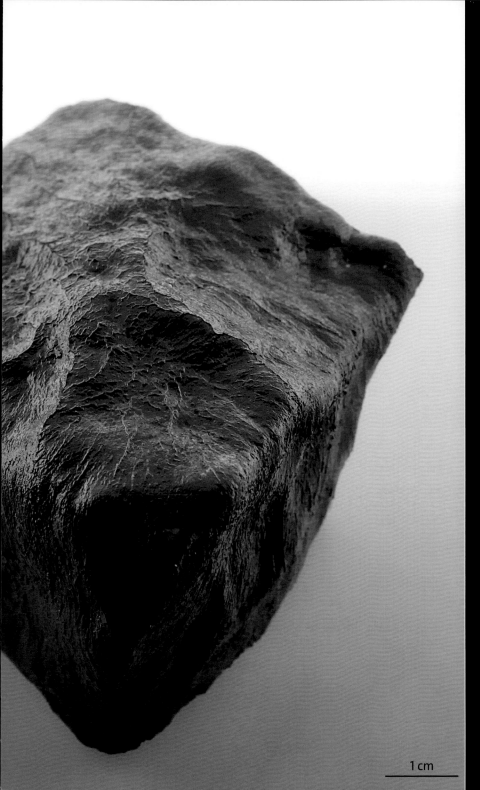

1 cm

Nakhla. Nakhlit. Nach Detonationen und dem Auftreten von Rauchfahnen, die von erschreckten Einheimischen beobachtet wurden, ging am 28. Juni 1911 inmitten des Nildeltas in Ägypten ein Meteoritenschauer nieder. Rund 40 Steine wurden aufgesammelt. Unbestätigten Berichten zufolge soll einer der Steine einen Hund getötet haben. Nakhla ist der namensgebende Vertreter der als Nakhlite bezeichneten Meteoritengruppe (links).

Nakhla. Nakhlite. A meteorite shower fell in the Nile delta in Egypt on 28 June 1911 after detonations and observation of smoke trails that frightened local people. About 40 stones were recovered; one of them supposedly killed a dog. It is the first of the so-called "nakhlite" group of Martian meteorites (left).

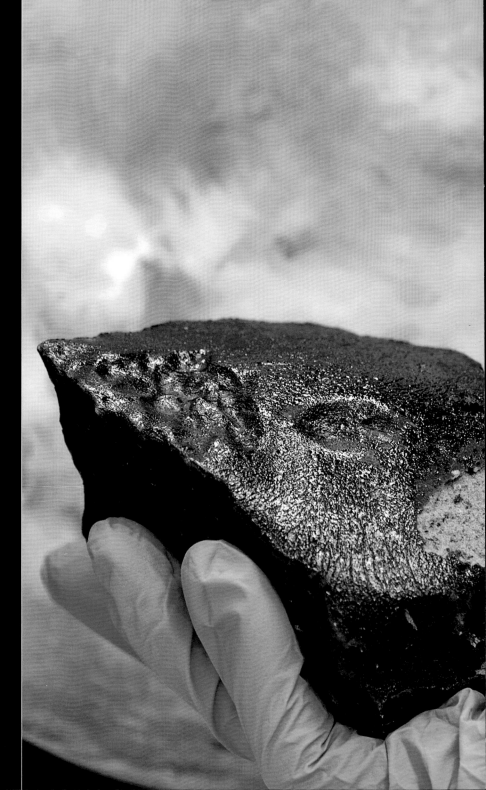

Zagami. Shergottit. Nach einer gewaltigen Detonation fiel am 3. Oktober 1962 in Nigeria ein Stein vom Himmel – nur wenige Meter entfernt von einem Bauern, der gerade Krähen von seinem Feld verscheuchte. Der Stein wurde aus einem rund 0,5 m tiefen Loch geborgen. Zagami ist das größte bekannte Einzelstück eines Marsmeteoriten.

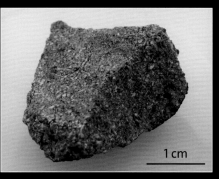

1 cm

Zagami. Shergottite. On 3 October 1962, accompanied by loud detonations, a large stone fell in Nigeria, only a few meters from a farmer who was chasing crows from his field. The meteorite was recovered from a hole about half a meter deep. Zagami is the largest known single individual Martian meteorite.

Tissint. Shergottit. Nach dem Erscheinen eines hellen Feuerballs fielen am 18. Juli 2011 im Oued-Drâa-Tal bei Tata, Marokko, mehrere Steine vom Himmel. Im Oktober 2011 wurden die ersten davon von Nomaden gefunden. Tissint ist der fünfte, durch Augenzeugen belegte Fall eines Marsmeteoriten und der zweitgrößte bezüglich der aufgesammelten Gesamtmasse (links).

Tissint. Shergottite. Fell in the Oued Drâa valley, near Tata, Morocco, at ~2 am on 18 July 2011 after observation of a bright fireball. Several individual stones from this fall were first recovered by nomads in October 2011. It is the fifth witnessed fall of a Martian meteorite and the second largest in terms of recovered mass (left).

Dar al Gani 670. Shergottit. 1999 wurde in der Sahara, in der Dar-al-Gani-Region, Libyen, ein in drei Teile zerbrochener dunkelbrauner Stein gefunden, der später als Marsmeteorit erkannt wurde. Das dünne Plättchen des Meteoriten zeigt dessen innere Struktur, die typisch für magmatische Gesteine ist.

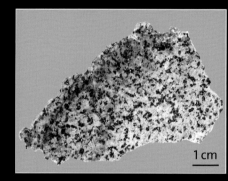

1 cm

Dar al Gani 670. Shergottite. Three fragments of a dark-brown stone were found in 1999 in the Dar al Gani region (Libya) of the Sahara Desert; it was later recognized as a Martian meteorite. This thin slice of one of these stones shows an internal texture that is typical for magmatic rocks.

MARS UND MARSMETEORITEN
MARS AND MARTIAN METEORITES

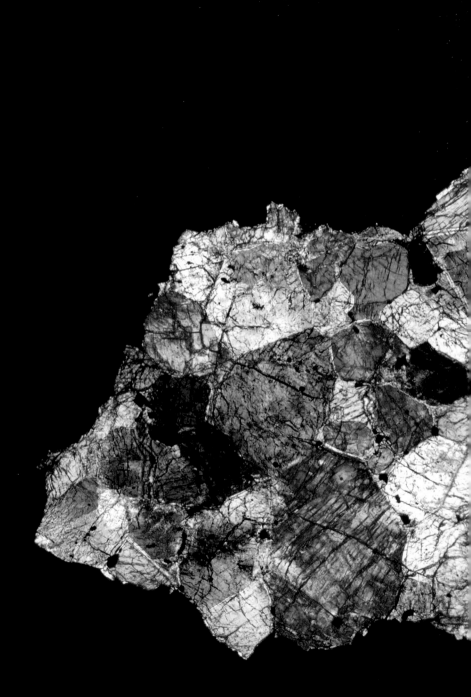

MARSMETEORITEN unterscheiden sich ganz deutlich von anderen Meteoriten: 1. Sie sind mit einem Entstehungsalter von 150 Millionen bis 4,1 Milliarden Jahren wesentlich jünger als andere Meteoriten und müssen daher von einem großen Planeten stammen. 2. Sie haben eine chemische Zusammensetzung, die der der Marsoberfläche sehr ähnlich ist. 3. In ihnen findet man eingeschlossenes Gas, dessen Zusammensetzung jener der Marsatmosphäre entspricht.

MARTIAN METEORITES are thought to be from Mars because they are significantly different from most other meteorites, especially in the following respects: 1) with ages of 150 million to 4.1 billion years, they are much younger than "normal" meteorites, which are 4.6 billion years old, and thus have to come from a larger planet; 2) they have a chemical composition that is similar to that of the surface of Mars, and 3) they contain gas inclusions of the same composition as the Martian atmosphere.

Mikrofoto des Chassigny-Meteoriten, der hauptsächlich aus dem Eisen-Magnesium-Silikat Olivin besteht.

Microscopic image *of the Chassigny meteorite, showing mostly crystals of the iron-magnesium silicate olivine.*

1 mm

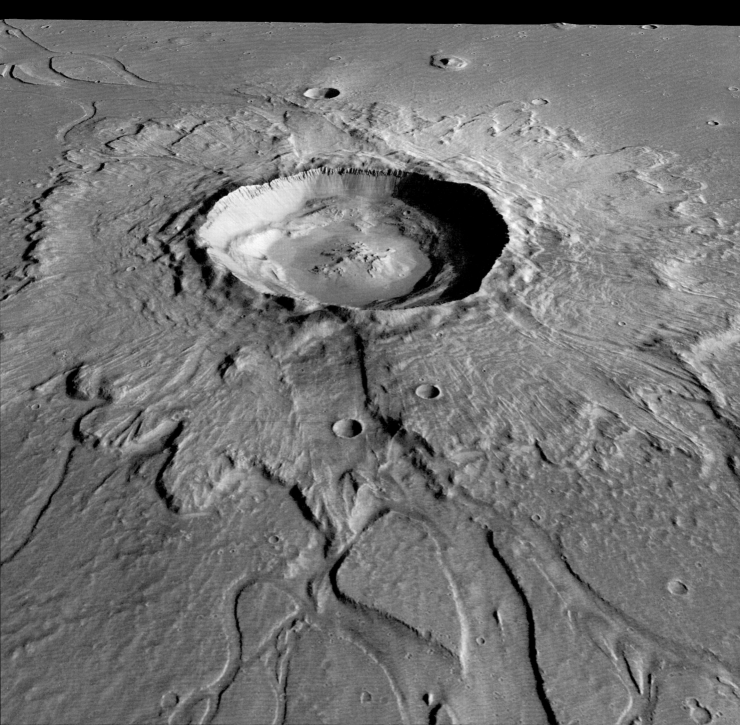

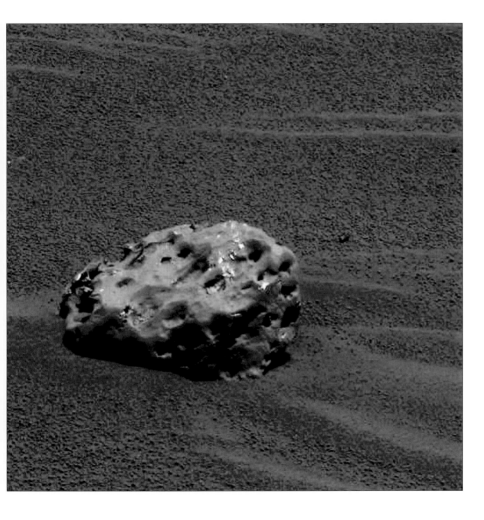

DIE OBERFLÄCHE DES PLANETEN MARS
ist mit vielen Einschlagskratern bedeckt, wie zum Beispiel diesem 20 km großen Krater in der Hephaestus-Fossae-Region (ganz links). Vergleichbar mit dem Eintreten in die Erdatmosphäre und dem Fall auf die Erdoberfläche, „überleben" manche Meteoroide den Flug durch die (dünne) Marsatmosphäre und landen auf der Oberfläche als Meteoriten, so wie dieser, Meridiani Planum genannte Eisenmeteorit. Dieses etwa basketballgroße Objekt wurde im Jänner 2005 vom NASA-Rover Opportunity entdeckt (links).

THE SURFACE OF MARS is covered with numerous meteorite impact craters, such as the one here (far left) in the Hephaestus Fossae region. As on Earth, some meteoroids survive the passage through the (thin) Martian atmosphere and land on the surface of Mars; here the "Heat Shield Rock" (also know as the Meridiani Planum meteorite), a basketball-sized iron meteorite found on Mars in January 2005 by the NASA rover Opportunity (left).

Der erste Fußabdruck auf dem Mond, Apollo 11, 1969.
The first footprint on the Moon, Apollo 11, 1969.

Unser Verständnis des Mondes wäre undenkbar ohne die Erkenntnisse der Mondlandungen. Die erste Mondlandung, Apollo 11, erfolgte am 20. Juli 1969. Bis 1972 haben 12 US-amerikanische Astronauten während sechs verschiedener Missionen insgesamt 381,7 kg Mondgestein zur Erde zurückgebracht, das im NASA Johnson Space Center in Houston, Texas, USA, aufbewahrt wird und weltweit von hunderten Forschern untersucht wurde. Zusätzlich haben drei automatische sowjetische Raumsonden ca. 0,3 kg Gestein zur Erde zurückgebracht. Seit 1986 wurden auch über 100 Meteoriten auf der Erde gefunden, die vom Mond stammen. Diese Meteoriten sind Mondgestein, das bei Meteoriteneinschlägen auf dem Mond von der Mondoberfläche zur Erde geschleudert wurde.

The first human landing on the Moon was on 20 July 1969. During the six Apollo missions of 1969–1972, 12 American astronauts walked on the Moon. They brought back 381.7 kg of lunar rock and soil to Earth, most of which is stored in NASA's Johnson Space Center in Houston (Texas, USA). About 0.3 kg of lunar material was also brought back to Earth by three automatic Soviet Union Luna spacecraft. In addition, since 1986, a number of lunar meteorites have been recognized on Earth. Large impact events on the Moon ejected surface rocks all the way to the Earth.

Das Apollo 11 Lunar Module mit dem Mare Smythii und der aufgehenden Erde (1969).

Apollo 11 lunar module with Mare Smythii and the rising Earth (1969).

STECKBRIEF MOND
Mittlere Erdentfernung: 384 400 km
Perigäum (Erdnähe): 356 400 km
Apogäum (Erdferne): 406 700 km
Durchmesser: 3 475 km
Masse: 7,35 x 10^{22} kg
Dichte: 3,35 g/cm^3
Entweichgeschwindigkeit: 2,38 km/s
Rotationsperiode: 27,3 Tage
Oberflächentemperatur: -150°C – +130°C

ID CARD OF THE MOON
Average distance from Earth: 384 400 km
Perigee (closest distance): 356 400 km
Apogee (farthest distance): 406 700 km
Diameter: 3 475 km
Mass: 7.35 x 10^{22} kg
Density: 3.35 g/cm^3
Escape velocity: 2.38 km/s
Rotation period: 27.3 days
Surface temperature: -150°C – +130°C

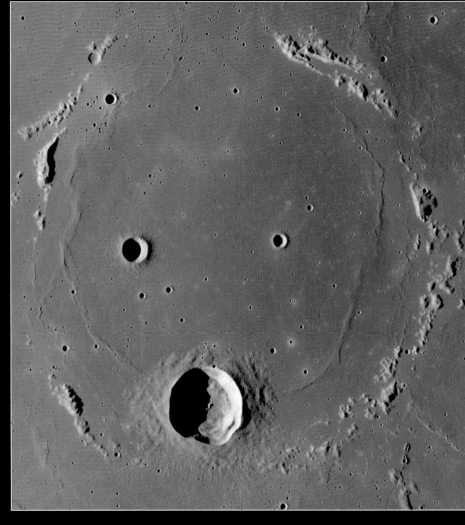

Der Flamsteed Krater. Mann im Mond?
The Flamsteed Crater. Man in the Moon?

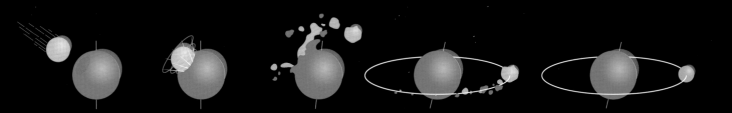

DIE ENTSTEHUNG DES MONDES. Die heute weithin akzeptierte Theorie der Entstehung des Mondes besagt, dass in der Frühzeit des Sonnensystems, knapp 50 Millionen Jahre nach der Entstehung der Ursonne, ein etwa marsgroßer Körper mit der Protoerde kollidierte und der ausgeschleuderte Erdmantel zusammen mit Material des einschlagenden Körpers eine Scheibe um die Erde bildete, aus der dann relativ rasch der Mond entstand. Nach seiner Entstehung war der Mond fast vollständig aufgeschmolzen und von einem Magmaozean bedeckt. Bei der Abkühlung kam es zu einer Entmischung der verschiedenen Gesteinstypen, wobei die feldspatreichen Anorthosite nach oben geschwommen sind.

THE FORMATION OF THE MOON. In the currently most widely accepted hypothesis of the formation of the Moon, a Mars-sized proto-planet collided with the proto-Earth about 50 million years after the formation of the Sun. A disc of material was formed from parts of the ejected mantle of the proto-Earth, together with the mantle of the other body, from which the Moon formed fairly rapidly. After its formation the Moon was almost completely molten and covered in a global magma ocean. During cooling of the magma ocean, the various rock types unmixed and feldspar-rich anorthosites rose to the surface, forming the early crust.

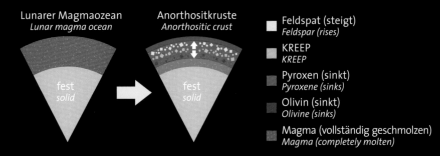

Lunarer Magmaozean
Lunar magma ocean

Anorthositkruste
Anorthositic crust

Feldspat (steigt)
Feldspar (rises)

KREEP
KREEP

Pyroxen (sinkt)
Pyroxene (sinks)

Olivin (sinkt)
Olivine (sinks)

Magma (vollständig geschmolzen)
Magma (completely molten)

fest
solid

Die Bildung der Mondkruste nach Mondentstehung aus dem Magmaozean.
Formation of the lunar crust from a magma ocean soon after the origin of the Moon.

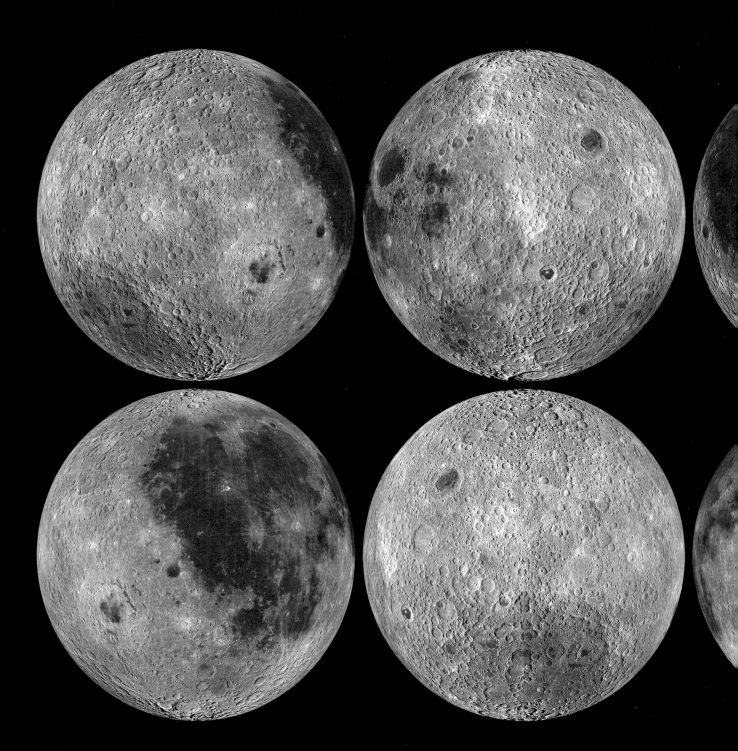

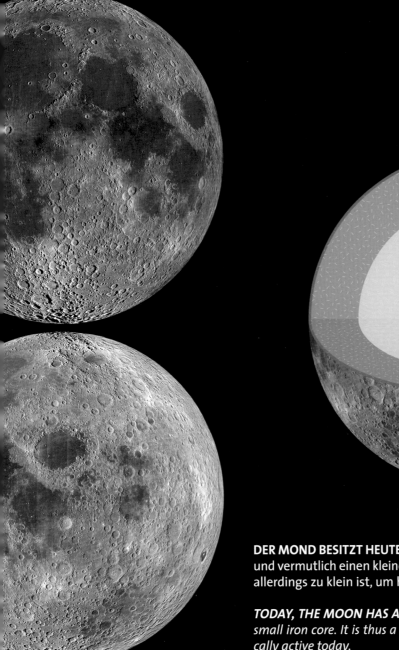

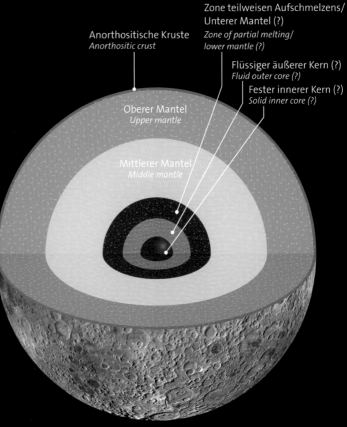

Anorthositische Kruste
Anorthositic crust

Zone teilweisen Aufschmelzens/
Unterer Mantel (?)
*Zone of partial melting/
lower mantle (?)*

Flüssiger äußerer Kern (?)
Fluid outer core (?)

Fester innerer Kern (?)
Solid inner core (?)

Oberer Mantel
Upper mantle

Mittlerer Mantel
Middle mantle

DER MOND BESITZT HEUTE EINE DICKE KRUSTE, einen Mantel (ähnlich wie die Erde) und vermutlich einen kleinen Eisenkern; er ist daher ein „differenzierter" Körper, der allerdings zu klein ist, um heute noch geologisch aktiv zu sein.

TODAY, THE MOON HAS A THICK CRUST, *a mantle similar to Earth, and possibly a small iron core. It is thus a "differentiated" body, but is too small to still be geologically active today.*

DIE MONDOBERFLÄCHE hat helle Gebiete, die Hochländer, und dunkle Gebiete (fast nur auf der erdzugewandten Seite), die Mare. Die Hochländer sind sehr alt und bestehen aus Anorthositgestein (ein Gestein, das reich am Mineral Feldspat ist), meist in Form von Brekzien, während die Mare durch Kollisionen mit großen Asteroiden vor ca. vier Milliarden Jahren entstanden sind und danach durch Magma gefüllt wurden. Sie bestehen hauptsächlich aus basaltischem Gestein. Da der Mond keine Atmosphäre besitzt, treffen Meteoriten und Asteroiden ungebremst auf seine Oberfläche. Die jetzige Mondoberfläche ist von zwei Prozessen geprägt – einerseits vom Vulkanismus, der aber schon lange zum Erliegen gekommen ist, und andererseits von Impakten, die die Oberfläche permanent verändern.

Die gesamte Mondoberfläche ist mit einer Schicht aus Staub und Gesteinstrümmern bedeckt, die man Regolith nennt und die durch Einschlagsprozesse entsteht. Neben Gläsern, die durch das Aufschmelzen von Gesteinen bei Impakten entstanden sind, wurden in den Mondproben auch vulkanische Gesteine und Gläser (z. B. grüne und orange Glaskügelchen) gefunden.

THE LUNAR SURFACE is characterized by bright areas, the highlands, and dark areas, the mare (which occur almost exclusively on the side facing Earth). The highlands are very old and consist of anorthositic rocks (a rock that is rich in the mineral feldspar), mostly in the form of breccias, whereas the mare formed by rising magma after collisions with large asteroids ca. 4 billion years ago. They are mostly made up of basaltic rocks.
Because the Moon has no atmosphere, meteorites and asteroids hit the lunar surface unimpeded. Today, the surface is marked by two important processes – early volcanism (which has mostly ceased) and incessant impact events that constantly reshape the surface.
The whole lunar surface is covered with a layer of rock fragments and dust, several meters thick, which is called a regolith and which forms by impact processes. In addition to impact glasses, volcanic rocks and volcanic glasses (e.g., green and orange spherules) have also been found in lunar samples.

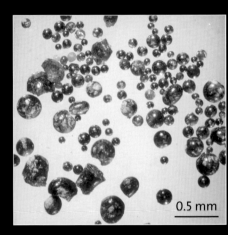

0.5 mm

Apollo 15: Vulkanische Gläser.
Apollo 15: Volcanic glasses.

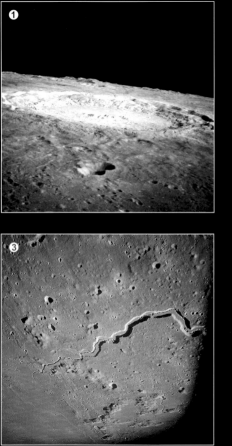

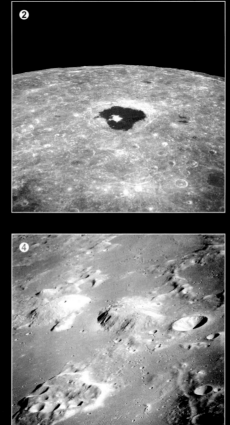

❶ Der Kopernikus-Einschlagskrater misst 100 km im Durchmesser.
❷ Der Tsiolkovsky-Einschlagskrater auf der Rückseite des Mondes hat einen Durchmesser von 180 km.
❸ Lavaströme in der früheren Mondgeschichte bildeten das Schrötertal.
❹ Die vulkanischen Gruithuisen-Berge.

❶ *The 100-km-diameter Copernicus impact crater.*
❷ *The 180-km-diameter Tsiolkovski impact crater on the lunar far side.*
❸ *The Schröter Valley was formed by flowing lava earlier in the lunar history.*
❹ *The volcanic Gruithuisen mountains.*

Mondgestein. Mikrofoto eines typischen Mare-Basalts. Mare-Basalte bestehen hauptsächlich aus großen Pyroxen- (auf dem Foto gelb, violett und blau), Olivin-Kristallen (grün) und kleineren Plagioklas-Nadeln.

Lunar rock. Microscopic image of a typical mare basalt showing mainly large pyroxene (yellow, pink and blue on this photo) and olivine (greenish) crystals, and smaller plagioclase laths.

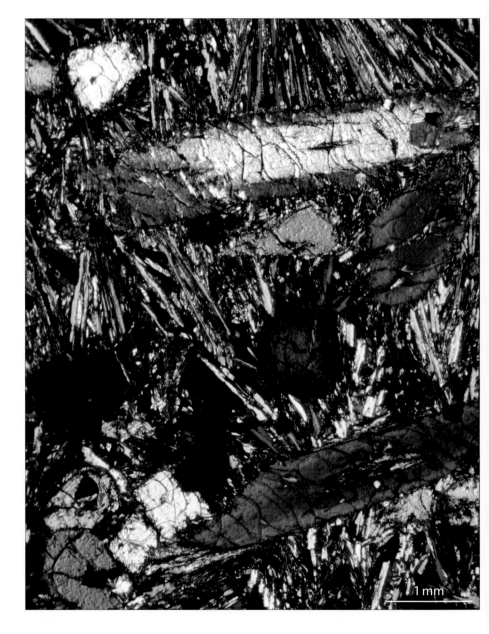

1 mm

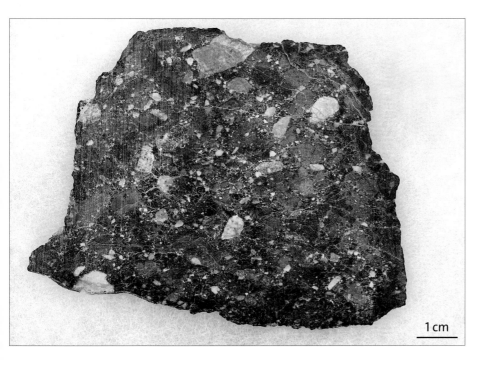

1 cm

Dar al Gani 400. Platte des Mondmeteoriten. In der dunkelgrauen Matrix der typischen lunaren Brekzie dominiert das Calcium-Aluminium-Silikat Plagioklas (hellgraue bis weißliche Einschlüsse). Mondmeteoriten sind größtenteils Brekzien und umfassen einen weiten Bereich von Gesteinstypen aus den Mare-Gebieten und aus dem Mondhochland.

Dar al Gani 400. Slice of the lunar meteorite. This typical breccia from the lunar highlands is dominated by the calcium-aluminum silicate plagioclase (light gray to white inclusions). Most lunar meteorites are breccias and include a variety of rock types from the lunar highlands and the mare basins.

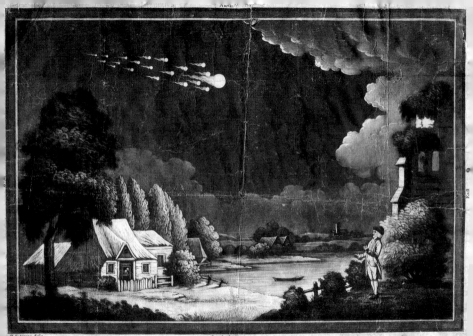

North

South

H. Robinson delin.

An accurate Representation of the Meteor which was seen on Aug.t 28th 1783. — At first it appeared as one Ball of Fire, but, in a few Seconds, broke into many small ones. Its Course was from N.W. to S.E. — This extraordinary Phenomenon was of that Species of Meteor which the great Phisiologist Dr Woodward and others call the Draco volans or Flying Dragon. — The above View was taken at Winthorpe near Newark upon Trent, by Henry Robinson, Schoolmaster. — and Published by him as the Act directs, 14 Oct.r 1783. — This Plate is inscribed to Roger Pocklington, Esq.r by his much obliged humble Servant, *Henry Robinson?*

Meteoroide sind Objekte mit typischerweise weniger als 50 m Durchmesser, die im interplanetaren Raum die Sonne umkreisen. Beim Eintritt eines Meteoroids in die Erdatmosphäre kommt es durch Ionisation und Anregung der Luft zu spektakulären Leuchterscheinungen – den Meteoren. Übersteht ein Meteoroid den Flug durch die Atmosphäre und den Aufprall auf die Erdoberfläche, wird er als Meteorit bezeichnet. Viele Meteoroide zerbrechen in der Atmosphäre und fallen dann als ein aus zahlreichen Bruchstücken bestehender Schauer zur Erde. Das Fallgebiet eines Meteoritenschauers – das sogenannte Streufeld – hat oft die Form einer Ellipse.

Meteoroids are small interplanetary solid objects in the solar system, typically less than 50 m in diameter. A meteor is the visible light phenomenon resulting from excitation and ionization of air during the passage of a meteoroid through the Earth's atmosphere. If a meteoroid survives the atmospheric transit and impact with the Earth's surface, it is called a meteorite. Many meteoroids break up during atmospheric entry and fall to Earth as a shower containing numerous fragments. In most cases, these meteorite fragments are distributed in a so-called "strewn field" of elliptical shape.

Zeitgenössische Darstellung eines spektakulären Meteors, der am 18. August 1783 über Winthorpe, England, zu sehen war. Zuerst erschien ein einziger Feuerball, der nach wenigen Sekunden in mehrere Feuerbälle zerfiel.

Contemporary representation of a spectacular meteor as seen from Winthorpe (England) on 18 August 1783. At first, a single fireball appeared, which split into several fireballs a few seconds later.

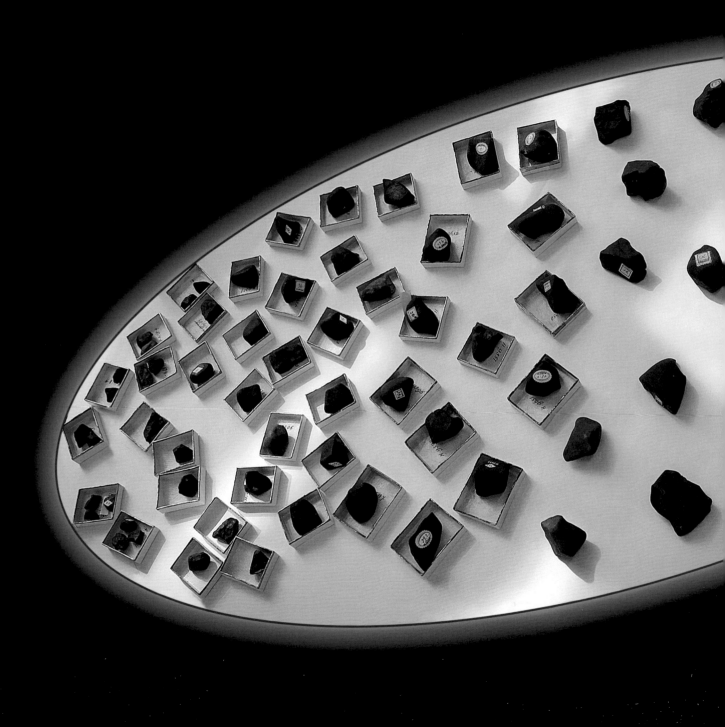

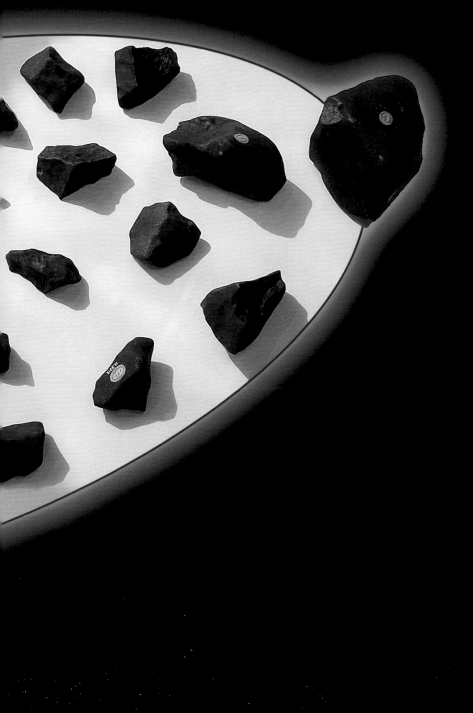

MODELLHAFTE DARSTELLUNG eines Streufelds mit Steinen des Mocs-Meteoritenschauers (Massen im Bereich von 3,4 g bis 1,6 kg). Über die Verteilung der Bruchstücke kann die Flugrichtung rekonstruiert werden. Schwerere Stücke behalten länger einen Teil ihrer kosmischen Geschwindigkeit bei und fliegen daher weiter.

MODEL REPRESENTATION of meteorite strewn field exemplified by stones of the Mocs meteorite shower (mass range from 3.4 g to 1.6 kg). The distribution of fragments allows the reconstruction of the direction of flight; the heavier a fragment is, the longer it will retain some of its cosmic velocity and thus travel farther.

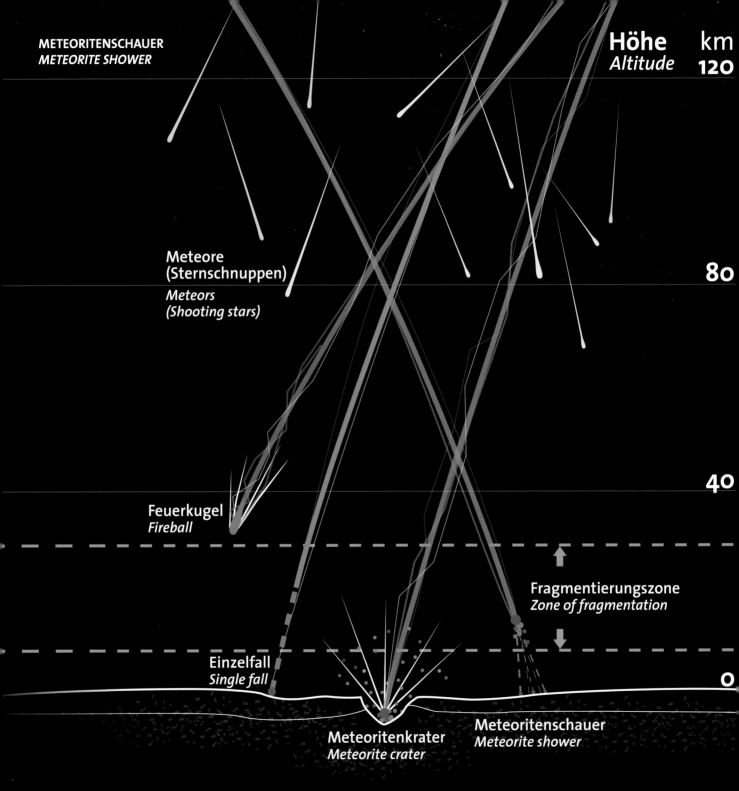

METEORITENSCHAUER
METEORITE SHOWER

Höhe km
Altitude
120

Meteore
(Sternschnuppen)
*Meteors
(Shooting stars)*

80

40

Feuerkugel
Fireball

Fragmentierungszone
Zone of fragmentation

0

Einzelfall
Single fall

Meteoritenkrater
Meteorite crater

Meteoritenschauer
Meteorite shower

L'Aigle. Orne, Frankreich. Gewöhnlicher Chondrit (L6). Der detaillierte Bericht von Jean-Baptiste Biot hat die Wissenschaft überzeugt, dass Meteoriten vom Himmel herabgefallene Steine sind, die nicht von der Erde stammen.

Datum: 26. April 1803, 13:00 Uhr
Gesamtmasse: 37 kg
Anzahl Bruchstücke: etwa 2 000–3 000
Größtes Einzelstück: 9 kg
Streufeld: 10 x 4 km

Älteste publizierte Karte eines Meteoriten-Streufelds (Biot, 1803).

SCHEMATISCHE DARSTELLUNG des Eintritts von Meteoroiden in die Atmosphäre, der Entstehung von Meteoren und von Meteoritenfällen (einzelner Meteorit oder Meteoritenschauer) (links).

SCHEMATIC REPRESENTATION of the atmospheric entry of meteoroids, the formation of meteors, and the resulting meteorites (single fall or meteorite shower) (left).

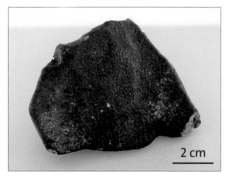

2 cm

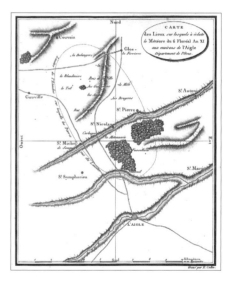

L'Aigle. Orne, France. Ordinary chondrite (L6). The detailed report about this shower by Jean-Baptiste Biot convinced most scientists at the time that meteorites are indeed of extraterrestrial origin.

Date: 26 April 1803, 13:00 hrs
Total mass: 37 kg
Number of fragments: about 2 000–3 000
Largest piece: 9 kg
Strewn field: 10 x 4 km

Earliest published map of a meteorite strewn field (Biot, 1803).

METEORITENSCHAUER
METEORITE SHOWER

Streufeld des
Sikhote-Alin-Meteoriten.
Sikhote-Alin meteorite strewn field.

N

Einschlaglöcher Ø 5–28 m
Impact holes Ø 5–28 m

Einschlaglöcher Ø < 5 m
Impact holes Ø < 5 m

Meteoriten 10 g–100 kg
Meteorites 10 g–100 kg

Sikhote-Alin. Primorsky Krai, Russland. Eisenmeteorit (IIAB). Aus dem Streufeld wurden rund 106 Einschlagslöcher (das größte davon mit einem Durchmesser von 28 m) beschrieben, die große Meteoritenfragmente enthielten.

Datum: 12. Februar 1947, 10:38 Uhr
Gesamtmasse: 27 000 kg
Anzahl Bruchstücke: mehrere tausend
Größtes Einzelstück: 300 kg
Streufeld: 100 x 600 m

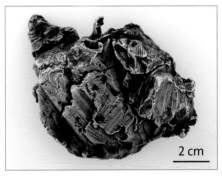

2 cm

Sikhote-Alin. Primorsky Krai, Russia. Iron meteorite (IIAB). About 106 impact pits, the largest being 28 m in diameter, containing large meteorite fragments were described from the strewn field.

Date: 12 February 1947, 10:38 hrs
Total mass: 27 000 kg
Number of fragments: several thousand
Largest piece: 300 kg
Strewn field: 100 x 600 m

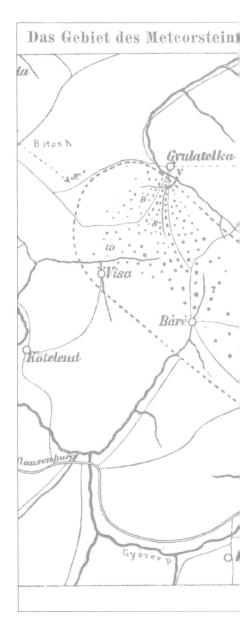

Das Gebiet des Meteorstein

Mocs. Cluj, Rumänien. Gewöhnlicher Chondrit (L5–6). Ungefähr 1 600 Einzelstücke des Mocs-Meteoriten befinden sich in der Sammlung des Naturhistorischen Museums; nur wenige davon sind ausgestellt.

Datum: 3. Februar 1882
Gesamtmasse: 300 kg
Anzahl Bruchstücke: etwa 3 000
Größtes Einzelstück: 56 kg
Streufeld: 14,5 x 3 km

2 cm

Mocs. *Cluj, Romania. Ordinary chondrite (L5–6). About 1 600 individual stones of Mocs are in the collection of the Natural History Museum; only a few of them are displayed here.*

Meteorite type: Ordinary chondrite (L5–6)
Date: 3 February 1882
Total mass: 300 kg
Number of fragments: about 3 000
Largest piece: 56 kg
Strewn field: 14,5 x 3 km

Homestead. Iowa County, USA. Gewöhnlicher Chondrit (L5).

Datum: 12. Februar 1875, 22:15 Uhr
Gesamtmasse: 227 kg
Anzahl Bruchstücke: etwa 100
Größtes Einzelstück: 34 kg
Streufeld: 46 km²

2 cm

Homestead. *Iowa County, USA. Ordinary chondrite (L5).*

Date: 12 February 1875, 22:15 hrs
Total mass: 227 kg
Number of fragments: about 100
Largest piece: 34 kg
Strewn field: 46 km²

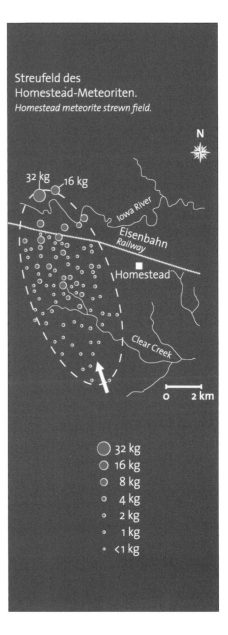

Streufeld des Homestead-Meteoriten.
Homestead meteorite strewn field.

○ 32 kg
○ 16 kg
○ 8 kg
∘ 4 kg
∘ 2 kg
· 1 kg
· <1 kg

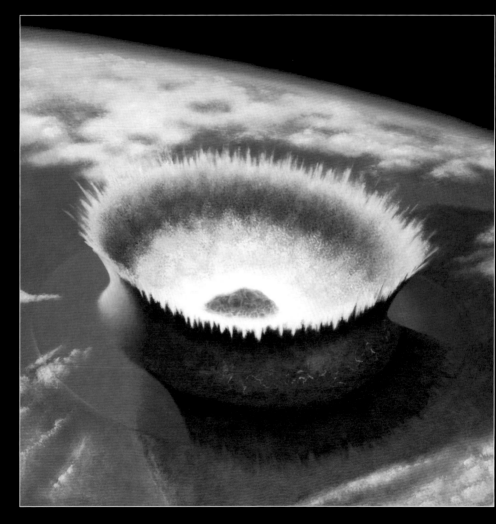

Illustration des Chicxulub-Einschlages am Ende der Kreidezeit.
Illustration of the Chicxulub impact event at the end of the Cretaceous period.

Etwa 10 000 der bekannten Kleinplaneten können der Erde nahe kommen und stellen daher eine potenzielle Gefahr dar. Manchmal treffen diese Körper mit kosmischen Geschwindigkeiten zwischen 10 und 70 km/s auf die Erdoberfläche. Ein Kleinplanet mit einer Größe von ca. 2 km kann einen Krater von 40 km Durchmesser formen und ein Gebiet im Ausmaß von Zentraleuropa in Schutt und Asche legen, während Asteroiden, die größer als 10 km sind, eine weltweite Katastrophe auslösen können.

About 10 000 of the currently known minor planets can approach the Earth and are thus potentially hazardous. Occasionally, such bodies impact the Earth with cosmic velocities ranging from 10 to 70 km/s. A minor planet 2 km in size can form a crater 40 km in diameter and destroy a region the size of central Europe. The impact of asteroids larger than 10 km in diameter can cause world-wide destruction.

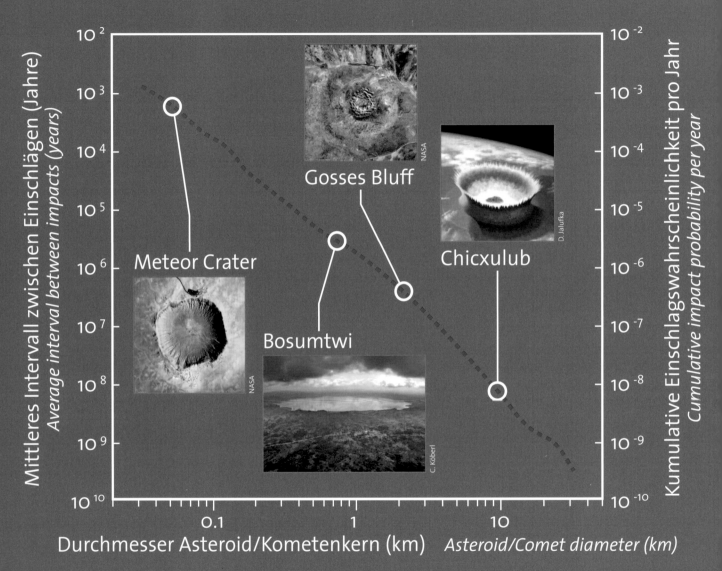

Zusammenhang zwischen Einschlagshäufigkeit und Durchmesser des einschlagenden Körpers auf der Erde (dargestellt für die mittlere Dichte von Steinmeteoriten/Asteroiden).

Relation between frequency of impacts and diameter of the impacting body on Earth (shown for average density stony meteorites/asteroids).

VERHÄLTNIS DER IMPAKTHÄUFIGKEIT
zum Durchmesser der einschlagenden
Asteroiden und der resultierenden
Impaktkrater auf der Erde. Größere
Einschläge sind weitaus seltener als
kleinere.

**THE RELATION BETWEEN IMPACT PRO-
BABILITY** and diameter of the impactors
and the resulting craters on Earth. Large
impact events are much less common
than small ones.

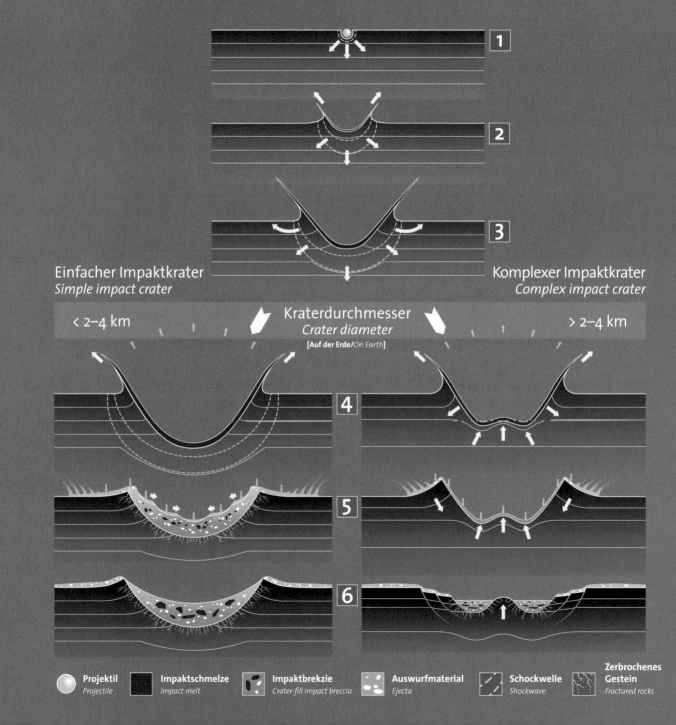

ENTSTEHUNG VON IMPAKTKRATERN
FORMATION OF IMPACT CRATERS

1

2

3

Einfacher Impaktkrater
Simple impact crater

Komplexer Impaktkrater
Complex impact crater

< 2–4 km

Kraterdurchmesser
Crater diameter
[**Auf der Erde**/*On Earth*]

> 2–4 km

4

5

6

Projektil
Projectile

Impaktschmelze
Impact melt

Impaktbrekzie
Crater-fill impact breccia

Auswurfmaterial
Ejecta

Schockwelle
Shockwave

Zerbrochenes Gestein
Fractured rocks

1. Der Einschlag eines extraterrestrischen Körpers erfolgt mit sehr hoher Geschwindigkeit und führt dazu, dass eine gewaltige Energiemenge in einem sehr kleinen Gebiet frei wird.

2. Der Asteroid verdampft fast völlig.

3. Beim Impakt werden Schockwellen gebildet, die in das Gestein des Bodens laufen und dort Änderungen in den Mineralen und Gesteinen auslösen.

4. Nach der Kompressionsphase folgt eine Entlastung in Form einer gigantischen Explosion, bei der das Gestein aus dem Krater ausgeworfen wird. Darüber befindet sich auch ein sich rasch ausdehnender glutheißer Feuerball, der aus verdampftem Projektil- und Targetmaterial besteht und der die Atmosphäre verdrängt.

5. Im Krater fließt das Material aus der Tiefe des sich öffnenden Kraters am immer weiter zurückweichenden Kraterrand vorbei und bildet eine Art Vorhang aus Auswurfmaterial.

6. Dieser Vorhang bewegt sich vom Krater weg, wobei Material ausregnet. Es besteht aus zerbrochenem, geschocktem oder aufgeschmolzenem Gestein. Ein Teil des Materials fällt wieder in den Krater zurück, wo es dicke Ablagerungen von Schmelzgestein und Brekzien bildet.

Fazit: Der gebildete Krater ist viel größer als der Asteroid, und der gesamte Vorgang dauert nur wenige Minuten.

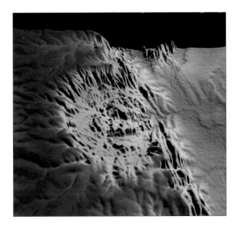

Digitales Höhenmodell der Luizi-Impaktstruktur, 17 km Durchmesser, DR Kongo. *Digital elevation model* of the Luizi impact structure (DR Congo), measuring 17 km in diameter.

1. *Extraterrestrial bodies collide with planetary surfaces at very high velocities, which causes huge amounts of energy to be released within a very small space.*

2. *The asteroid vaporizes almost completely during this process.*

3. *The impact causes shock waves to form and penetrate into the ground, leading to characteristic changes in the structure of minerals and rocks.*

4. *After this compression phase, the pressure is released in the form of a gigantic explosion that also excavates the crater. A huge expanding fireball forms and blows off the atmosphere and entrains melted and vaporized target material.*

5. *The material flows out of the expanding crater in the form of an ejecta curtain – a kind of inverted cone – that moves away from the crater, and from which material rains out.*

6. *This material consists of melted, broken, and shocked rocks. Part of these rocks fall back into the crater, where they form thick layers of melt rocks and breccias.*

To summarize: *The final crater is much larger than the impacting asteroid, and the whole event lasts only a few minutes.*

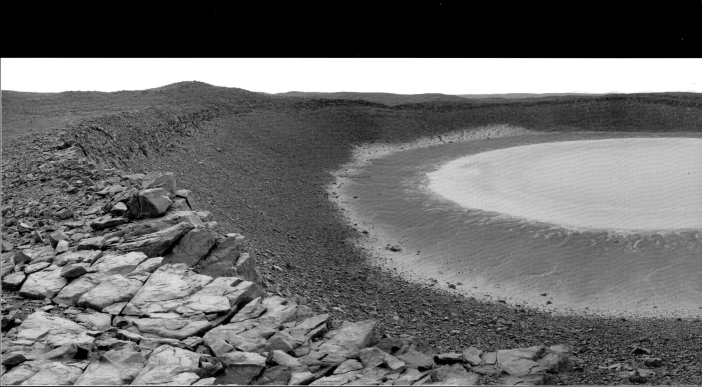

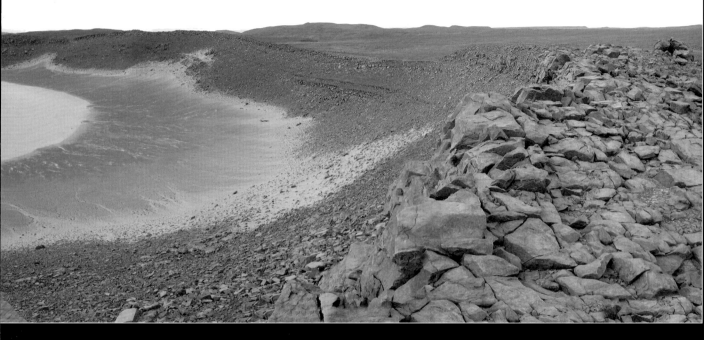

DER AMGUID-IMPAKTKRATER besitzt einen Durchmesser von 450 m und liegt etwa 250 km südöstlich von In Salah und 300 km nördlich der Stadt Tamanrasset in der algerischen Sahara. Er ist etwa 100 000 Jahre alt.

AMGUID IS A METEORITE IMPACT CRATER near Tamanrasset in the Algerian Sahara. It is 450 m in diameter and about 100,000 years old.

ARAGUAINHA, Brasilien | *Brazil*
ø 40 km, Alter | *Age* 244 Ma*

AOROUNGA, Tschad | *Chad*
ø 16 km, Alter | *Age* < 350 Ma

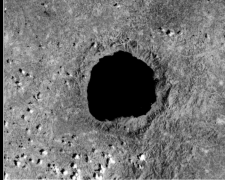

BOSUMTWI, Ghana
ø 11 km, Alter | *Age* 1.1 Ma

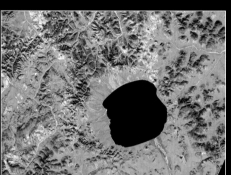

EL'GYGYTGYN, Russland | *Russia*
ø 18 km, Alter | *Age* 3.6 Ma

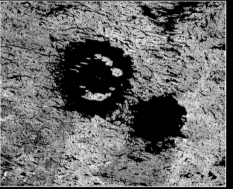

CLEARWATER, Kanada | *Canada*
ø 36 km/26 km, Alter | *Age* 290 Ma

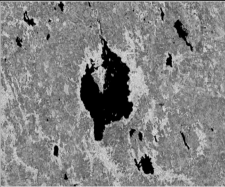

LAPPAJÄRVI, Finnland | *Finland*
ø 23 km, Alter | *Age* 73 Ma

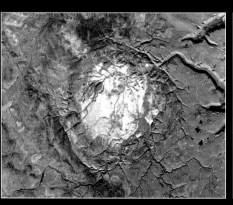

HAUGHTON, Kanada | *Canada*
ø 23 km, Alter | *Age* 39 Ma

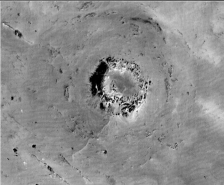

OASIS, Libyen | *Libya*
ø 18 km, Alter | *Age* < 120 Ma

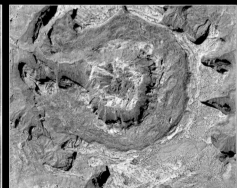

UPHEAVAL DOME, USA
ø 10 km, Alter | *Age* < 170 Ma

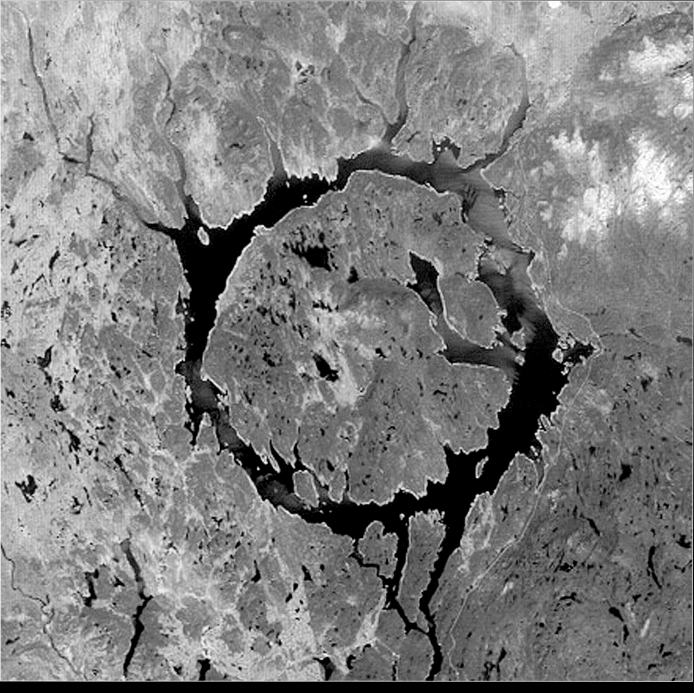

DER KRATER MONTURAQUI ist ein Einschlagskrater in der Atacamawüste in Chile. Sein Durchmesser beträgt etwa 460 m, und das Einschlagsereignis liegt weniger als eine Million Jahre zurück.

MONTURAQUI CRATER is located south of the Salar de Atacama in Chile. It is about 460 m in diameter and the impact event is thought to have occurred less than 1 million years ago.

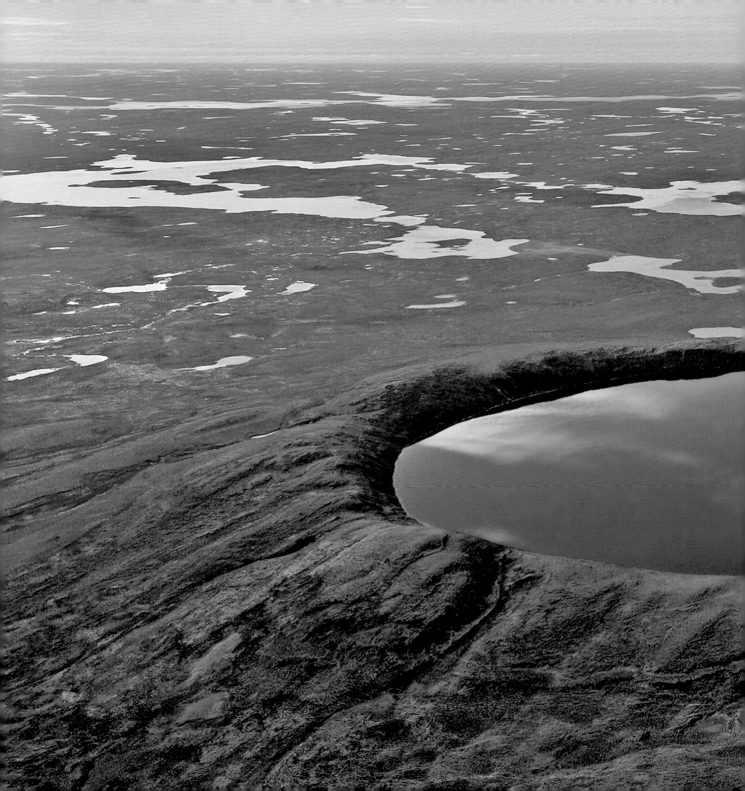

Verteilung der bekannten Impaktkrater auf der Erde.
Distribution of known meteorite impact craters on Earth.

Bohrkern aus dem Bosumtwi-Impaktkrater, Ghana.
Drill core from the Bosumtwi impact crater, Ghana.

DIE BESTÄTIGUNG EINES IMPAKTKRATERS erfolgt durch petrografische und mineralogische sowie geochemische Untersuchungen an Gesteinsproben der jeweiligen Kraterstruktur. Die geochemische Untersuchung von Impaktprodukten – wie zum Beispiel Impaktgläser, Impaktschmelzen und Brekzien – kann Hinweise auf die Entstehungsgeschichte sowie auf das Alter der jeweiligen Meteoritenkrater geben. Anreicherungen an Elementen, die in Meteoriten häufig vorkommen (wie zum Beispiel Platinmetalle), können ein Hinweis auf die Impaktentstehung einer Struktur sein. Von besonderer Bedeutung ist jedoch die Auswirkung des hohen Schockdruckes auf die betroffenen Minerale.

CONFIRMATION OF THE IMPACT ORIGIN of a geological structure requires detailed mineralogical, petrographic, and geochemical studies on rock samples from the respective crater structure, such as impact melts, glasses, or breccias. These studies can yield information on the origin and age of these rocks and the impact craters. Enrichments of chemical elements, such as the platinum group elements, which are very common in meteorites but rare in terrestrial rocks, can be indicative of the impact origin of a crater. Most important are, however, the shock effects in minerals that result from the high pressure during the impact event.

IMPAKTGESTEIN ENTSTEHT durch Druck- und Temperatureinwirkung auf normales Gestein bei einem Einschlagsereignis. Dabei wird das Gestein vermischt, aufgeschmolzen und zerbrochen, und es kommt zur Bildung von Impaktschmelzen und Brekzien. Impaktbrekzien mit einer Beimischung von geschmolzenem Gestein (Glas) bezeichnet man als Suevit. Durch die Schockeinwirkung können vor allem in feinkörnigem Gestein sogenannte Strahlenkegel („Shatter Cones") gebildet werden.

Pseudotachylit (Vredefort-Impaktstruktur, Südafrika). Brekzie mit großen Granitfragmenten in einer dunklen Schmelzmatrix (links).

Pseudotachylite (Vredefort impact structure, South Africa). Breccia made here of large granite fragments in a dark melt matrix (left).

IMPACTITES ARE FORMED by alteration of target rocks due to the extremely high pressure and temperature levels during an impact. This leads to mixing, melting, and brecciation, and formation of impact melt rocks and breccias. Impact breccias that contain some melt (glass) fragments are called suevites. Shock effects on fine-grained rocks can lead to the formation of so-called shatter cones.

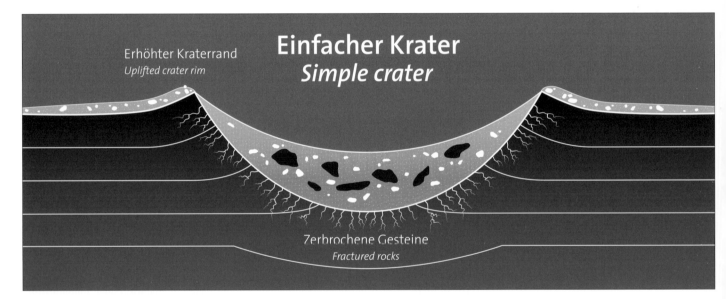

Erhöhter Kraterrand
Uplifted crater rim

Einfacher Krater
Simple crater

Zerbrochene Gesteine
Fractured rocks

MAN UNTERSCHEIDET aufgrund der verschiedenen Durchmesser und Strukturen zwei grundsätzlich unterschiedliche Arten von Einschlagskratern: die einfachen und die komplexen Krater. Auf der Erde sind alle Krater, die im Durchmesser kleiner als etwa 2 km sind, einfache, schüsselförmige Krater; alle anderen Krater sind komplexe Krater, die einen Zentralberg oder ein zentrales Ringsystem aufweisen.

BASED ON THEIR DIAMETER AND STRUCTURE, two different types of impact craters can be distinguished: simple and complex craters. On Earth, all craters with a diameter of less than about 2 km are simple, bowl-shaped craters, whereas all larger ones have a central uplift (a central peak) or a central ring system.

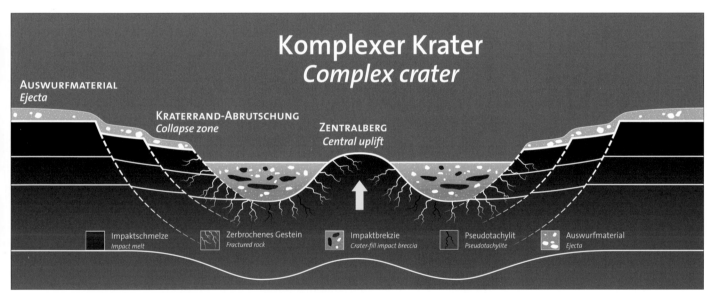

Komplexer Krater
Complex crater

AUSWURFMATERIAL
Ejecta

KRATERRAND-ABRUTSCHUNG
Collapse zone

ZENTRALBERG
Central uplift

Impaktschmelze
Impact melt

Zerbrochenes Gestein
Fractured rock

Impaktbrekzie
Crater-fill impact breccia

Pseudotachylit
Pseudotachylite

Auswurfmaterial
Ejecta

IMPAKTGESTEINE kommen in den verschiedensten Formen innerhalb eines Einschlagskraters vor, der hier schematisch dargestellt ist. Im Krateruntergrund kommt es zu Verwerfungen und der Bildung von Adern geschmolzenen Gesteins, den sogenannten Pseudotachyliten, während der Krater selbst mit Impaktschmelzen und Impaktbrekzien (z. B. Sueviten) verfüllt ist. Auch Strahlenkegel werden oft im Kratergestein gebildet.

VARIOUS TYPES OF IMPACTITES occur in different parts of an impact crater. Below the crater floor are large-scale displacements and veins filled with melted rock, the so-called pseudotachylites, whereas the crater itself is filled with various melt rocks and breccias, including suevites. Shatter cones also often form in the rocks of the central uplift.

ENTSTEHUNG VON IMPAKTKRATERN
FORMATION OF IMPACT CRATERS

TEKTITE SIND IMPAKTGLÄSER, die noch vor Bildung eines Kraters entstehen. Dabei wird Gestein in Sekundenbruchteilen geschmolzen und mit hohen Geschwindigkeiten sehr weit – bis tausende Kilometer vom Krater entfernt – ausgeworfen. Das geschmolzene Gestein kühlt sehr rasch ab und wird dadurch zu Glas. Tektite sind in sogenannten Streufeldern verteilt, von denen vier auf der Erde bekannt sind. Chemisch gesehen bestehen diese Gläser praktisch ausschließlich aus irdischem Gestein, mit nur ganz geringen Beimengungen von meteoritischem Material.

Zentraleuropäischer Tektit (Moldavit) (rechts).

Central European tektite (moldavite) (right).

TEKTITES ARE A SPECIAL TYPE of impact glasses that originates even before a crater is formed, when hot jets of molten rock are ejected at very high velocities to distances of up to several thousand kilometers from the crater. The molten rock rapidly solidifies and thus forms glass. Tektites are known from four so-called strewn fields. Chemically, these glasses are made up almost exclusively of terrestrial material, with rare and very minor admixtures of meteoritic matter.

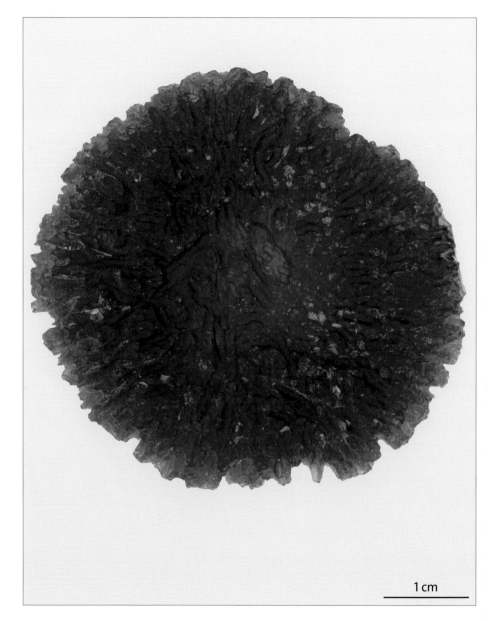

1 cm

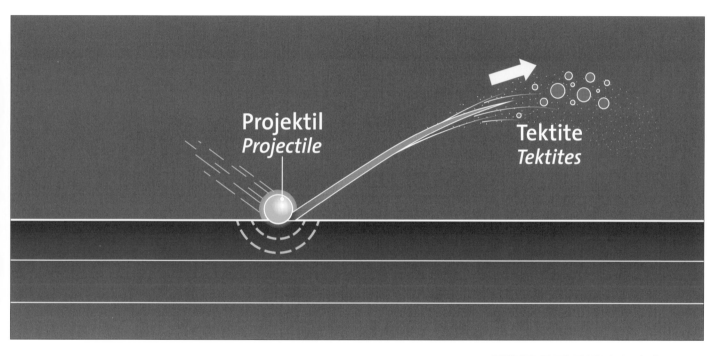

Projektil
Projectile

Tektite
Tektites

TEKTITE ENTSTEHEN bei schrägen Ein-
schlägen in der frühesten Phase des
Impaktvorganges.

*TEKTITES FORM during oblique impacts in
the earliest phase of the impact process.*

IMPAKTGLÄSER ENTSTEHEN durch das Aufschmelzen von irdischen Gesteinen im Krater während des Impaktvorganges und sind meist nur einige Zentimeter groß, erreichen aber in manchen Fällen auch 20–30 cm.

Impaktglas vom **Wabar-Impaktkrater,** Saudi-Arabien (rechts).

*Impact glass from the **Wabar impact crater**, Saudi Arabia (right).*

IMPACT GLASSES FORM by melting and quenching of terrestrial rocks within the crater during the impact process. In most cases, they are just a few centimeters in size, but some can reach 20–30 cm.

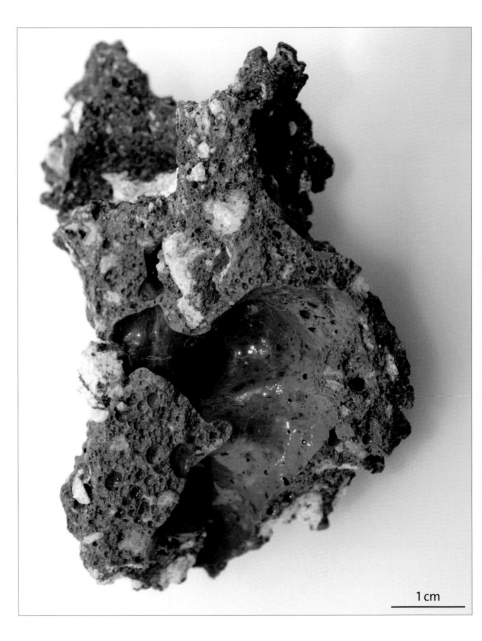

1 cm

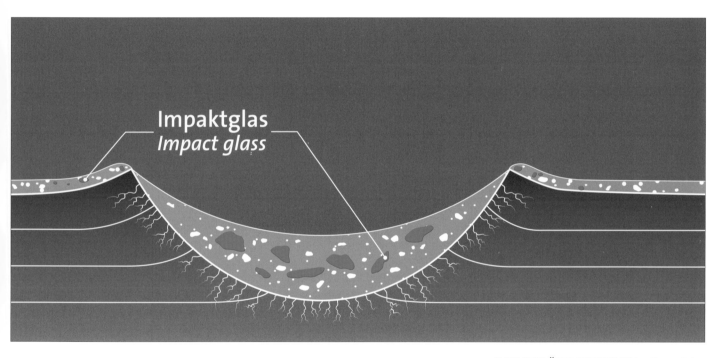

Impaktglas
Impact glass

IMPAKTGLÄSER ENTSTEHEN während der Kraterbildung meist später als Tektite und kommen im Krater oder in dessen Nähe vor.

IMPACT GLASSES ORIGINATE later than tektites during crater formation and occur within or around the crater.

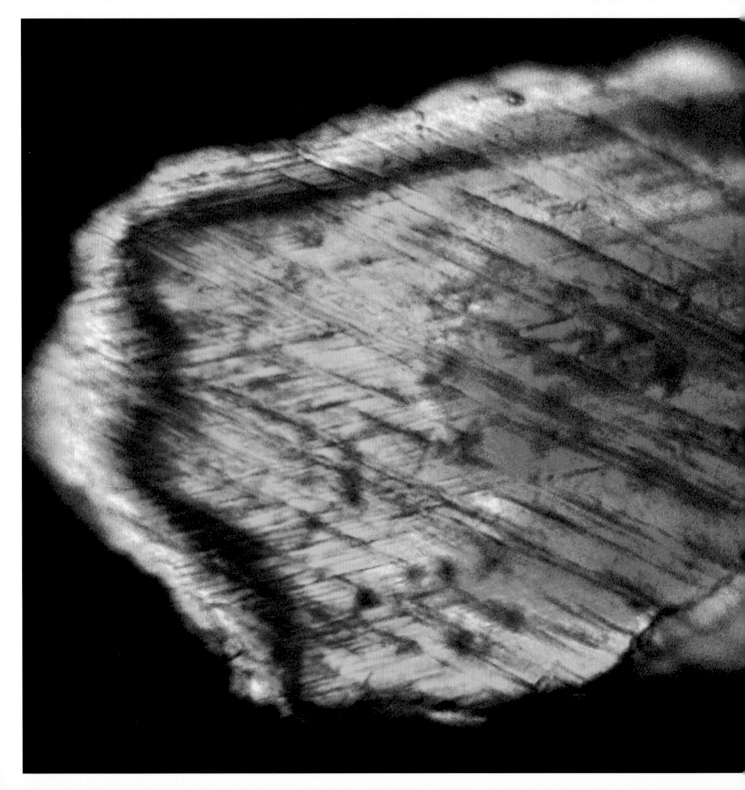

WÄHREND DES EINSCHLAGES eines extraterrestrischen Körpers auf der Erde kommt es zu ungeheuren Drucken und Temperaturen, und zwar innerhalb sehr kurzer Zeiträume. Diese verursachen unumkehrbare Veränderungen in den betroffenen Gesteinen und Mineralen. Insbesondere die Kristallstruktur der Minerale wird durch die hohen Drucke gestört. Es kann auch zur Bildung von Hochdruckphasen vieler Minerale (z. B. Coesit aus Quarz, Stishovit aus Coesit, Diamant aus Graphit) kommen. Besonders typisch für diese „Schock-Metamorphose" sind „Schocklamellen": regelmäßige, parallele und zueinander im gleichen Abstand stehende, extrem gerade (planare) Lamellen, die die Kristalle durchziehen, aber nur mit dem Mikroskop gesehen werden können (siehe Bild links: „Schocklamellen" in Quarz; Auswurfmaterial des Manson-Kraters, Iowa, USA).

THE IMPACT OF AN EXTRATERRESTRIAL BODY on Earth causes extremely high pressure and temperature levels within a very short time span, leading to irreversible changes in the impacted rocks and minerals. In particular, the crystal structure of minerals is modified by the high pressure levels. High-pressure phases of many minerals (e.g., coesite and stishovite after quartz, or diamond after graphite) may also form. Typical of this "shock metamorphism" are "shock lamellae" – parallel and equidistant, extremely straight (planar) lamellae – extending throughout the crystals; they can only be seen with a microscope (see image on the left: shock lamellae in quartz; ejecta from the Manson crater, Iowa, USA).

10 µm

Der Krebsnebel – Überrest einer Supernovaexplosion im Jahre 1054.
The Crab Nebula – remnant of a supernova explosion in the year 1054.

Das Universum war bereits über neun Milliarden Jahre alt, als am Rand einer Spiralgalaxie eine große Gas- und Staubwolke zusammenzustürzen begann, möglicherweise ausgelöst durch eine nahe Supernovaexplosion. Durch den Kollaps kam es zu einer immer schnelleren Rotation, wobei sich im Zentrum der jetzt diskusförmigen Wolke die Materie (hauptsächlich aus den leichtesten chemischen Elementen, Wasserstoff und Helium, bestehend) zusammenballte. Nach wenigen hunderttausend Jahren wurde daraus ein junger Stern, die frühe Sonne, die zu leuchten begann, als der Druck und die Temperatur in ihrem Inneren so hoch war, dass Kernfusionsreaktionen zündeten. Durch die Hitze des jungen Sterns verdampfte der Staub im umgebenden Nebel und kondensierte in größerer Entfernung wieder aus. Aus diesen Bestandteilen entstanden die Meteoriten und Planeten.

The universe was already 9 billion years old when, at the edge of a spiral galaxy, a gas and dust cloud started to collapse, possibly initiated by a nearby supernova explosion. As the cloud contracted, it rotated faster and faster and became disk-shaped. In the center of this cloud, matter (mainly the light elements hydrogen and helium) accumulated, forming, after a few hundred thousand years, a star. Pressure and temperature levels within the young sun were so high that nuclear fusion reactions started. The heat of the new star caused evaporation of volatile substances in the inner part of the disk-shaped nebula, which recondensed at greater distances. From this material, meteorites and planets formed.

SONNENSYSTEM
SOLAR SYSTEM

IM FRÜHEN SONNENNEBEL BALLTEN SICH DIE STAUBTEILCHEN durch einen Vorgang, der als Akkumulation bezeichnet wird, zusammen. Nachdem sie eine ausreichende Größe erreicht hatten, zogen sich die nun „Planetesimale" genannten Brocken aus Staub‹ und Eis durch die Schwerkraft an; dieser Prozess wird Akkretion genannt. Durch Kollisionen untereinander wuchsen die Planeten rasch – innerhalb von nur wenigen Millionen Jahren – und erreichten fast ihre heutige Größe.

DUST GRAINS STARTED TO CLUMP TOGETHER in a process called accumulation; once they reached a certain size, the ice and rock fragments were gravitationally attracted to one another through the force of gravity in a process called accretion. As a result of collisions, the planets rapidly grew to almost their current size within a time-span of just a few million years.

SCHEMABILD DER ENTSTEHUNG UNSERES SONNENSYSTEMS, von einer gigantischen Gas- und Staubwolke bis zum Planetensystem.
SCHEMATIC DIAGRAM OF THE FORMATION OF OUR SOLAR SYSTEM, *from a giant gas and dust cloud to the planetary system.*

SONNENSYSTEM
SOLAR SYSTEM

2 Ma
Erste Menschen
First humans

230–65 Ma
Dinosaurier
Dinosaurs

~380 Ma
Erste Landwirbeltiere
First vertebrate land animals

~530 Ma
Kambrische Explosion
Cambrian explosion

750–635 Ma
Zwei globale
Vereisungsphasen
*Two Snowball Earth
events*

4550 Ma
Entstehung der Erde
Formation of the Earth

~4520 Ma
Entstehung des Erdmondes
Formation of the Moon

~3800 Ma
Ende der späten
Bombardementphase
*End of the Late Heavy
Bombardment*

~3500 Ma
Beginn der
Photosynthese
Photosynthesis start

Entwicklung der Erde
History of the Earth

65 Ma — Känozoikum / Cenozoic

251 Ma — Mesozoikum / Mesozoic

542 Ma — Paläozoikum / Paleozoic

4.6 Ga

4 Ga

3.8 Ga

3 Ga

2.5 Ga

2 Ga

1 Ga

Hadaikum / Hadean

Archaikum / Archean

Proterozoikum / Proterozoic

Ma Million Jahre
Million years

Ga Milliarde Jahre
Billion years

■ Menschen
Humans

▨ Säugetiere
Mammals

□ Landpflanzen
Land plants

■ Tiere
Animals

□ Vielzeller
Multicellular life

■ Eukaryoten
Eukaryotes

■ Prokaryoten
Prokaryotes

~2300 Ma
Erster Sauerstoff in der Atmosphäre,
erste globale Vereisung
*First oxygen appears in atmosphere,
first Snowball Earth*

DAS ALTER VON METEORITEN wird anhand des Zerfalls radioaktiver Elemente bestimmt. Deren Atome zerfallen nach physikalischen Gesetzmäßigkeiten. Innerhalb einer Halbwertszeit zerfällt die Hälfte der ursprünglich vorhandenen radioaktiven Atome (z. B. Uran) in nicht radioaktive Tochterisotope (z. B. Blei). Man misst also zum Beispiel, wie viel vom ursprünglichen Uran noch vorhanden ist und wie viel Blei sich angesammelt hat, woraus dann das Alter der Meteoriten abgeleitet werden kann. Das Ergebnis dieser und vieler anderer Isotopenmessungen war, dass alle Meteoriten das gleiche Alter aufweisen und ~4,6 Milliarden Jahre alt sind. Dies entspricht dem Alter des Sonnensystems und der Erde.

THE AGE OF METEORITES is determined from the decay of radioactive elements. Physical laws determine this decay. During one "half life", half of the originally present radioactive atoms (e.g., uranium) decay to non-radioactive daughter atoms (e.g., lead). Measuring the ratio of the remaining uranium atoms and the newly formed lead atoms can determine the age of a meteorite. Results of these and other isotopic age determinations indicate that all meteorites have the same age and are 4.6 billion years old, which is also the age of the Earth and the solar system.

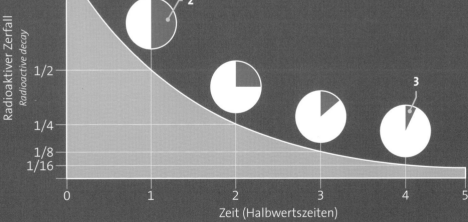

Radioaktiver Zerfall
Radioactive decay

1/1
1/2
1/4
1/8
1/16

0 1 2 3 4 5

Zeit (Halbwertszeiten)
Time (half-lives)

1 Gestein entsteht; enthält radioaktive Atome.
When rock forms, it may contain some radioactive elements.

2 Nach einer Halbwertszeit ist die Hälfte dieser Atome zerfallen.
At half-life, half the amount of the radioactive element has decayed.

3 Messung der verbleibenden radioaktiven Atome erlaubt Berechnung des Alters.
By measuring this amount, the age of the rock can be calculated.

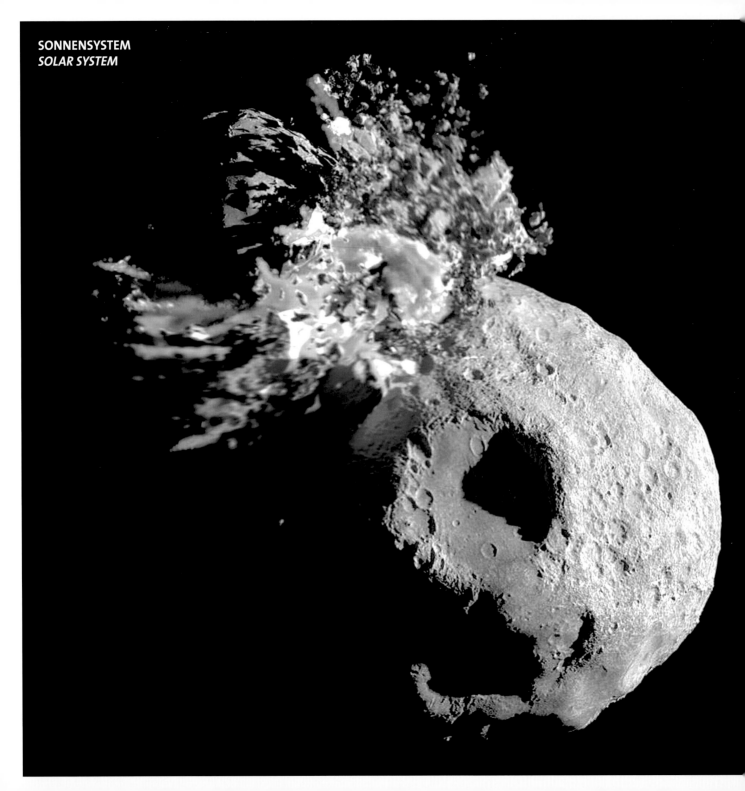

BEI METEORITEN KANN MAN – MITHILFE VON UNTERSCHIEDLICHEN RADIOAKTIVEN ISOTOPENSYSTEMEN – DREI VERSCHIEDENE ALTER BESTIMMEN. Das Entstehungsalter ist für fast alle Meteoriten gleich: 4,6 Milliarden Jahre. Dies ist das Alter des Sonnensystems; zu dieser Zeit entstanden die Meteoritenmutterkörper (die Asteroiden) aus der Gas- und Staubwolke des Sonnennebels. Viel später kommt es dann zu Zusammenstößen von Asteroiden. Dabei können Bruchstücke ins innere Sonnensystem gelangen und z. B. auch auf die Erde stürzen. Den Zeitraum zwischen der Kollision und der Landung des Objektes auf der Erde nennt man das Bestrahlungsalter; dies kann viele Millionen Jahre betragen. Den Zeitraum vom Fall des Meteoriten auf die Erde bis zu seiner Entdeckung nennt man das terrestrische Alter. Wenn ein Meteorit in eine Wüste oder in die Antarktis stürzt, wo er vor der Verwitterung geschützt ist, kann das terrestrische Alter viele zehntausende oder (vor allem bei Eisenmeteoriten) sogar hunderttausende Jahre betragen.

IT IS POSSIBLE TO USE VARIOUS RADIOACTIVE ISOTOPE SYSTEMS TO DETERMINE THREE DIFFERENT AGES FOR METEORITES. The formation age is the same for almost all meteorites, the age of the solar system: 4.6 billion years. At that time, all meteorite parent bodies (the asteroids) formed from the gas and dust of the solar nebula. Later, asteroids collided with each other. In this way, fragments may enter the inner solar system and, for example, collide with Earth. The time period between a collision and when the meteorite falls on Earth is called the irradiation age or transfer time, which can last many millions of years. The period between the fall of a meteorite onto Earth and its discovery is called the terrestrial age. If a meteorite falls in a desert region or Antarctica, the terrestrial age can be many tens of thousands of years, or, in the case of iron meteorites, even hundreds of thousands of years.

No. 1737. Meteorit
1864 K
Orgueil
Loc. Montauban
Frankreich

Dr. F. Krantz
Rheinisches Mineralien-Contor Bonn.

H 3451. 140.-

1 cm

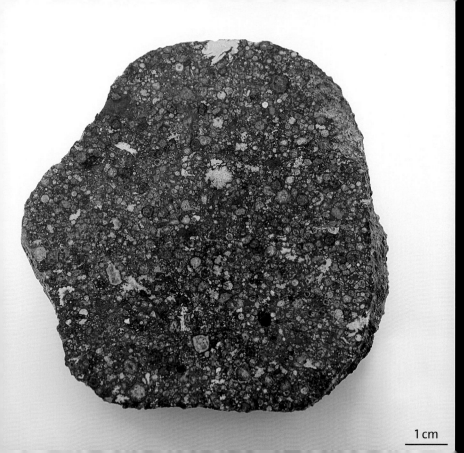

1 cm

METEORITEN SIND ZEITZEUGEN de[r] Entstehung des Sonnensystems. Hie[r] sind zwei besonders ursprüngliche[n] Meteoriten zu sehen – die „kohliger[n] Chondrite" Orgueil (ganz links) und Allende (links). Sie bestehen aus einer Mi[-] schung von Hochtemperaturmineralen[,] die aus dem heißen Sonnennebel zuers[t] auskondensiert sind (in den Objekte[n] sind das die weißen Minerale), und Tieftemperaturmineralen und -materia[l] (z. B. Kohlenstoff), welche zuletzt im Sonnennebel entstanden sind.

METEORITES ARE WITNESSES of the *formation of the solar system. Here are* *two particularly primitive meteorites –* *the carbonaceous chondrites Orguei[l]* *(far left) and Allende (left). They are [a]* *mixture of high-temperature mineral[s]* *(the white inclusions), which were the* *first solids to condense in the hot sola[r]* *nebula, and low-temperature mineral[s]* *and substances (e.g., carbon), which wer[e]* *the last to form in the cool solar nebula*

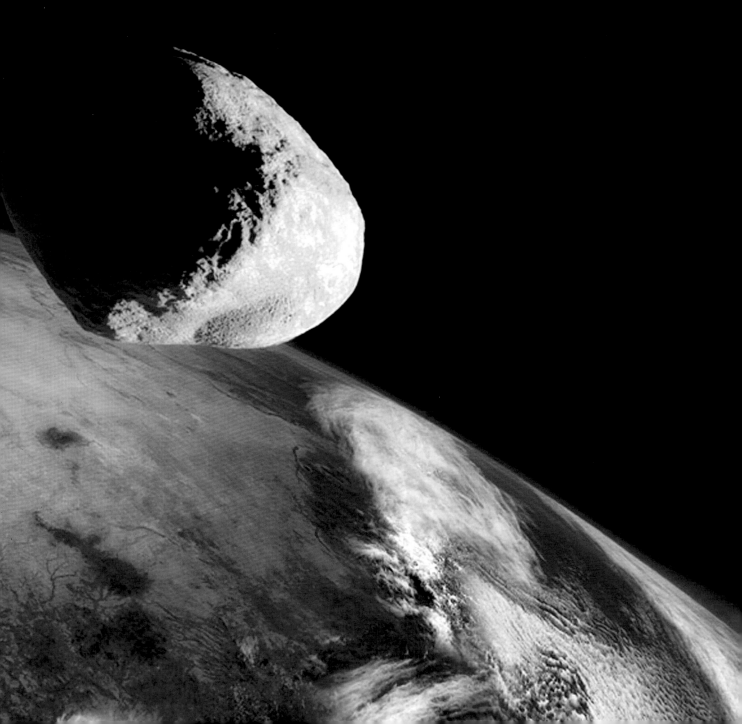

WIR SIND ALLE STERNENSTAUB
WE ALL ARE STARDUST

Spiralgalaxie M74.
Spiral galaxy M74.

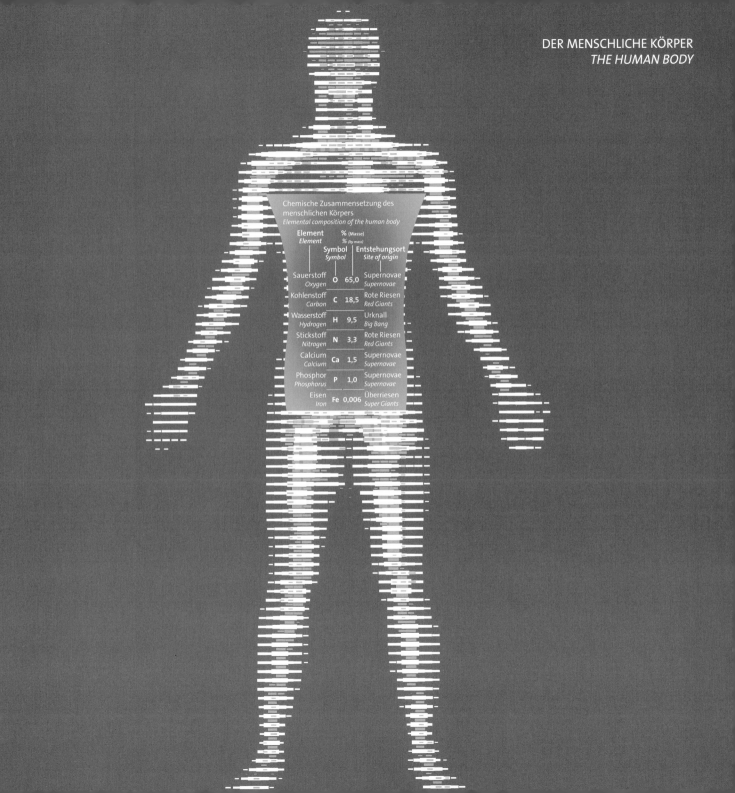

Chemische Zusammensetzung des
menschlichen Körpers
Elemental composition of the human body

Element *Element*	Symbol *Symbol*	% (Masse) *% (by mass)*	Entstehungsort *Site of origin*
Sauerstoff *Oxygen*	O	65,0	Supernovae *Supernovae*
Kohlenstoff *Carbon*	C	18,5	Rote Riesen *Red Giants*
Wasserstoff *Hydrogen*	H	9,5	Urknall *Big Bang*
Stickstoff *Nitrogen*	N	3,3	Rote Riesen *Red Giants*
Calcium *Calcium*	Ca	1,5	Supernovae *Supernovae*
Phosphor *Phosphorus*	P	1,0	Supernovae *Supernovae*
Eisen *Iron*	Fe	0,006	Überriesen *Super Giants*

WIR SIND ALLE STERNENSTAUB
WE ALL ARE STARDUST

Urknall
Big Bang

Galaxienhaufen
Galaxy cluster

Lebenszyklus eines Sterns
Life cycle of a star

Supernova
Supernova

Planetarer Nebel
Planetary nebula

Sonnenähnlicher Stern
Sun-like star

Riesenstern
Giant star

Spiralgalaxie
Spiral galaxy

Stern
Star

Protosolare Wolke
Protosolar cloud

WO UND WANN SIND DIE CHEMISCHEN ELEMENTE, DIE GRUNDLAGE ALLER MATERIE, DES UNIVERSUMS, DER ERDE UND DER NATUR, ENTSTANDEN? Für die Erklärung waren Untersuchungen von Meteoriten von großer Bedeutung. Das einfachste Element, Wasserstoff, und ein Teil des nächst schweren Elements, Helium, entstanden beim Urknall vor 13,7 Milliarden Jahren. Danach wurden mehr Helium und viele schwerere Elemente im tiefen Inneren von Sternen (wie z. B. unserer Sonne) „gekocht".

Die einfachste derartige Kernfusionsreaktion ist der Proton-Proton-Zyklus, in dem vier Wasserstoffkerne (4 Protonen) zu einem Kern des Elements Helium, dem zweiten Elements des Periodensystems, verschmolzen werden; dabei wird sehr viel Energie frei, die für das Leuchten der Sonne verantwortlich ist. Schwerere Elemente bis zum Eisen (26 Protonen im Kern) werden im Inneren von alten Sternen bei hoher Temperatur und hohem Druck gebildet.

Noch schwerere Elemente, bis zum Uran, können nur bei den extremen Bedingungen in großen und heißen alten Sternen oder in Supernovaexplosionen gebildet werden. Bei solchen Explosionen bleiben von den Sternen nur noch sich rasch ausbreitende Gaswolken übrig, die die Elemente im Weltraum verteilen, und woraus dann wieder neue Sterne und Planeten – und auch wir – entstehen.

WHERE AND HOW DID THE CHEMICAL ELEMENTS – WHICH MAKE UP THE UNIVERSE, THE EARTH, AND ALL OF NATURE – FORM? Scientists derived the answer from studying meteorites. The simplest element, hydrogen, and part of the next heavier element, helium, were created in the Big Bang. Heavier elements, including more helium, formed later in the deep interior of stars (e.g., our Sun).

The most fundamental of such nuclear fusion reactions is the proton-proton cycle, in which 4 hydrogen nuclei (protons) are fused to a helium nucleus – the second element in the periodic table of elements. This reaction releases a lot of energy and is the reason why stars emit light and heat. Elements heavier than helium, up to iron, are formed at high temperatures and under high pressure by other fusion reactions in the interior of old, dying stars.

Even heavier elements, from iron to uranium, form only under the extreme conditions present in large, hot, old stars or during supernova explosions. The remnants of such explosions are rapidly expanding gas clouds that distribute the elements into space, and these clouds provide the raw material for new stars and planets – and for us.

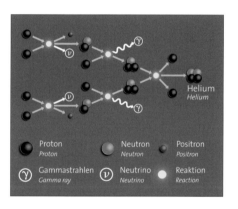

Kernfusion von Wasserstoff zu Helium im Inneren der Sonne und anderer ähnlicher Sterne.
Fusion of hydrogen to helium in the interior of the Sun and other normal stars.

WIR SIND ALLE STERNENSTAUB
WE ALL ARE STARDUST

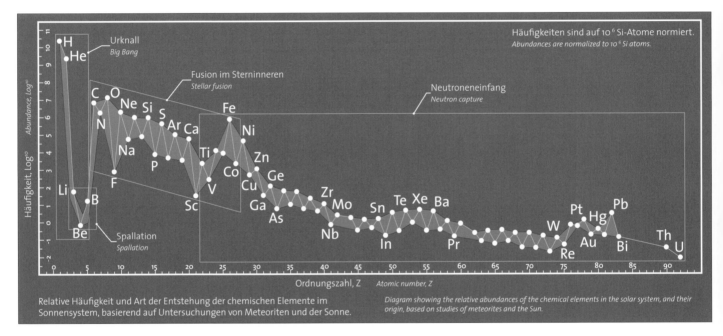

Relative Häufigkeit und Art der Entstehung der chemischen Elemente im Sonnensystem, basierend auf Untersuchungen von Meteoriten und der Sonne.

Diagram showing the relative abundances of the chemical elements in the solar system, and their origin, based on studies of meteorites and the Sun.

DIE CHEMISCHEN ELEMENTE sind die Grundlage der Chemie und aller Materie (Erze, Rohstoffe, Gesteine, Wasser, Luft, Pflanzen, Tiere, Menschen,...) und daher allen Lebens. Die kleinsten Teilchen eines chemischen Elementes sind die Atome, welche wiederum aus einem Atomkern (mit Protonen und Neutronen) und einer Elektronenhülle bestehen. Die Anzahl der Protonen im Kern (die Ordnungszahl) bestimmt, um welches Element es sich handelt. Isotope sind Varianten von Elementen, die bei gleicher Protonenzahl eine unterschiedliche Anzahl an Neutronen enthalten.

THE CHEMICAL ELEMENTS are the basis of all matter (from rocks, minerals, and ores, to air, water, plants, animals, and humans) and are thus the foundation of all life. Each element consists of a nucleus (protons and neutrons) and an electron shell. The number of protons, called atomic number, uniquely defines each element, whereas the electrons are responsible for chemical reactions.

ES SIND 80 STABILE ELEMENTE BEKANNT, und auf der Erde oder in Meteoriten kommen noch 14 teilweise langlebige radioaktive Elemente vor. Weitere Elemente wurden künstlich hergestellt. Die Anordnung der chemischen Elemente nach ihren chemischen Eigenschaften, eingeteilt in Perioden sowie Haupt- und Nebengruppen, wird das Periodensystem der Elemente genannt. Jedes Element wird durch ein Elementsymbol bezeichnet, wobei die Abkürzung in vielen Fällen vom lateinischen Namen des Elements abgeleitet ist.

80 STABLE ELEMENTS AND 14 RADIOACTIVE ELEMENTS occur naturally on Earth or in meteorites; others have been created artificially. Isotopes are varieties of elements that have the same number of protons, but different numbers of neutrons in their nucleus. The arrangement of elements in groups and periods, based on their chemical properties and increasing atomic number, is called the periodic table of the elements. Each element is assigned a symbol that is usually derived from the Latin name of the respective element.

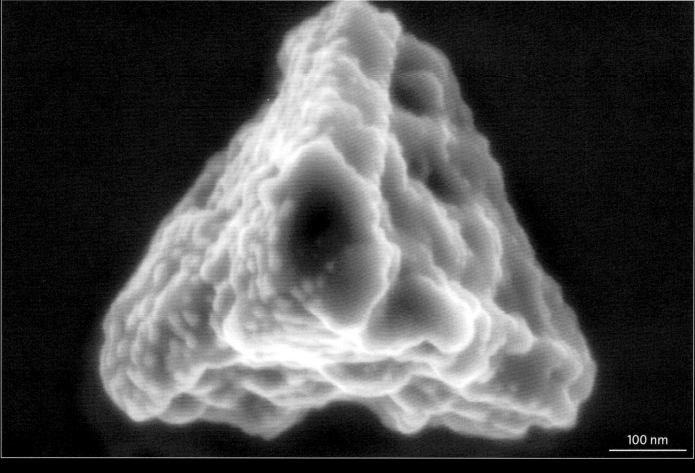

100 nm

Murchison. Elektronenmikroskopische Aufnahme eines Siliciumcarbidkorns.
Murchison. Electron microscope image of a silicon carbide grain.

METEORITEN ENTSTANDEN aus einer Gas- und Staubwolke, die bei der Bildung des Planetensystems gut durchgemischt und aufgeschmolzen wurde. Aus der heißen Wolke kondensierten der Reihe nach chemische Verbindungen und Minerale je nach ihrer Bildungstemperatur (zuerst z. B. Calcium-Aluminium-reiche Minerale). Einige Meteoriten enthalten jedoch auch Bestandteile wie Diamanten, Korundkristalle oder Siliciumcarbidkörner, die dieser Vermischung und Neubildung nicht unterworfen waren – diese Objekte sind viel älter als das Sonnensystem und stammen aus den Atmosphären sterbender Sterne, die als planetare Nebel abgestoßen wurden.

DURING THE SOLAR SYSTEM'S FORMATION, meteorites originated from a well-mixed, early gas and dust cloud. As the cloud cooled, minerals and compounds condensed in the order of their formation temperatures (e.g., calcium-aluminum-rich minerals first). Some meteorites also contain components such as diamonds, corundum crystals, and silicon carbide grains that were not homogenized in the hot gas; these are presolar grains that are older than the solar system and formed when the atmospheres of dying stars were ejected as planetary nebulae.

WIR SIND ALLE STERNENSTAUB
WE ALL ARE STARDUST

naturhistorisches museum wien

EDITION LAMMERHUBER

IMPRESSUM *CREDITS*

Concept Franz Brandstätter, Ludovic Ferrière, Christian Köberl

Text Franz Brandstätter, Ludovic Ferrière, Christian Köberl

Translation Christian Köberl
Proofreading Sandra Wilfinger-Bak, Brigitte Scott

Art Director Lois Lammerhuber
Layout Martin Ackerl
Digital post production Birgit Hofbauer

Font The Sans
Project coordination Johanna Reithmayer
Print Ueberreuter Print GmbH, Korneuburg
Binding Lachenmaier GmbH, Reutlingen, Germany
Paper Hello Silk 170 g/m²

Managing Director EDITION LAMMERHUBER Silvia Lammerhuber

EDITION LAMMERHUBER
Dumbagasse 9, A-2500 Baden
edition.lammerhuber.at
Copyright 2013 by
ISBN Edition Lammerhuber
978-3-901753-43-5

VERLAG DES NATURHISTORISCHEN MUSEUMS
Burgring 7, A-1010 Vienna, Austria
www.nhm-wien.ac.at/verlag
EDITION LAMMERHUBER, Verlag des NHM
ISBN Verlag des NHM
978-3-902421-68-5

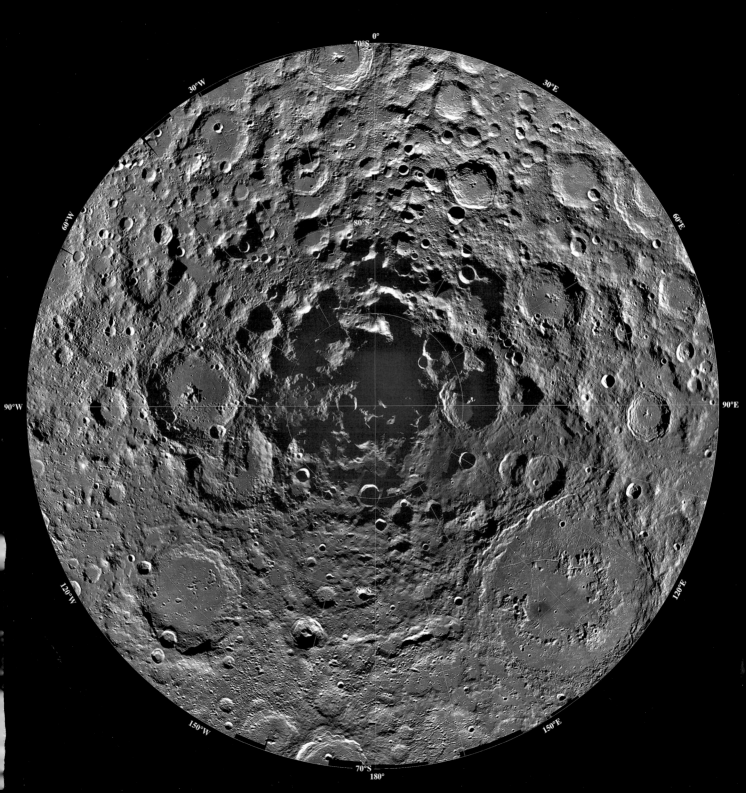